UNITED RANGER CORPS

SURVIVAL MANUAL

MILLENNIAL EDITION

COMPILED BY ROBERT GREENBERGER

INSIGHT
EDITIONS

San Rafael, California

A NOTE FROM COMMANDER VELAN

Cadet, you are honored to hold in your hands a true artifact of the world we left behind one thousand years ago. Printed on real paper using techniques not seen for a millennium, this unique edition of the *United Ranger Corps Survival Manual* is given only to those cadets who show exceptional promise in the field. In its pages you'll find not only detailed information on Ranger equipment, cutlass combat, and the strengths and weaknesses of our enemies, but also a complete history of Nova Prime and the sacrifices your predecessors have made over the years to keep our adopted homeworld safe. Throughout the book you'll also find a number of images and items from the personal collection of the Prime Commander, General Cypher Raige, thus making this edition truly indispensable. Read on, Cadet: you are well on your way to becoming the true pride of Nova Prime: a member of the United Ranger Corps.

CONTENTS

INTRODUCTION

★ ★ ★ ★ ★

Our duty is to preserve humanity.

That is who we are, and it is my responsibility to instill that into every citizen of Nova Prime who volunteers to serve in the United Ranger Corps.

We did not ask for this job, but for more than seven hundred years, we have had to maintain a stance of war in anticipation of attacks by our alien enemies, the Skrel and their vicious creations, the Ursa. Oftentimes, we encounter situations where, in order to preserve humanity, we must protect it from itself. In those dark days when humankind was nearly lost, for example, the United Ranger Corps rose up to ensure the human race survived. We struggled to keep civilization civil, allowing engineers and scientists to build the interstellar vehicles that would give nearly one million people a chance to survive. We then had to maintain that order for a century of travel, unaware that only half of us would make it to our new home. Once we arrived on Nova Prime, it was our job to explore the planet while containing the eager throng that wanted to begin building or to do exploring of their own. Managing expectations was a brand-new skill the Rangers soon mastered.

To become a Ranger is to accept a way of life that goes beyond the oath we all take when we graduate from training. It is to put responsibility ahead of all other concerns. To put our lives on the line to protect the lives of others. Every day that we put on our uniforms, we are a visible reminder that the Rangers exist to make sure humans can thrive in the hostile reaches of space.

I am a Raige, and with that comes a heritage of achievement and service that traces its way back to the formation of the Corps, and beyond. Our commitment to preserve humanity has become part of the Ranger DNA, and it can weigh heavily at times—asking us to put the needs of the people before our own or those of the people we love. Few are immune from this, and serving our duty can sometimes mask the deep personal pain that comes with the job. Not long ago, I was reminded of this all over again when my son, Kitai, and I were stranded on Earth. I had allowed a schism to form between us, almost letting blind devotion to the cause cost me the privilege of knowing my son and watching him become the man I had always hoped he would grow to be.

As the military arm of Nova Prime's tripartite government, the Rangers—more than our religious division, led by the Primus, and our scientific division, led by the Savant—can easily lose themselves in their service to others. It is a sacrifice we willingly make, but we must always be cautious not to let it wall us off from the very people we protect. If you take away anything from this survival manual, let it be that.

General Cypher Raige
Prime Commander, United Ranger Corps

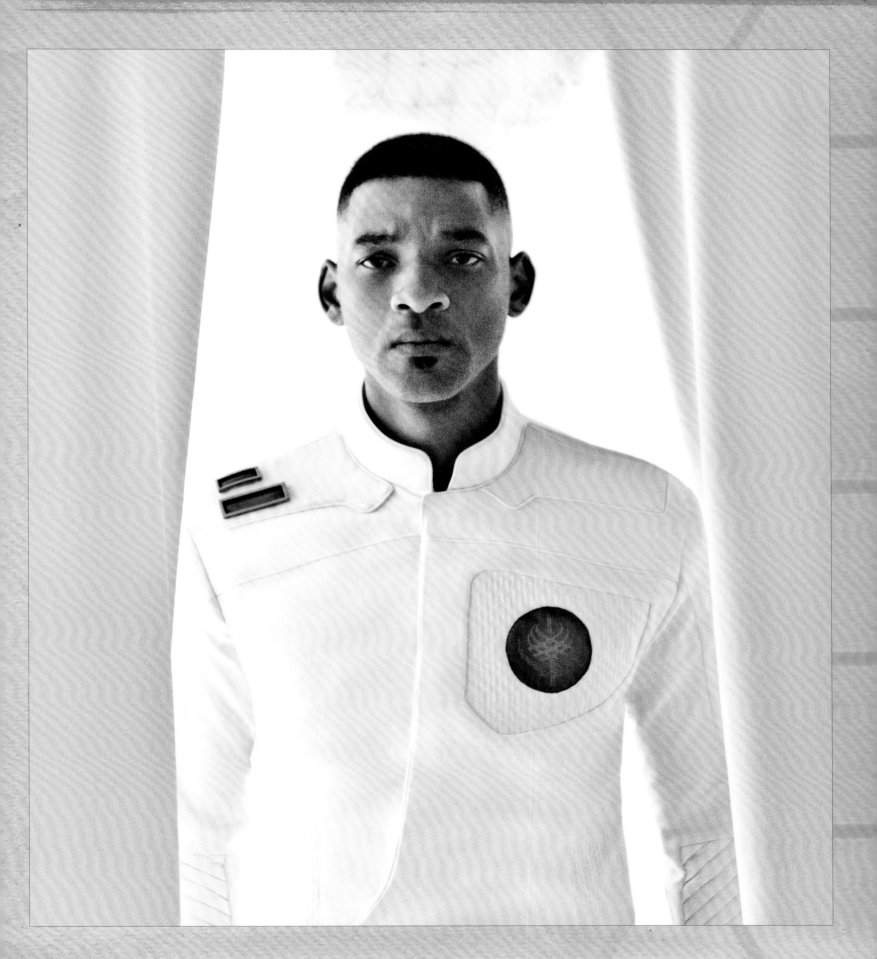

A BRIEF HISTORY OF

EARTH'S
LAST DAYS

EARTH'S LAST DAYS

ECOLOGICAL NIGHTMARES

For all those who survived, so many more perished on Earth on October 23, 2071—the day Mother Earth turned against us. Over a century of environmental neglect and abuse led to sudden and drastic changes in the atmosphere, the water table, and food supply. All becoming lethally toxic. Rendering the planet uninhabitable. Billions perished in the following months. And, by 2077, Earth's human population was zero. Mother Earth had had enough.

WHILE THE STATEMENT ABOVE IS ACCURATE, it is not complete. Concerns over the planet's long-term sustainability were first raised more than a century earlier. Ecology, recycling, and related issues became topics of concern, protest, and conversation. The continual pumping of carbon dioxide into the atmosphere, dating back to the advent of the Industrial Revolution centuries earlier, continued to trap solar radiation, incrementally raising the planet's overall temperature. In time, the ozone layer protecting all life from harmful ultraviolet radiation began to grow porous, and by the beginning of the twenty-first century AD, the polar ice caps were receding and glaciers were dramatically shrinking in size. The great coral reefs were dying off at a frightening rate. Sea levels were increasing, and constantly warming weather patterns forced life on sea and land to adapt or die.

By 2011, it was believed the climate was nearing a "tipping point" that would be disastrous for humankind. New signals suggested that the Arctic was thawing and releasing additional quantities of carbon dioxide and methane into the air.

As early as 2012, experts surmised that the ecological tipping point would be achieved by 2050, but events accelerated, and scientists declared Earth had reached that pivotal event by

2020. The president of the United States of America secretly convened a video conference among global leaders that saw the birth of a bold, daring plan to save at least some of mankind. Project Next Generation was launched with scientist Athena Tsaparakis named its first director, tasked with finding ways to preserve life on Earth through genetic measures. The project's goal was to use every resource available to find a way to send as many people, animals, and plants into space, aiming these colonists toward the planet most likely to sustain life.

Within four years, all reports indicated a growing ecological nightmare. Following a rise in violent outbreaks, the United Nations, a well-meaning but largely ineffectual organization, sent peacekeeping forces to work with national armies, but all were overwhelmed.

While astronomers probed all available data to find viable planets that might be able to sustain life, other scientists attempted to work out how to ferry people to such worlds. Additional work was devoted to determining how best to transport living samples of plant and animal life during the voyage. Some were needed to propagate a new world while others were there to provide sustenance during the mission.

With humankind making ambitious plans to flee Earth, it became necessary that an increasing number of key people be exposed to one of the planet's best-kept secrets, a piece of classified information that dated back to 1908 AD: Humankind was not alone in the universe.

On June 30, 1908, an explosion occurred near the Podkamennaya Tunguska River in Russia. The early-morning event was first believed to have been caused by the air burst of a large meteoroid or comet fragment at an altitude between 5 and 10 kilometers above the Earth's surface. Different studies yield varying estimates of the object's size, with general

A NOTE FROM COMMANDER VELAN

Why do we insist on Rangers knowing the history of Earth, even a millennium removed from departure? Because, as the old Earth adage goes, those who forget the past are doomed to repeat it. The fates have given us a second chance, and we do not wish to squander this opportunity. Earth's final days may have been horrific, but they would have been far worse had the United Ranger Corps not stepped up and kept order amid global chaos. Our proud history is intertwined with those final days, and it is vital that we always remember what it was like so that we never again hear a civilization's death knell. For all those who survived, billions more perished in the most unpleasant way possible. We honor their sacrifice and will always keep them in our thoughts.

ABOVE A bird's-eye view of the meteorological changes that swept the world. Here, a densely populated portion of the United States of America is facing an incoming hurricane.

agreement that it was several tens of meters across. However, when the source of the explosion was discovered, investigators found not a smoldering rock, but an alien spacecraft.

Over the following years, Russian scientists studied, measured, weighed, and theorized about how this spacecraft technology worked. Meanwhile, the country's leader, Czar Nikolay Alexandrovich Romanov, was more concerned about where the spaceship came from and whether it was a threat to his country. He tried to control the flow of information, but it was clear the expertise of the era's greatest international minds was needed. Among the men consulted were scientists and engineers including Nikola Tesla, Henry Ford, Thomas Alva Edison, and Albert Einstein, with private funding coming from financiers led by John D. Rockefeller, J.P. Morgan, and John Jacob Astor IV. This group of the world's finest minds was known as the Pan Global Scientific Research Consortium.

In time, enough was learned from reverse-engineering the alien technology to propel the world into a century of amazing progress. Over the following decades, the craft's engines yielded secrets that would lead humans to escape gravity's hold and examine the stars. The alien technology was named the Lightstream, or LST, Engine, a term borrowed from the popular literature of the day. What remained elusive was where the ship came from and what these aliens wanted from Earth.

In 2012 at the National Air and Space Administration's 100 Year Starship Symposium, NASA revealed that a method had been discovered to warp space, drastically cutting down travel time through the stars. Although the Lightstream technology was being discussed in public, its alien origins were not acknowledged. What was revealed, however, was that engines created using this proposed technology could generate a powerful wave that compressed space-time before a vessel and expanded space-time behind it, like the prow of a boat slicing through the water and creating a wake. The vessel that utilized this technology would actually be floating in a bubble along the wave being generated, literally surfing through space at a speed faster than light relative to objects outside the bubble.

What wasn't revealed to the public was that the alien engines managed to tap into the universe's dark energy in ways that still perplexed scientists. Once that problem was solved, interstellar travel could become a reality.

Project Next Generation was determined to harness the LST Engines to power vessels that could transport people away from Earth. The alien engines could travel faster than light, and it was now believed that technique could be replicated with equivalent man-made engines. The revolutionary new method of travel was dubbed Lightstream Space, and best estimates pointed to humankind needing fifty years to have such vehicles ready. A Project Next Generation clock was launched, ticking down to a departure date of 2075.

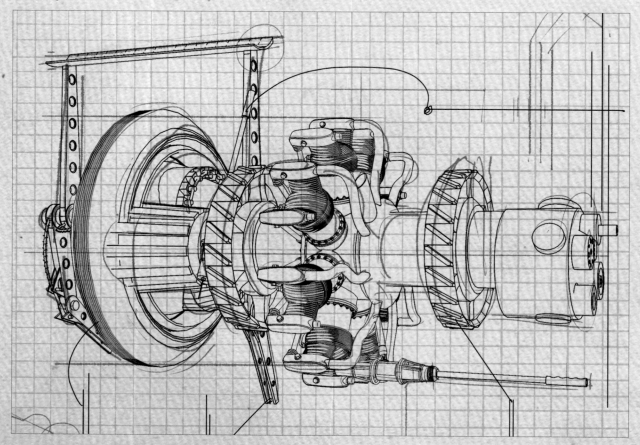

LEFT An artist's rendition of the Lightstream Engine first discovered in Russia. On first inspection, this portion of the engine appeared to be its core unit, but it took decades to fully understand the device.
OPPOSITE After collecting the necessary energy in the Sahara Desert, transport ship construction was carried out all over the world, including Antarctica.

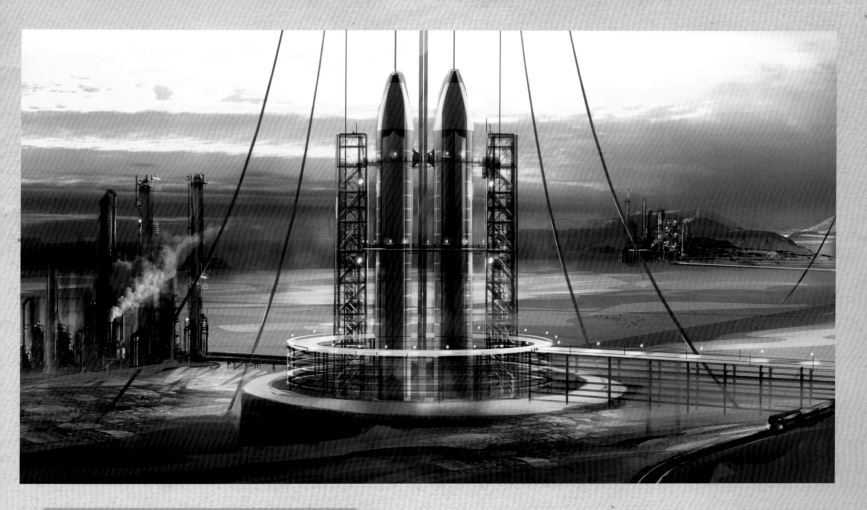

PREPARING FOR THE FUTURE

In response to the escalating concern about the sustenance of the world's resources in the early twenty-first century AD, in October 2008, the Norwegian government built a "Doomsday Vault" in a mountain on the remote Svalbard islands between Norway and the North Pole to house the world's seed collections. This was considered the ultimate safety net, protecting them from a wide range of threats including war, natural disasters, lack of funding, or even just poor agricultural management.

A decade later, the "Noah Vault" was opened in an adjacent mountain, a repository for DNA from all available avian, insect, fish, and animal species.

When a selection of potential planets was finalized for additional study, the estimated travel time using the man-made LST Engines was more than a century to even the nearest option. This led a subset of scientists to determine how the crew and its passenger complement could endure the travel duration. A new approach to life-preservation was presented at a Geneva Conference in 2037 AD, showing that adding extra telomerase to cells in utero can prolong a natural lifespan. Set against the global catastrophes filling the headlines daily, people objected to the concept of prolonged life, sparking controversies that delayed the research. Two years later, scientists in the United States developed synthetic telomerase, replacing the portion of a subject's DNA that was lost during cell division, effectively reversing the aging process. A year later, there was a call to ban any kind of telomerase, citing the logistical problems that would result from what was effectively immortality. The research was abandoned, but careful records and lab results were retained.

Concurrently, the predictions of early twenty-first-century futurist Ray Kurzweil came true in 2046 AD when fully cognizant artificial intelligence was achieved. This proved providential now that humankind needed to build space "arks" to transport huge numbers of people offworld and calculate stellar navigation on a scale never previously attempted.

Another breakthrough came with the creation of AI designed to exploit Lightstream technology. This finally provided scientists the additional high-speed processing power to solve the problem of accessing dark matter to power man-made engines. Interstellar space flight and man's survival was now a reality.

A short time later, Project Next Generation presented its astronomical findings for peer review. It was unanimously approved and forwarded to the world's leaders.

Simultaneously, a separate report was delivered to world leaders proposing the formation of an international corps of highly trained soldiers to protect not only the construction of the arks but also those individuals fortunate enough to be selected to leave Earth.

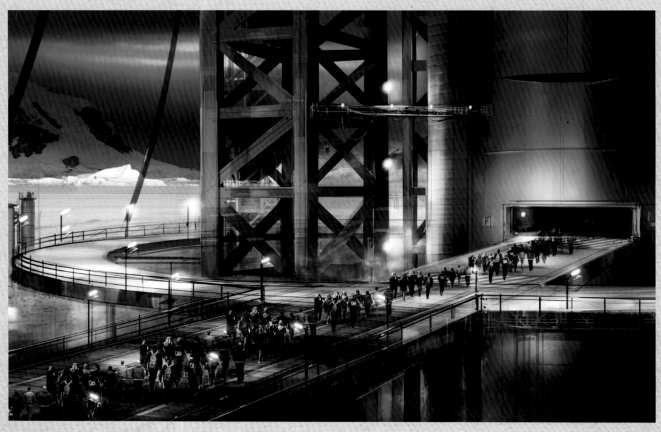

LEFT A lucky few chosen to depart Earth arrive at the launch site in Antarctica to board the transport ships, taking with them a prescribed amount of personal belongings. OPPOSITE One of the Rangers' first assignments was ensuring that ship construction would not be impeded. There was no time to lose, and the project faced many threats from a scared population. BELOW Those boarding the ships at the launch site in Antarctica would face many long years of space travel before reaching their destination.

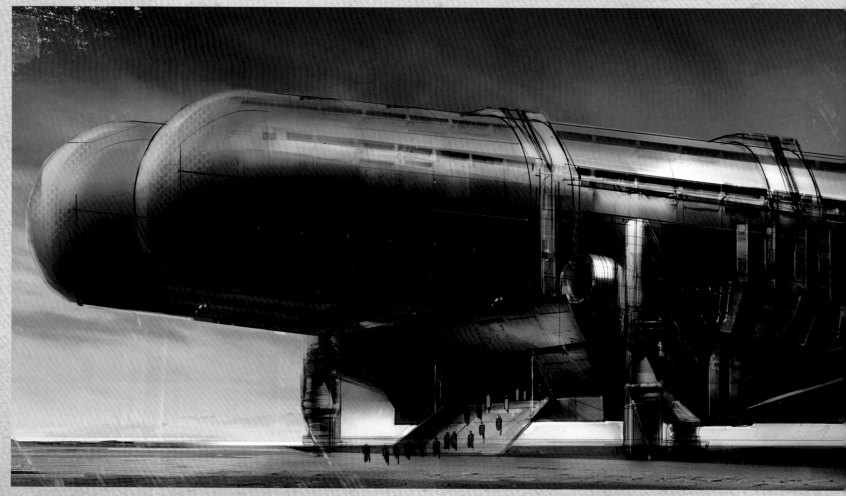

The United Ranger Corps was finally commissioned in 2052 AD. Each government selected its best tacticians, pilots, sharpshooters, and soldiers to be sent for evaluation and intensive training. Every country contributed not only personnel but also high-tech materials that would be fashioned into state-of-the-art equipment for the Rangers to use. Anyone assigned to the Rangers was required to pass punishing tests and psychological evaluations before being placed under one year of incredibly rigorous training.

Being a Ranger became the new gold standard for military service. Only the best of the best survived the challenges to qualify for membership. At first, the training was overseen by a UN-sanctioned command structure with the goal of building its own organizational hierarchy. The intent would be to have a one-million-soldier-strong force placed strategically around the world for instant response during the final years of ark construction and loading.

As they were being readied, ecological and political issues caused the Project Next Generation clock to be advanced from 2075 to 2072. Riots, skirmishes, and sheer panic began to interrupt normal trade and business. It had become clear to the general public that circumstances were not improving and all of humanity might be facing extinction within a generation or two.

World leaders held a universal webcast in 2054, acknowledging for the first time the depth of the problems facing humanity and Earth. It was here that the United Ranger Corps was first introduced

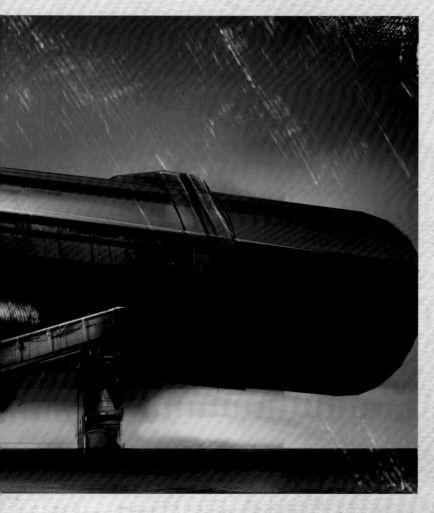

to the public, the leaders explaining their simple but substantially important mandate: to Preserve Humanity.

Project Next Generation's scientists, aided by artificial intelligence, conceived of modular spacecraft that would efficiently escape Earth's gravity, then link up in space to form the giant arks that would then engage their Lightstream drives. The first step was to construct five prototype arks. Smaller in scale than the planned arks that would transport humanity offworld, they were ready to be tested in 2062 AD. The first such vessel, the *Starfinder*, composed of a dozen smaller craft, seamlessly assembled in a matter of hours, then slipped from Earth's orbit without problem before returning home. The second ship, the *Explorer*, entered wormhole space but vanished with its crew complement of fifty. Ships three through five passed their tests without fail over the next eighteen months. With little choice, the world's leaders approved the incredibly costly ark program, ramping up production. Large portions of the Sahara Desert were home to solar battery arrays required for the

manufacturing. When this area became overloaded, production was moved to the snowy plains of Antarctica and a number of other vast regions across the planet. Rangers were taken from the field to protect the construction sites as the Project Next Generation clock was reset to 2071.

As one might imagine, during this period of panic, rumors spread that private, wealthy individuals and corporations were building their own spacecraft in an attempt to preserve their lives.

Because the thrust needed to lift such vast constructions from Earth would require too much fuel, it was determined that much of the contents and passengers would be ferried into space in smaller transport vessels and final assembly of the massive arks would occur in orbit using the Lagrange points to help stabilize the positions. Only after all the transport ships combined to create the six arks could they be launched from orbit into space.

While debates raged around the world about who should board these arks, it became increasingly clear that by the

ABOVE Aboard one of the flotilla ships, a passenger takes a last look at Earth.

revised deadline only the pieces necessary to form six arks, not ten, could be safely constructed. The global leaders met to trim the proposed rosters. Fearing global rioting, the Rangers, for the first time, became active participants in the planning.

THE BEGINNING OF THE END

The 2071 collapse was later traced to climate change and a disruption in the planet's magnetic fields, generated by a rise in temperature affecting the molten iron at the Earth's core. The liquid outer core, where most of the electromagnetic charges flow, combined with the solar wind, a stream of energy particles emanating from the Earth's sun, to generate the planet's magnetic fields. When the outer core exceeded the Curie point—the temperature at which certain metals lose magnetism—the magnetic fields collapsed, leaving all life vulnerable.

Without the protection of its magnetic shields, the Earth was bombarded by the sun's solar wind, destroying life on the surface. The atmosphere began to thin out at its upper limits and night/day temperature swings grew more extreme. The need to evacuate the planet became critical. The Earth could sustain only a few more years of human life, making it more vital than ever before to send as many people as possible into space so the human race would have a chance for survival.

Skyler Raige II, the first Supreme Commander of the United Ranger Corps, declared that each ship would be overseen by a general he had personally selected for the task (see "A History of the United Ranger Corps," page 44). The component craft comprising the first ark, christened the *Exodus*, under command of General Horatio Teller, departed Earth and began rendezvousing in space at predetermined Lagrange points. The transport ships seamlessly united to form the *Exodus* and departed Earth orbit on November 14, 2071 AD. A year later, the remaining five arks made ready to depart for Nova Prime.

THE OTHER ARKS

THE ASIMOV commanded by Captain Julie Grossman
THE CHAN commanded by General Aaron Abalu
THE PHOENIX commanded by General Agnes Mphalele
THE PEGASUS commanded by General Kyle Touhy
THE DENKYEM commanded by General Adolfo Vasquez

At the time of departure, each ark carried 125,000 people, representing .0000625 percent of humankind.

Three of the arks never made it to Nova Prime. The *Denkyem* lost contact with the fleet when it dropped from wormhole space in 32 After Earth (AE). Its final fate remains unknown. The LST drive on the *Chan* failed in 43 AE, and it too dropped from wormhole space. The arks had scheduled times when they were to drop from wormhole space and check in with one another, double-checking celestial navigation and assessing their collective status. Reports received during the next scheduled stop indicated the *Denkyem*'s loss was caused by sabotage perpetrated by a member of the Rangers (a black mark on the history of the Corps). What happened after that has been subject to speculation, but a distress signal was received from the descendants of one of the missing ships in 979 AE, prompting the disastrous *Explorer I* rescue mission. The *Phoenix* survived as long as 65 AE before its LST drive failed after impact with some unidentified space anomaly. The crew of the *Phoenix* had spotted a potential planet that might support human life, and the last time they were heard from they were limping there at sub-light speed.

Each of the half dozen arks periodically dropped probes dubbed "bread crumbs" to mark the path humankind took across the Orion galactic arm from Earth to Nova Prime. They were designed to act as a galactic positioning network so that, should an ark develop navigational problems, it could find the nearest probe signal.

Although it had previously been banned, telomerase research began once again aboard the *Asimov*. These studies focused on a select group of passengers, assessing whether prolonged life could enhance survival opportunities on their new homeworld.

When the three surviving arks—the *Exodus*, *Asimov*, and *Pegasus*—arrived at their destination just over a century after departure, they split into their component vessels for safe landing and were eventually dismantled, as planned, to supply the raw materials needed to build shelters and form the core of a new human society.

RIGHT The transport ships, as seen in this artist's depiction, departed and went into orbit, where they eventually linked up to form the six great arks that would bring mankind to a new home.

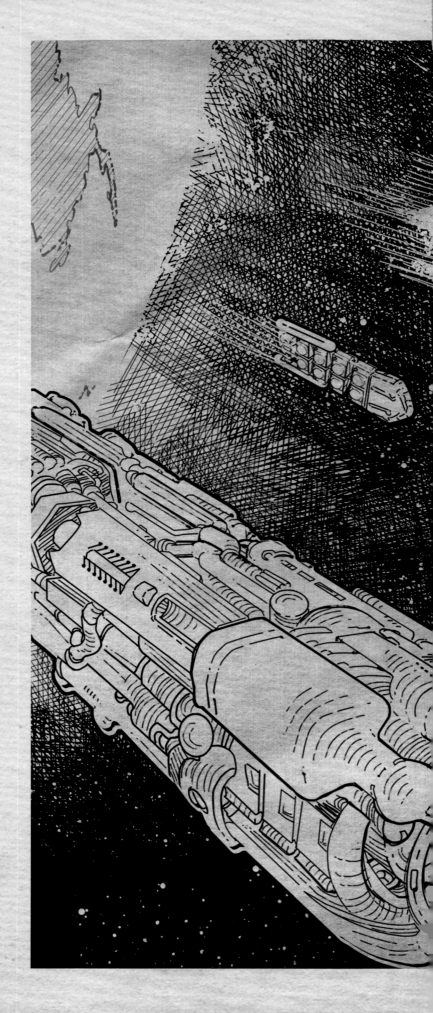

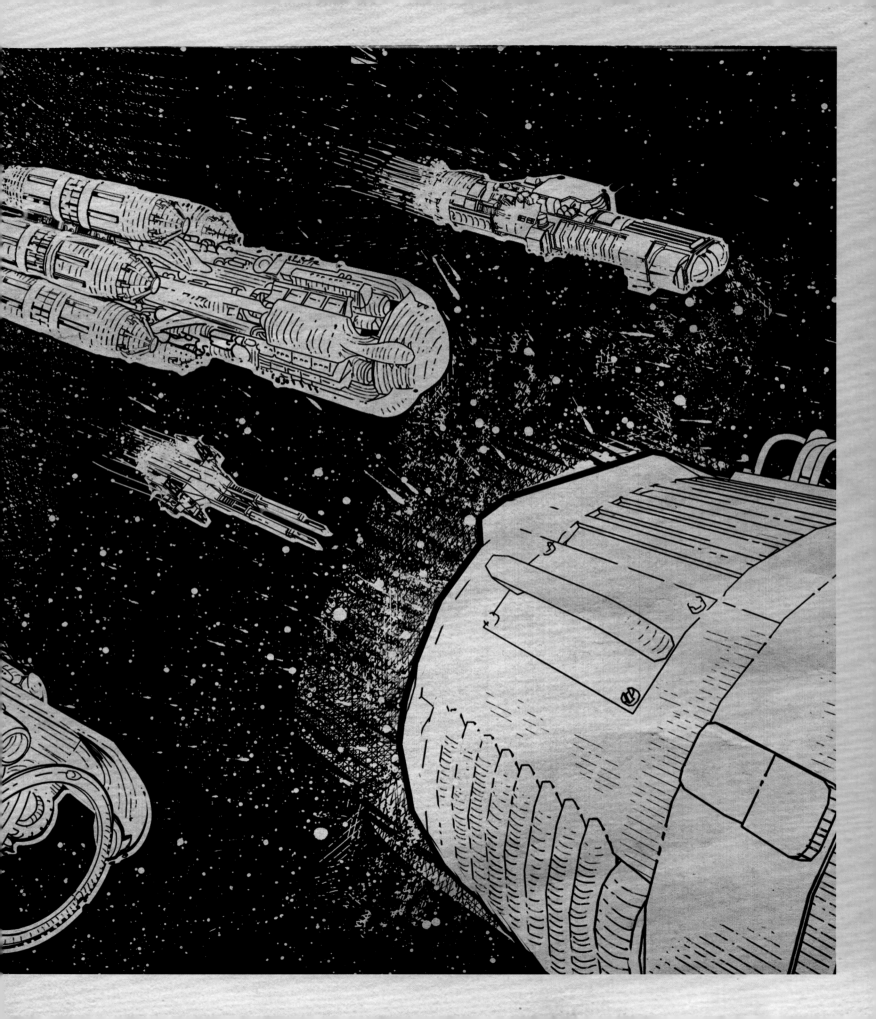

SURVIVING ON
NOVA PRIME

SURVIVING ON
NOVA PRIME

★ ★ ★ ★ ★ ★ ★

NOVA PRIME WAS ONE OF SEVERAL WORLDS located in what was once known as the "Goldilocks zone": not too hot, not too cold, but with just the right conditions to sustain not only human life but all other life-forms brought from Earth.

When humankind left Earth aboard the three arks that made it to Nova Prime, their Lightstream drives carried them slightly faster than the speed of light, through wormhole space, heading coreward along the Orion arm. At that rate, they traveled approximately 31 parsecs from Earth to their new home.

It fell to the scientists on board the arks to recommend prime landing locations where there appeared to be mild weather, fresh water, and no apparent predator species. The Rangers also examined each site to see which was best positioned for defense from any potential enemies, while still allowing ample room for the anticipated growth and development of the settlements. A location on the largest continent, near the equator and surrounded mostly by mountains, was finally selected. This initial settlement, now known as Nova Prime City, or simply Nova City, lies south of the Tangredi Jungle, which, due to limited natural water resources, is relatively small compared to the jungles on Earth. Northwest from the city is Aldrin Forest.

Upon arriving on Nova Prime, the greatest challenge was managing the populace's expectations. Already demoralized by the loss of three of the six arks, the remaining members of the human race were holding out hope for a Garden of Eden. Instead they were met with a harsh, hot environment that promised hard work ahead. As a result, it was decided that the population of each ark would stay together in separate encampments until permanent facilities were ready.

Ranger survey teams were sent out in a 200-kilometer radius from the combined human settlement to scout for land,

vegetation, and water. Teams of scientists at the settlements began analyzing ground data that satellites, dropped into orbit before landing, had collected as well. There was resistance to the slow, methodical methods employed to secure the planet for colonization. Generations after leaving Earth, the people were restless and eager to get their new lives started. There was concern over shelter and sustenance as whispers about food shortages fueled gossip and panic. It fell to the Rangers to prevent chaos from breaking out as hundreds of thousands of worried humans began eyeing the precious food resources.

Rangers were stationed by all the supplies, and while the concerns over resources were legitimate, they were also exaggerated. Still, Commander General Thomas Onaku lost several good Rangers to rioting during these difficult early years. Ranger recruitment was also an issue as people remained uncertain about their future on this planet. The stresses continued to build as research, investigation, and exploration continued.

During this period, the Rangers worked with architects and geologists to best determine how to build structures to shelter the populace. Survival on Nova Prime meant adapting and harmonizing with the environment, not trying to tame it—harsh lessons learned from Earth's tragic history. Homes and businesses were housed within the giant mountains and bluffs that appeared to offer the survivors of Earth their best opportunity for a stable location. Geological studies of the surrounding mountains indicated networks of caverns, and architects began theorizing that they could be shored up, deepened, and turned into dwellings, shaped along the lines of beehives. Work began in earnest, and within a decade, families began to move into these new "neighborhoods."

A NOTE FROM COMMANDER VELAN

While it is important to know how to maintain your weapon, and to understand the intricacies of your medical kit, it is equally vital to know your surroundings. We had no idea what we would find when we entered this new planetary system and had to quickly adjust and adapt to a new life on Nova Prime. It took time, but we mastered a new world and we continue to learn about it. Knowing your surroundings and understanding the relationship between the suns, the moons, and our world is invaluable, and, believe it or not, it could save your life.

ABOVE Following the first landing on Nova Prime, a nervous contingent of passengers—the descendants of those who left Earth one hundred years prior—take their first steps on solid ground. This ancient illustration dates back to around 100 AE.

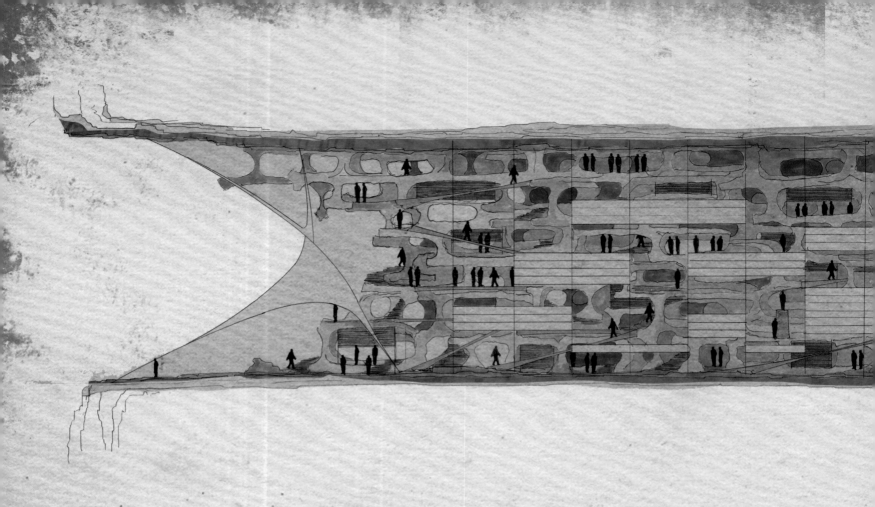

Provisions, tools, machines, and supplies were segregated into several compounds, secured by the Rangers. Agrarians worked to try growing grains and vegetables within a prescribed area, and once life took root, Rangers were then posted to prevent poaching. The livestock was tended by a mixture of zoologists and Rangers, further thinning the ranks of humanity's protectors. Cadets often took animal guard duty, rotating in twelve-hour shifts.

The leaders of the arks formed a Great Conclave to hear the Rangers' and scientists' reports that Nova Prime was a harsh but habitable world, ready for humanity, confirming initial studies of the planet. The Great Conclave approved the next stage of colonization and the construction of permanent habitats for people and animals.

Initially, habitats were formed with the materials ferried from Earth, but they proved inadequate for the environment. Environmental engineers designed large, billowing structures that let the relentless heat of Nova Prime's twin suns rise from within, throwing off shade to cool people and animals. Native woods were used to build a variety of experimental structures

from Peruvian-style pyramids to Nordic-style lodges. This proved adequate in the short term, but other options were clearly needed.

The first large-scale plantings were carried out as spring arrived. Every family was charged with maintaining a personal garden and contributing to communal garden sites. Great silos, barns, and warehouses were planned with construction scheduled for summer. Raw material procurement was the priority.

The Rangers maintained the peace, relieved to be overseeing a population that had been productively put to work and that no longer had time to mill about, aimlessly fretting over the challenges it faced. It still wasn't easy, however, as there remained pockets of trouble, from material theft to the illegal hunting of the few cloned animals that the scientists of Nova Prime had managed to create. Many of the United Ranger Corps rules and regulations were rewritten during this period to reflect the new realities, superseding the rules that had once worked on the self-contained arks.

According to reports filed in 106 AE, most animal and fish species transported from Earth were able to adapt to the new

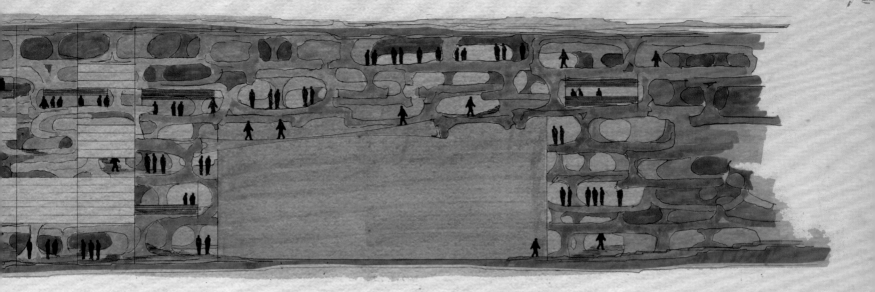

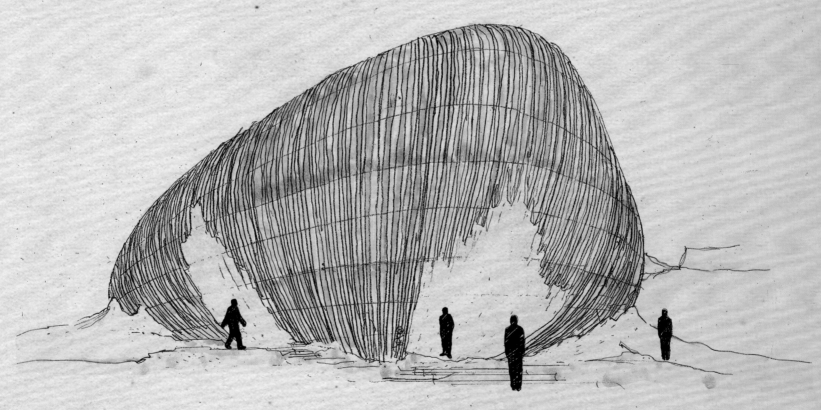

TOP In the early years on Nova Prime, a wide variety of home construction ideas were employed to shelter the population, before permanent settlements could be constructed. This cross-section shows the natural beehive-like structures found in mountainous areas that the settlers used as homes for a time. ABOVE Temporary dwellings were built in large, rounded shapes to house entire communities, as this early design illustrates.

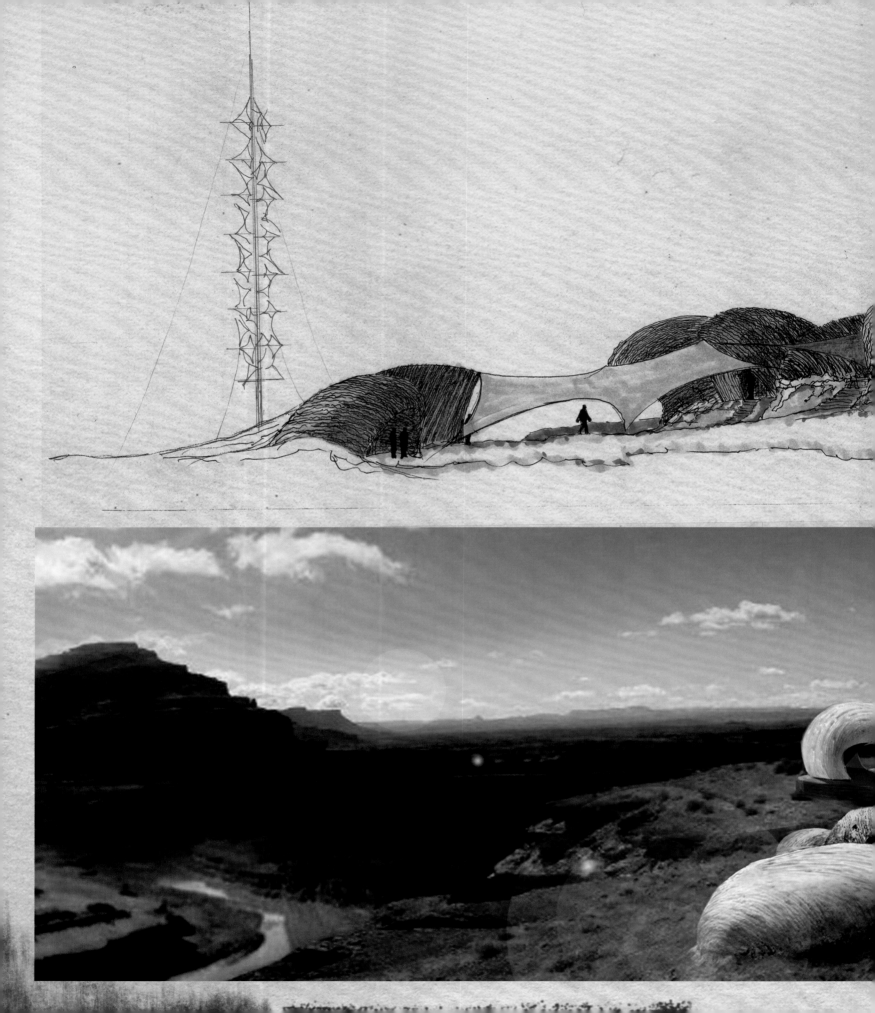

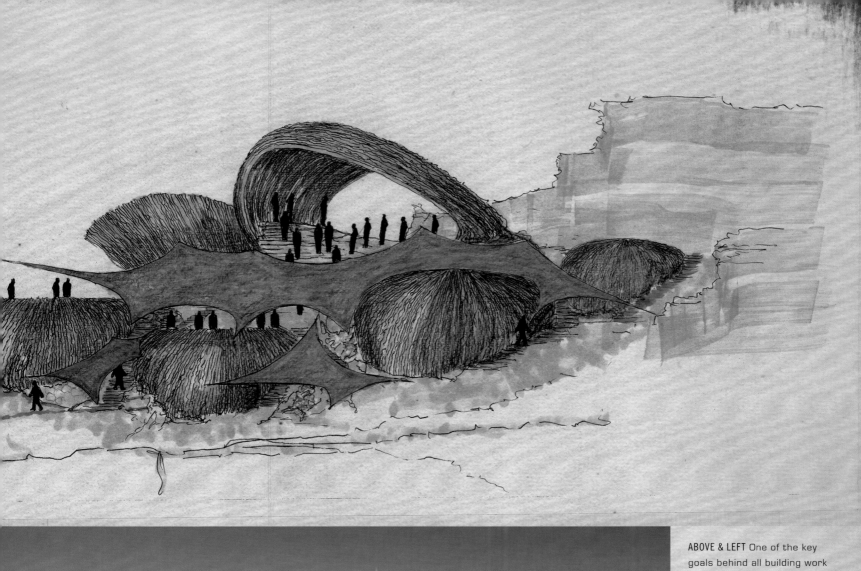

ABOVE & LEFT One of the key goals behind all building work carried out on Nova Prime was to maintain harmony with the land and surrounding environment, as seen in the beginnings of Nova Prime City.

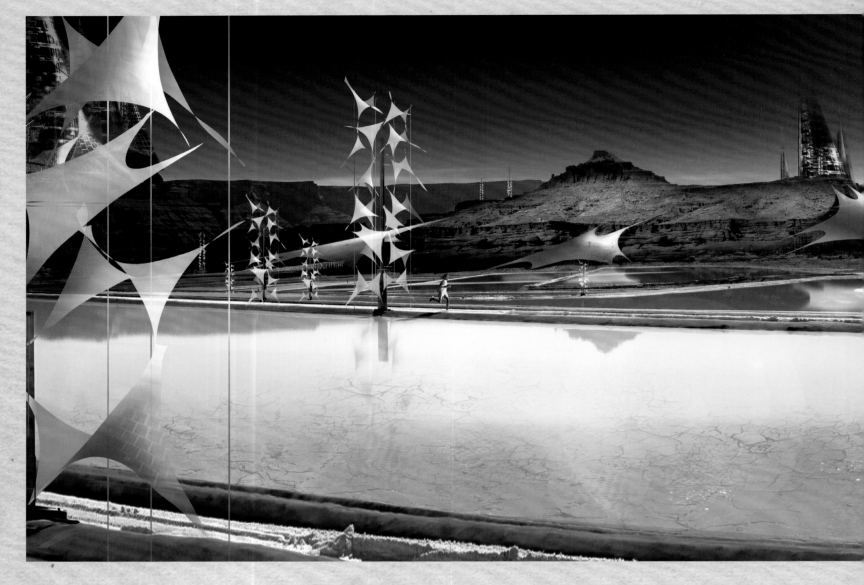

world, although some primates and mammals did not. The prospects for avian life were less certain, as most of the birds flew beyond the range of the communities.

By this time, agriculture had taken hold, and as each community learned what worked, it tailored its planting rotation to maximize yield. This was early in the first decade on Nova Prime, before the people learned how temperamental the environment could be. Enough data had been collected to understand that weather patterns on the new world would be more volatile than those on Earth. This was due to the gravimetric forces exerted by Nova Prime's twin suns and two moons. A freak series of hurricanes in 109 AE threatened the year's crop and created concerns among the people.

The *Asimov* community decided to risk some of its precious fuel and send out an expedition to further study the wildly shifting weather. They also hoped to figure out where the bird life brought from Earth had gone. After two months the results determined that the wild weather was a natural part of life under two suns.

Following the ecological disaster on Earth, the careful recycling of materials continued to be a priority, and as a result waste has yet to become a problem. Although animal bones from the first Earth life-forms introduced to the planet have been buried in pits, they have been subtly altering the soil's pH levels in places. The farmers have adjusted by avoiding these burial sites.

Without any evidence of fossils similar to those formed from the remains of Earth's dinosaurs, there were no resulting fossil fuels such as oil and gasoline to exploit. Petroleum needed to be replaced with other energy sources, challenging the engineers to build huge sunlight collectors for raw energy. The people were entirely dependent on sun, wind, and hydro power until new energy-producing technologies were perfected centuries later.

When Savant Donovan Flint found new ways to harness magnetic systems in the sixth century AE, it was the dawn of a new age, allowing fleets of mag-lev flyers to fill the skies and enabling more people to spread out, exploring and colonizing

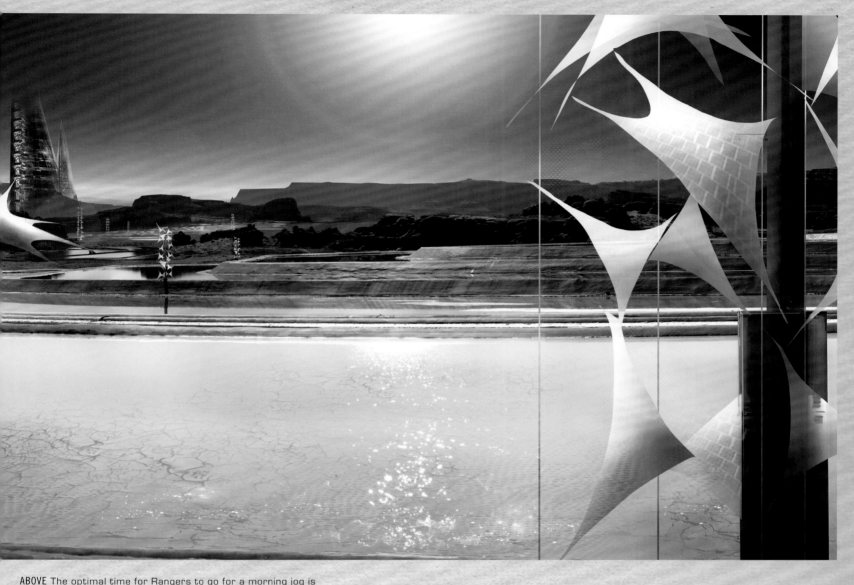

ABOVE The optimal time for Rangers to go for a morning jog is before second sun, with the Skyler Raige Memorial Reservoir a favorite locale. BELOW Given technological advances, and the honeycomb layout for many homes, even simple settings such as a kitchen needed to be rethought.

new territories far from Nova Prime City. The ability to cross the Falkor Desert to the south led some to form New Earth City, the second major colony and the next-largest city.

While the other continents and islands have been explored, few additional colonies have been formed. Most people prefer the safety afforded by proximity to Nova Prime City after so few survived Earth's destruction and the attacks by the Skrel and Ursa (see "The Skrel & the Ursa," page 102).

In time, most of the population lived at the base of the mountains in improved structures or in the mountains themselves. Over the first two centuries, a growing population meant the need to build atop the mountains with connecting walkways, roadways, and passages. Gleaming towers were built atop these majestic ridges to harness the abundant sunlight radiation that powers the city. Beyond the outer rim are now the Golem Ridges where once there was a colony city that the Skrel attacked during their second aerial assault. Remarkably, the Skrel precisely targeted the towers, preserving the foundations atop the ridges. The towers were never rebuilt and their ruins were preserved as a memorial for the fallen. Unfortunately, Ursa have been known to hide there on occasion, waiting for ill-timed visits by people making a pilgrimage to the site.

While the Rangers helped pick the landing site for its defensibility from outside threats, ironically their efforts were more often required internally. Over the first decade, there were various tests of the Corps' resolve. First, the two Primuses—our religious leaders—fell out with one another, and their followers nearly came to blows on more than one occasion. Similarly, having three parallel factions of Rangers, each division formed by their initial assignment to one of the three surviving arks, led to rivalries and infighting. This ultimately led to the 108 AE challenge, a series of competitions to consolidate the three arks' Ranger factions under one Supreme Commander, which resulted in Skyler Raige III becoming the Commander General of all Nova Prime's Rangers (see "A History of the United Ranger Corps," page 44).

An exploring party in 128 AE found a surprise: a new species of finch, mutated from an Earth finch brought to Nova Prime aboard one of the arks. The island it was traced to was named Darwin and the species given the binomial name *Fringillidae prime*, in the convention started on Earth. This was the first complex life-form discovered on the planet that could properly be described as native to Nova Prime.

The first century on Nova Prime tested everyone, but none more than the thousands of Rangers who managed a nervous population and guided them toward making Nova Prime not just a world to be visited but a home to be tended. Those who died in the line of duty during that first one-hundred-year period are memorialized with a permanent flame in Nova Prime City's Ranger Park, just outside the original settlements, letting their sacrifice light the way for the rest of us.

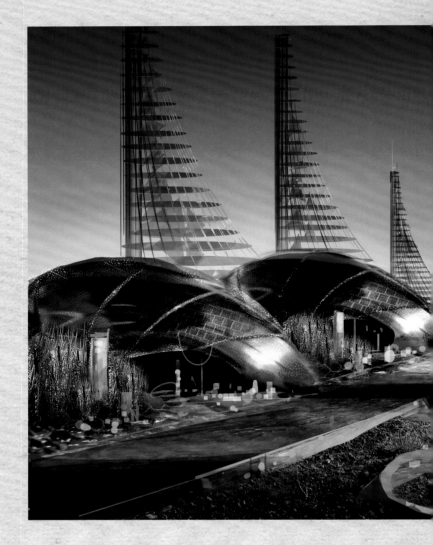

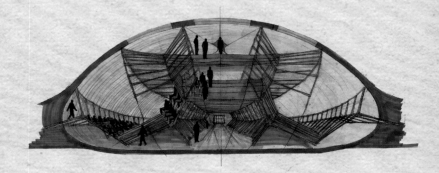

TOP A view of Nova Prime City. In the foreground is one of several monuments to those who lost their lives to the Ursa. At the foot of the monument are the ruins of a number of the dwellings first built by the Nova Prime settlers. The background provides a good sense of Nova Prime City's scale, integrating agriculture, horticulture, and living space. ABOVE This schematic demonstrates the many levels that allow people to move freely while staying in relative comfort. This is a pedestrian court for those conducting business on the Nova Exchange. RIGHT Another view from Nova Prime City, this one showing towers absorbing solar energy with hydro power flowing below.

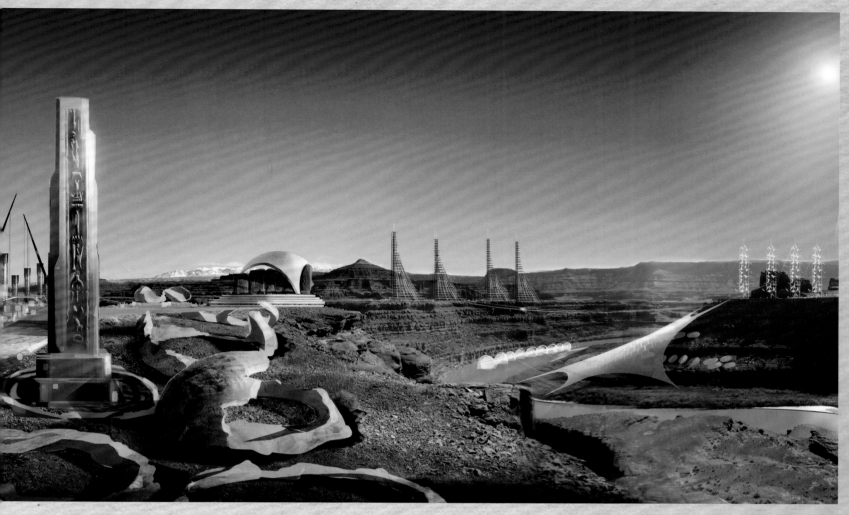

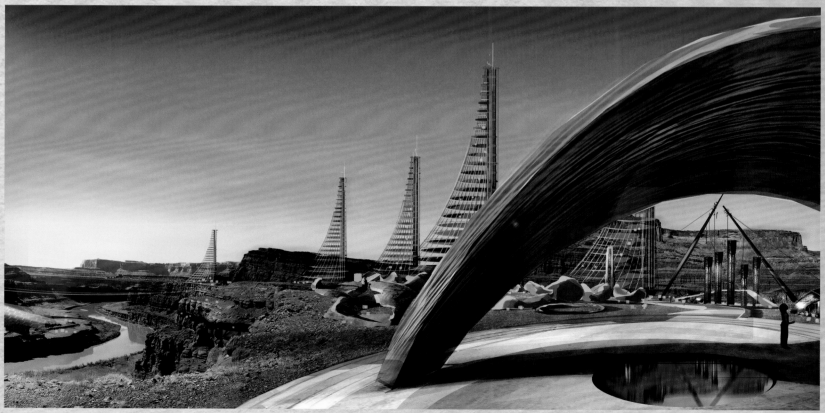

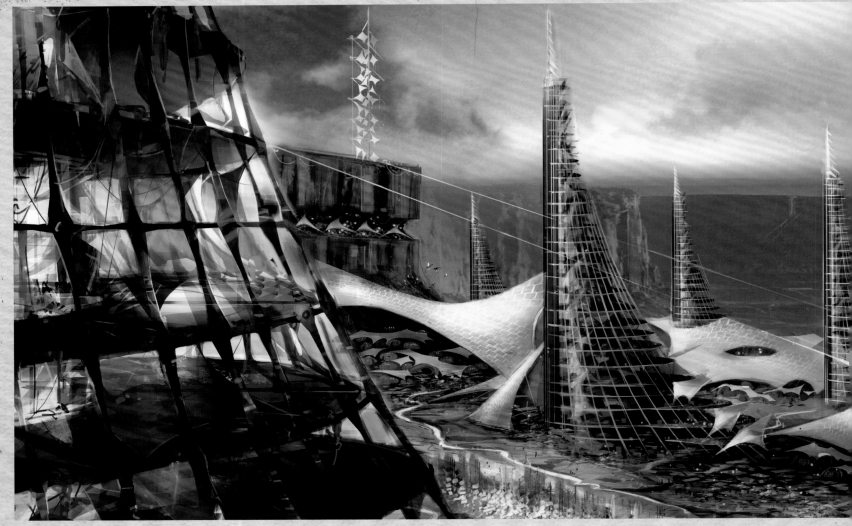

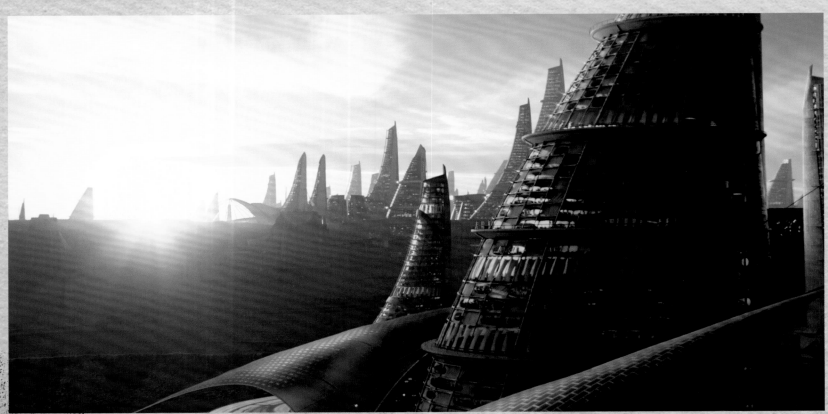

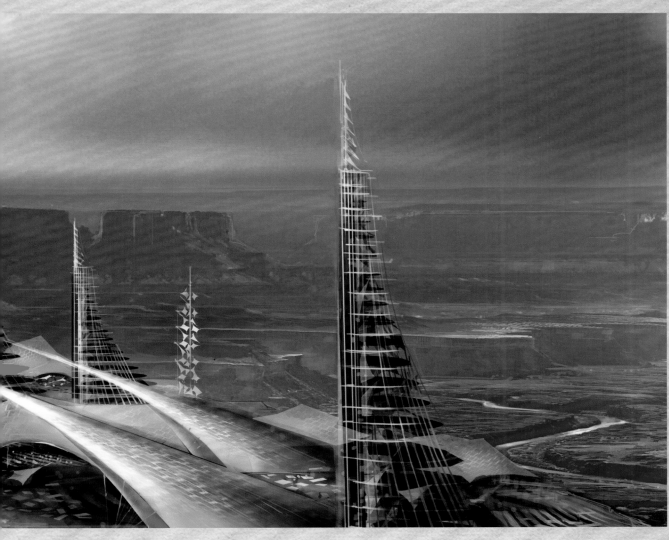

LEFT An artist's rendition showing the next stage of Nova Prime City's evolution. This iteration took city defenses into account following the first Skrel attacks in the third century.
BELOW LEFT & RIGHT Architects and engineers collaborated in finding ways to house the growing population, using the natural rock formations as a base. Note the tiers of walkways providing connections between communities and workplaces.

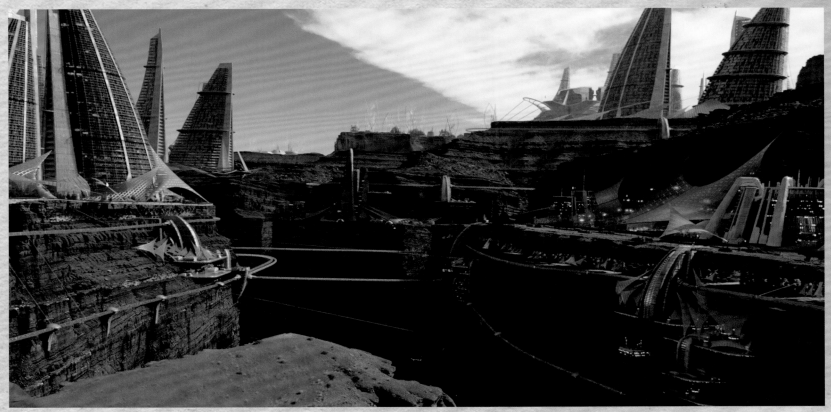

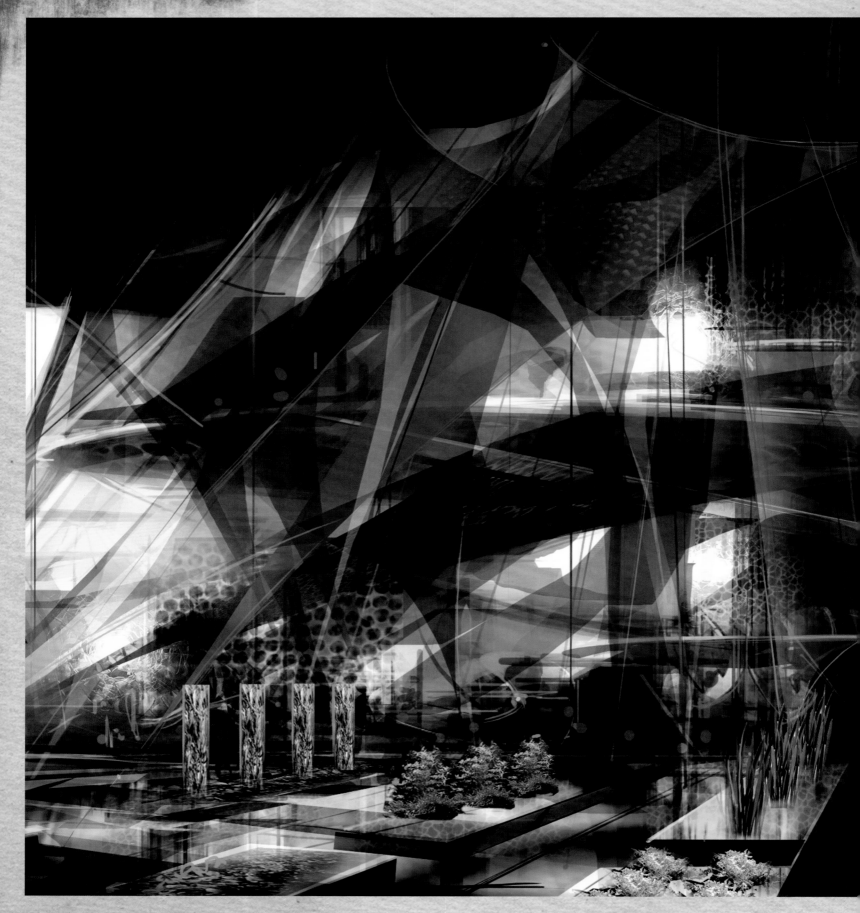

ABOVE Smart fabric filters sunlight, providing the right balance of radiation to allow for plant growth. It is from these plants that we derive medicines, raw materials, and food. These are among our most vital resources and therefore a high priority for the Rangers.

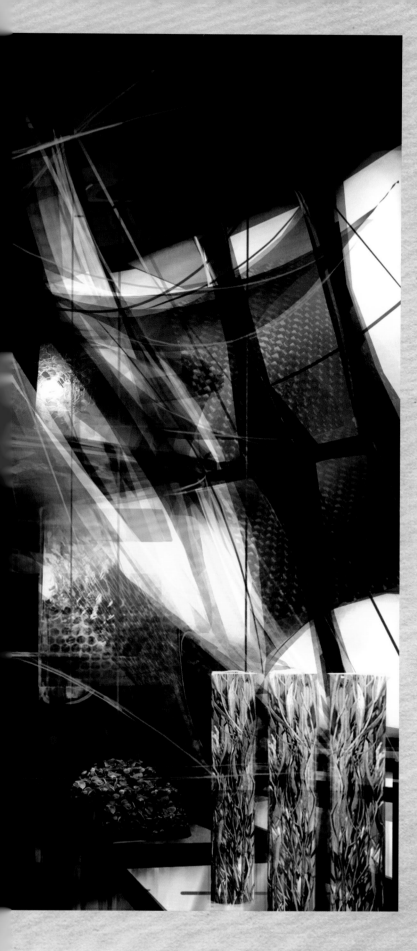

In 203 AE, a report was released that indicated humanity was thriving on their new homeworld with the population growing to 754, 904. Five new species of fish and seven new species of bird had been identified, although the lost mammal and primate life had not been recovered or replaced. Seventy-six percent of the seed brought from Earth had taken hold to one degree or another on the planet. While the planet did not house native life-forms, the ones from Earth adapted, and some went from domesticated to feral, creating new dangers for the colonists.

By the beginning of the third century of human life on Nova Prime, the variance in gravity between Earth and Nova Prime had begun to show itself in the human form, with natives developing a slightly lighter bone structure. Musculature had also decreased based on the somewhat lower gravity, showing that mankind was adapting to its new home.

In 355 AE, anthropologists discovered the first entirely new mammalian life-form on the planet: a four-legged, low-bodied predator, whose fierce nature and powerful hind legs made it a threat to livestock. It was given the Latin binomial name *quattuor-tripodes, low tricorporem rapax*, nicknamed the rapax.

A century later a malaria-like disease, communicated by bugbites, began to spread throughout Nova Prime. The "Great Plague" wiped out 8 percent of the population until scientists were able to synthesize an inoculation. The death rate dropped to zero, and scientists later claimed with conviction that this was simply an act of nature and not an alien attack.

To power the growing population, variations of the recently invented, technologically sophisticated smart fabric were employed to help channel sunlight into energy. The pieces of smart fabric thickened to shade populated areas and grew transparent after the temperature dropped to more comfortable levels.

Life was hard but not impossible, and after escaping Earth, Nova Prime's first citizens were determined to make things work. Their hard effort led to a harmonious use of resources that allowed plant and animal life to take hold. Sustaining that life and letting it grow became the next challenge in the following centuries. Nine hundred years later, we can look back and marvel at what they endured. Today, we can honor their effort and rededicate ourselves to preserving those accomplishments.

NOVA PRIME FACTS

» Nova Prime is the only habitable world orbiting the twin suns in this planetary system. Upon arrival, the people named the suns after aspects of Norse mythology as a reminder of their heritage: the larger sun was dubbed Huginn ("thought") and the smaller sun Muninn ("memory"). Huginn, Nova Prime's primary sun, is a modest but larger cool star with a mass measuring 1.98900 x 1029. The smaller sun is a white dwarf burning its remaining fuel, measuring at 50,000 degrees Kelvin.

» Nova Prime takes three hundred days to orbit its suns (its year is shorter than Earth's was because the two stars together have more mass, and therefore more gravity, than Sol). The planet was made habitable for life after Muninn, in the process of becoming a white dwarf, shed some 75 percent of its heat. This meant much of the water on gaseous Nova Prime burned off and cooled down to allow primitive life to begin developing. Because of its thirty-two-degree rotational axis, the planet has four seasons, like Earth, but the twin suns also mean that changes in weather are much more dramatic than those witnessed on Earth when the planet was in its prime.

» Nova Prime's twin suns are balanced by two moons: a smaller one with a closer orbit and a larger one with a wider orbit. The smaller one is subject to a gravitational tug-of-war, similar to Jupiter's moon Io being caught between Jupiter's and Sol's gravity back in the solar system, and remains geologically active with volcanoes and a gaseous atmosphere. As a result, it was named Gealach na Tine (Celtic for "moon of fire"). The second moon is bigger than the one orbiting Earth and is totally devoid of atmosphere and life, which is why satellite receivers and monitoring equipment were stationed there. Its lack of life also accounts for why it was named Hildago (Basque for "dead").

» The homeworld is slightly larger than Earth with less gravity. It has 60 to 70 percent land mass with 30 to 40 percent oceans including the frozen polar caps. Unlike Earth, the oceans are largely above and below the four major continents, between them and the poles. The transport ships that once comprised the three arks all landed near the equator on the largest of the continents, a land rich in minerals that they named Xīn de yītiān kāishǐle (which is Mandarin for "new beginning").

» The three-hundred-day year is divided into ten thirty-day months, each named in memory of a country on Earth: America, Australia, Brazil, China, Egypt, Germany, Kenya, India, Mexico, and Russia.

RIGHT Nova Prime City spread its resources to allow communities to grow and to ensure no one area could be attacked in a way that would cripple supply lines.

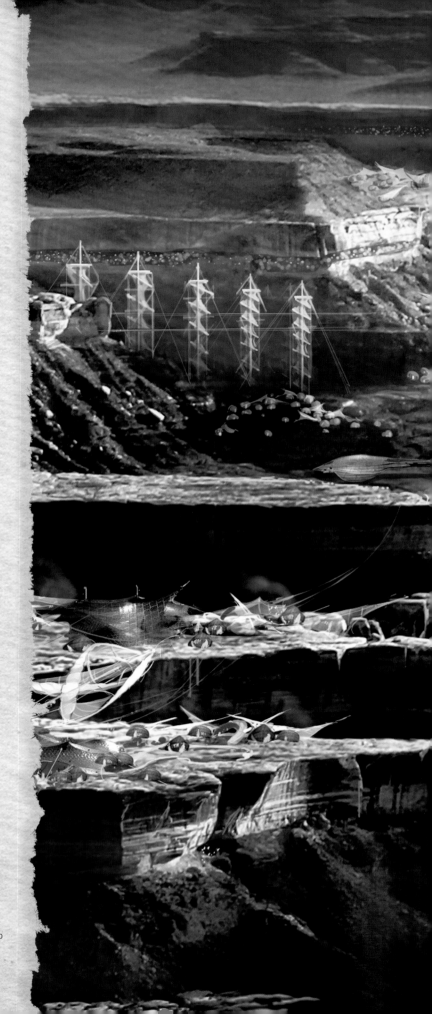

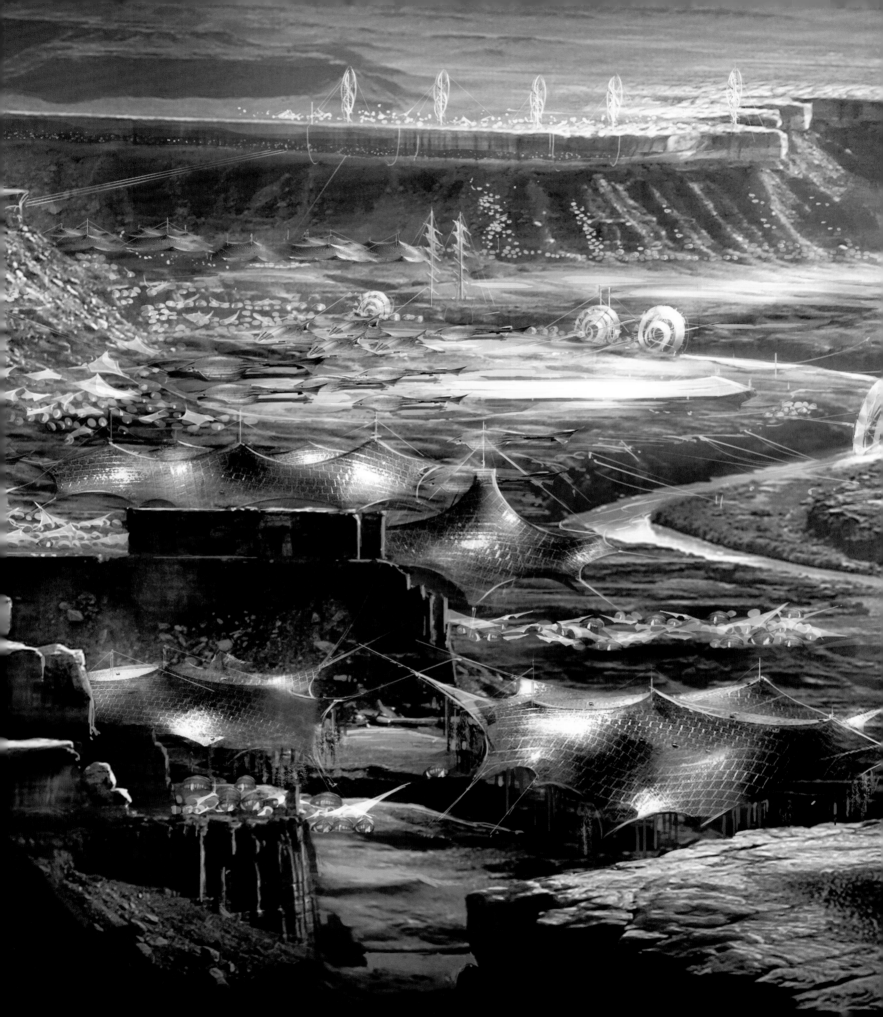

THE
PRIMUS
& THE
SAVANT

THE
PRIMUS

A NOTE FROM COMMANDER VELAN

Through your studies of Earth history, you will know that there were countless religious beliefs dotting the globe and dating back through recorded history. Since humans left Earth for the stars, several belief systems collapsed until only a small handful were left, all guided by the principles outlined in the Book of Truth. As a result, a singular spiritual leader rose to guide people when they most needed solace: the Primus. Since then, the Primus has risen to a role that represents one-third of Nova Prime's leadership. Far from divine, the holder of the office has to juggle the needs of the many and work in concert with the Prime Commander and the Savant. Understanding the rich history of the Primus gives you insights not only into the role, but also into how it is intertwined with that of the Prime Commander.

DURING THE LONG VOYAGE FROM EARTH TO NOVA PRIME, the survivors were feeling a spiritual void. Aboard the *Exodus* ark, the people decided that in addition to the United Ranger Corps looking after the people's physical well-being, a new leader would look after their souls. The office of the Primus was created, forming a new religious organization that sought to address needs the Rangers were not trained to handle. As the Primus was envisioned, all beliefs were to be treated with respect and equality. Most of Earth's major religions at the time of The Departure—Buddhism, Christianity, Hinduism, Islam, and Judaism—were still in practice, while several other belief systems faded from existence. Several new dogmas sprang up as people tried to understand what became of their world, with many slowly growing to believe that Higher Powers had enabled humankind to find a way to survive.

The first to be named Primus was the devout Jeremiah Salt, reverend of the Church of Reclamation, in 32 AE, although he served only two years as Primus before his untimely death. Maxwell Kincaid, his rival, next took office. Kincaid organized major events to unite the people, such as the legendary Sermon in the Square, declaring the importance for humankind to not repeat the same mistakes that led to them having to flee Earth. At the climax of his speech, Kincaid collapsed and fell into a coma, only to miraculously recover a year later. Walter Raige became the third Primus in less than a decade and was always suspected of being behind Kincaid's illness. Kincaid refused to take back the post, instead writing the Book of Truth, a new guide to theology that essentially replaced the Bible and similar religious tomes. It was greatly acclaimed when first introduced in 46 AE.

Disciples of the Primus became known as augurs, and the Office of the Primus grew to see to the spiritual and creative needs of the people.

As one might imagine, the growth of the Primus's impact was cause for concern among the Rangers administration, as an inevitable rivalry began to grow. The natural divide between the people's physical health and safety and their spiritual well-being would suggest these were clear spheres of influence that did not necessarily need to clash. Unfortunately, it soon became clear that while humans had moved to a new world, human nature remained the same. This was evident when in 67 AE Primus Xavier Kilgallen took disaffected Rangers and turned them into his Army of the Primus, much to the chagrin of the Corps. In the aftermath of the political strife this caused, the Temple Authority rewrote the rules, so being named Primus became a lifetime commitment and no longer a political spoil.

In 82 AE, the *Asimov* became the second ark to adopt the Office of the Primus, naming Dr. Jessica Mannino its first Primus. Soon after settling on Nova Prime, the two Primuses, Mannino and the *Exodus*'s Benjamin Gates, agreed there should be only one to speak to the people, and Gates prevailed.

While peace between Primus and Commander General was maintained during the following years, Primus Joris Man took a hard line against scientific research and industrialization. In 222 AE he proclaimed that it was such activities that had ruined the Earth. Man began touring the communities and spoke out against the sciences with vehemence. Negative reaction to such remarks may have contributed to the rise of the Savant later that year. Any conflict was averted when the less fiery and more practical M'Liss Cornetta became the next Primus. She ensured that the people remained on a righteous path, finding faith with every sunrise and giving thanks at each sunset.

According to augur scholars, Jenna D'Agostino, who served from 312 to 354 AE, was the greatest of the Primuses, given her long, peaceful time in office and popularity among the people.

On the other hand, the spiritual crisis felt by Primus Leonard Rostropovich during the first Ursa incursion in 576 AE could be considered the office's darkest hour. After Rostropovich attempted to manipulate the populace into agreeing that the Rangers should be downsized or eliminated, the Ursa attacks began, and he felt partly responsible for bringing these devils down on the people.

Various religious uprisings have been recorded throughout Nova Prime's brief history, each requiring the intervention of the Rangers to keep peace and order. The peak may have been in 881 AE when the people appeared ready to split into three competing factions. Prime Commander (PC) Trevor Raige believed that Primus Aaron Templeton was taking them on a course toward disaster. So did Savant Um Chalthoum. An Ursa attack killed both the Primus and the need for further debate on the topic. Soon after, the Primus's army evolved into the Nova Prime Civilian Defense Corps, essentially a civilian-directed supporting force for the Rangers.

As of the current edition of this manual, Liliandra Quen serves as Primus.

PRIMUS

ABOVE In this artist's rendition, Primus Johann Viola conducts a service in the wake of the third Ursa incursion during the eighth century. As always, his words brought comfort during a time of great mourning.

THE
SAVANT

A NOTE FROM COMMANDER VELAN

In this section, lessons can be learned about the value the people of Nova
Prime have placed on safety and peace of mind, sometimes to the detriment
of truth and progress. This may explain why the role of the Savant took
two centuries to be created, following the establishment of both the Prime
Commander and Primus positions. As a result, the tripartite government we now
enjoy provides checks and balances between security, the soul, and science.

TWO HUNDRED YEARS AFTER LEAVING EARTH for Nova
Prime, society had first endured, then prospered. The Prime
Commander and the Primus oversaw the decision making that
ensured orderly growth and progress. However, the scientific
community began to feel their voices were not being heard—
after all, it was their brethren that enabled humankind to
escape the cataclysmic event that made Earth uninhabitable.

After successful lobbying over a period of years, the Prime
Commander and Primus agreed to welcome a Savant to over-
see the sciences and speak on the scientific community's
behalf. One of the most outspoken citizens in favor of the new
position was Tamora Kelsey, who was almost unanimously
voted to become the first Savant in 222 AE.

By the time of the first Skrel attack in 243 AE, the Savant's
position was solidified thanks to scientists' efforts in under-
standing the alien weaponry and improving defenses. A
member of Savant Bree Kincaid's staff, Jack Kincaid, her
younger cousin, suggested a unique approach to developing
"shape-changing projectile" technology that proved effective
in repelling the Skrel attack.

A tripartite pact was formed a year later, wherein the govern-
ment was divided into three equal branches, led by the Primus,
Savant, and the Supreme Commander. No one branch would
have power over the other, but any two would have veto power
over the plans of the third, and each would abide by the deci-
sions of the other two. This separation of power was thought to
be essential lest humanity fall into another devastating war or
show weaknesses that could be exploited by potential invad-
ers. Each branch would have an inner council, responsible for
selecting the respective leaders.

Feeling freed or emboldened—perhaps both—Savant Kin-
caid swiftly reorganized the scientific community, allocating
resources to laboratories, observatories, and research facili-
ties. As the population swelled and new colony cities grew,
the Savant saw to it that the needs of the scientific community
were factored into all planning.

Under Kincaid's leadership, a new era of exploration began,
giving Nova Prime's citizens unprecedented information about
their new homeworld. In fact, much like the Raiges' history with
the United Ranger Corps, the Kincaids have a legacy of exem-
plary service to the sciences: It was Jack Kincaid who gave
us the F.E.N.I.X. technology that his descendant, Lyla Kincaid,
refashioned into the cutlass, the only weapon able to kill an Ursa.

The checks and balances among the three portions of gov-
ernment proved beneficial when Prime Commander Martina
Raige staged a mock Skrel attack and discovered lapses in
community defenses that resulted in updated, stringent laws
to improve the settlement's protection. As they were put into
practice, the people rebelled, fearing the government was turn-
ing into a police state. Shaken by these experiences, Sylvan
Dore-Kincaid resigned as Savant. The council named Lillian
Azpiri her replacement. Her keen mind was most welcome, as
her guidance helped restore calm and order. Savant Azpiri and
strident Primus Rick Saldon interceded and rewrote the new
laws in a way that mollified the citizenry.

It was the formidable Prime Commander Vanessa Raige who
reinstituted the Asimov Olympic Games in 652 AE, but that
was a rare highlight. Her tenure has been well chronicled and is
worth your leisure reading time, but know it ended fatally in 655
AE. As a result, a new Conclave was convened and the tripartite

government, suspended under Raige's rule, was reinstalled. A rule was approved preventing an individual from holding more than one position. Jacob Smead was named the new Savant, and his thirty-year tenure restored stability to the office.

There was harmony in the office of the Savant until centuries later when Savant Ella Dorsey pushed for more space exploration as a safety valve following further attacks by the Skrel and Ursa. Her forceful manner won the day, but the disastrous *Explorer I* mission led to her resignation.

As of the current edition of this manual, Gerard Martinelli serves as Savant.

The missions of the Savant and the Rangers tend more often than not to be complementary ones and their symbiotic relationship is based on a shared adherence to logic. We must, however, never show favoritism between one branch of government and another. As with the Primus and the augurs, the Savant's people are to be accorded every accommodation up to the point that it infringes on the safety and well-being of the people. Then it remains our sworn duty to protect and preserve all life.

SAVANT

ABOVE The Savant's scientists and engineers are constantly developing new equipment to aid the people in further developing Nova Prime without harming its ecosystem.

A HISTORY OF THE

UNITED

RANGER

CORPS

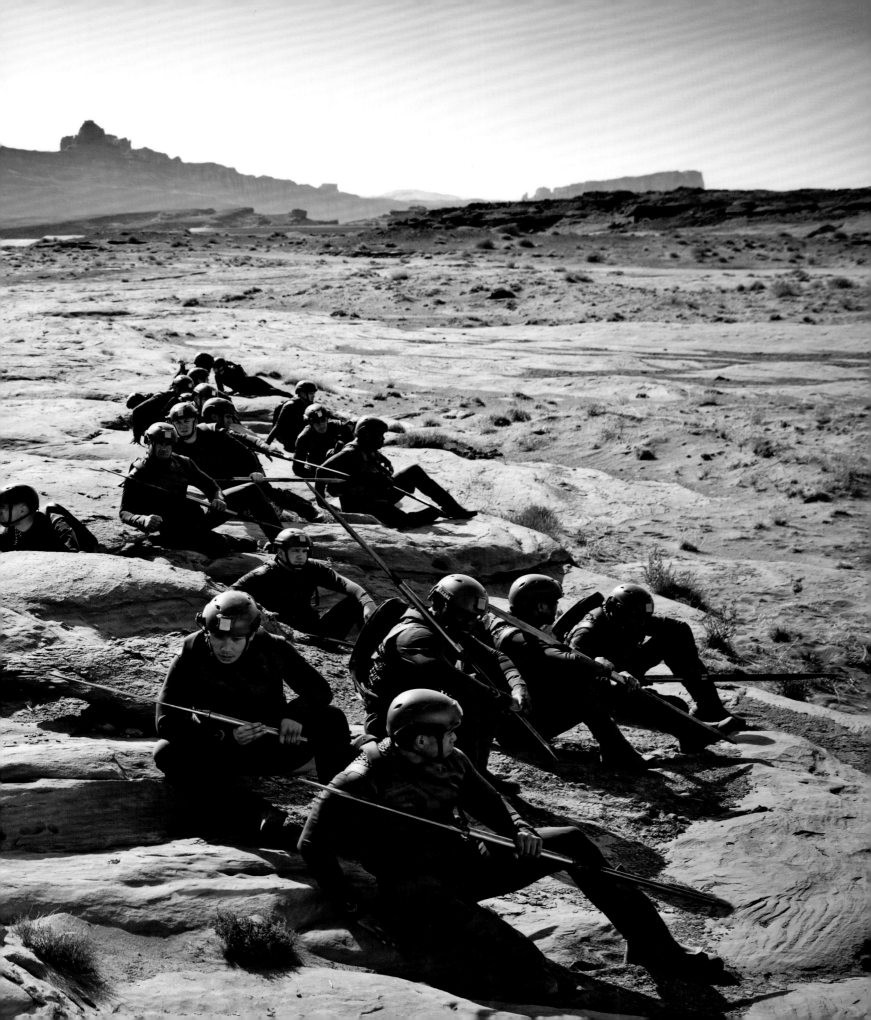

UNITED RANGER CORPS

THE UNITED RANGER CORPS was founded as a way to ensure the global effort to evacuate as many people as possible from Earth was not endangered by any who sought to interfere. It was Project Next Generation that proposed that an international peacekeeping force be commissioned to safeguard the time-sensitive and politically explosive work.

The president of the United States of America, Katherine Ribeiro, was instrumental in pressuring the international community to approve the proposal. Despite taking years to achieve, the United Ranger Corps was finally commissioned in 2052 AD. It became the responsibility of each member country of the United Nations to screen and name one thousand of its citizens to serve in this new force, seeding a force expected to grow over time to be one million strong.

The best of the best from each country were augmented by volunteers as word spread about this new organization. A savvy marketing campaign ensured that the Rangers were portrayed in the most flattering light, beginning with their public debut in 2054 AD during a global broadcast conducted by members of the UN Security Council, led by President Ribeiro.

A cadre of trainers, physicians, and psychologists oversaw the rigorous and demanding screening and training processes. Passing the physical and mental challenges was a badge of pride for the recruits, and the United Ranger Corps became a bright light during humankind's darkest hours.

Wearing a Ranger uniform earned a soldier widespread respect, and the very sight of a Ranger could quell many conflicts during their first years. The job got tougher and their mettle was tested as tensions flared up once construction on the arks began. Of course, the grim reality was that only a tiny fraction of the world's population had a chance to survive.

Supreme Commander Skyler Raige II, the first to hold the title when the Rangers gained independence from the United Nations, had to make the difficult choice regarding which of the Corps would stay behind to ensure the arks could safely launch. Plus, each ark needed a balanced selection of Rangers to maintain discipline and harmony for the anticipated century-long voyage to Nova Prime.

Once the three surviving arks landed on the new world, Supreme Commander Tyson Raige was charged with orchestrating the surveys before disembarking. Once the terrain and atmosphere were declared suitable, the first Great Conclave was held as leaders of the respective arks convened to work out common ground for humans to come together. The first Great Conclave ended in fiasco as Supreme Commanders Davi Couto (*Asimov*), Tyson Raige (*Exodus*), and Thomas Onaku (*Pegasus*) all vied for ultimate leadership of the Rangers and no consensus could be formed. A massive dispute erupted between various factions, as scientists, religious leaders, and military leaders could not come to any sort of consensus.

It was decided that residents of each ark would remain with their component vessels and try to set up their own communities. Each group began claiming huge tracts of territory they could call their own based on land surveys compiled via satellite as the arks had descended from space. The *Exodus* personnel remained in place at the landing site as the *Pegasus* and the *Asimov* crews dispersed, moving off in different directions to begin construction.

In 108 AE, a small skirmish—a meaningless disagreement between two squads, one from Onaku's *Pegasus* community and another from Raige's—resulted in a full-blown riot among the Rangers that threatened to consume the entire colony.

A NOTE FROM COMMANDER VELAN

Throughout the recorded history of Earth, armed forces have kept the peace. "Might makes right" was as strong a belief as any religion, and under the correct leader, people thrived. The great leaders-the Yellow Emperor, Alexander, Hannibal, Caesar, Washington and others-organized and fought with valor and bravery. When an entire planet needed a single unified force, the Rangers were born and tempered by the most fiery period in Earth's history. Their early successes ensured humanity survived Earth's last days, reached Nova Prime, and thrived. Our history is rich, varied, and well worth study. This brief history is excerpted from the multivolume *United Ranger Chronicles*, a work that continues adding entries every year.

THE CORPS PRINCIPLES

REMEMBER EARTH.

THE CUTLASS IS A REFLECTION OF
THE RANGER WHO HOLDS IT.

DANGER IS REAL.
FEAR IS A CHOICE.

ROOT YOURSELF IN THIS
PRESENT MOMENT.

PRESERVE HUMANITY.

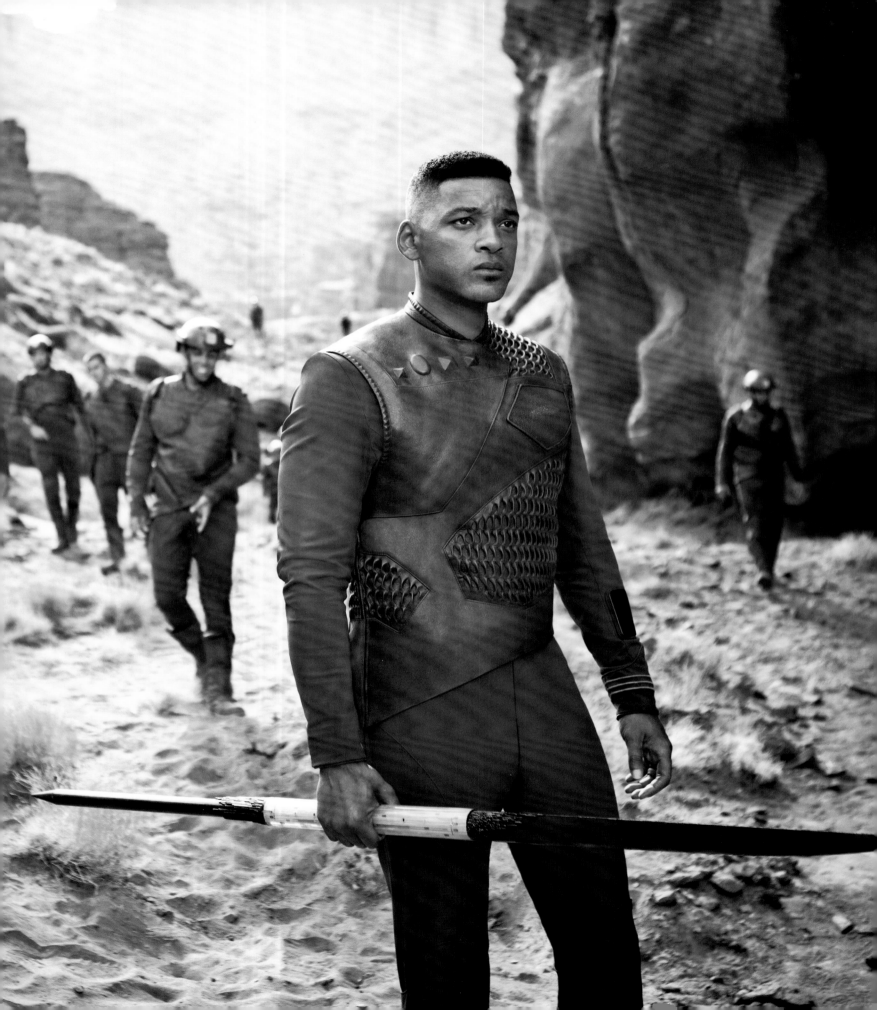

The *Asimov*'s Couto confronted Raige and Onaku, proposing that supreme leadership of the Rangers be decided through the only method that meant anything: a series of competitions to decide who was the fittest.

Skyler Raige III, named after his revered ancestor Skyler Raige II, slipped his father, Tyson Raige, an enhancement drug designed by his wife, Rita. It was a derivative of telomerase designed to increase Tyson's strength and stamina. Rita warned her husband that it could have a negative impact, but Skyler Raige III was determined to help his father.

Tyson Raige, unaware of the enhancement drug he'd been fed, dominated the competition despite being considerably older than his opponents. He was the undisputed winner, but when he crossed the final finish line, his heart literally exploded within his chest. Skyler, as Tyson's heir, was named Supreme Commander of the Ranger forces, but he felt so guilty about his actions that he immediately retired the title, replacing it with the rank of Prime Commander.

The Rangers are the first responders to natural disasters and were instrumental when it appeared civil war might split humankind into factions all over again. The Primus took disaffected Rangers and formed an army aboard the *Exodus*. From then on, the Primus maintained forces: a check and balance against the Rangers' potential ability to stage a military coup. Natural rivalries occasionally sparked into fights. The first such break occurred in 195 AE when Prime Commander Maxwell Barnes attempted to impose a version of martial law to restore order. He went so far as to take the title of Imperator, controlling all factions of government including the Office of the Primus. His efforts proved futile and he died during a riot in 197 AE, leaving Kiernan Raige as the new Commander. The title "Imperator" was removed from use for centuries. Raige finally managed to quell the conflict a year later, in part because people were turning their attention toward the bicentennial memorial, recognizing the two centuries that had passed since humanity left Earth. Ill will between the Rangers and the Primus's army simmered for the next few decades. The establishment of the Savant in 222 AE finally brought the tension to a close.

Peace reigned until the people were attacked for the first time by the Skrel in 243 AE. It was the Rangers who turned away the attack and increased security. Centuries later, in 576 AE, the Skrel deposited their genetically engineered Ursa on Nova Prime, and a new level of protection was required. Since then, wave after wave of increasingly sophisticated and fierce Ursa were brought to the world to scour it clean of humanity.

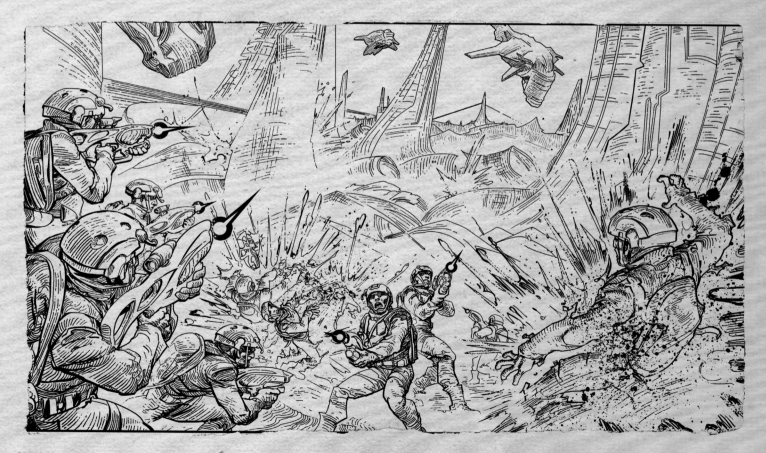

OPPOSITE Cypher Raige carrying the Rangers' weapon of choice, the cutlass. The first person to ghost, he is affectionately referred to as the "Original Ghost," or "O.G." for short. ABOVE Rangers bravely fight back during a devastating Skrel attack.

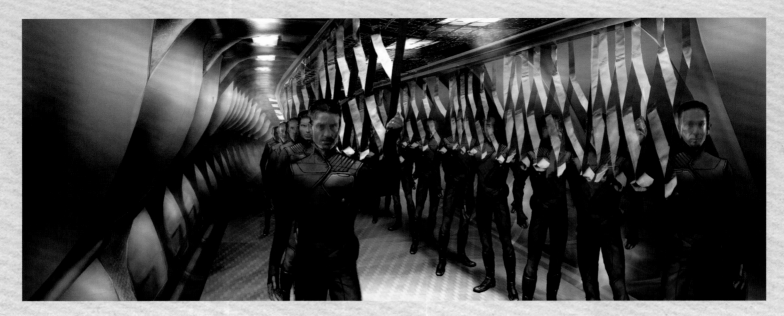

Each effort, including the most recent incursion fifty years ago, failed to achieve the Skrel's goal.

The conflict between competing branches of government and recognition that a hostile alien race wanted Nova Prime rid of human life was the catalyst that led to the Tripartite Pact that shared responsibility for equally governing the people. This did not mean a cessation of rivalries. For example, there was friction when Primus Amaroo insisted on instituting a draft in which a certain percentage of Rangers were "tithed" to the Church of the Book—the name by which the Primus's organization came to be known—paying a tax in order to "more evenly distribute the physical wealth and security." When the Savant voted in favor with the Primus in 404 AE, PC Harrison Raige had no choice but to acquiesce. That proved short-lived when Primus Sybil Kincaid died while hiking, and her successor, the more practical Martin Thomases, rescinded the tithe.

While Nova Prime City had the largest population, other communities began to develop further afield. Across the Falkor Desert, New Earth City grew to be the second-largest population center. When New Earth City, the developing community nearest to Nova Prime City, attempted to secede in 553 AE, a civil war threatened, and it fell to the Rangers to restore peace and order. Two decades later, Primus Leonard Rostropovich attempted to have the United Ranger Corps reduced in size and influence, suggesting the Tripartite Pact be rewritten to remove them entirely. As previously mentioned, the first Ursa incursion proved once and for all the importance of the Rangers and the need to maintain the balance of power among the three factions. Subsequent Ursa invasions have reinforced this wisdom.

In 726 AE, the people began debating the notion of abandoning Nova Prime rather than risk further attacks by the Skrel and their Ursa. The Primus forced a public debate on the topic, but in the end, the Primus and Savant Aduviri Simon agreed to take the matter under advisement, forestalling a decision or even an opinion. Years passed without an awaited response, prompting a new outcry. The Primus, Savant, and PC Orso Raige

ultimately vowed to remain and fight for their world, believing that they could not keep running every time a hostile race is encountered.

Khantun Timur Raige, whose name meant "Iron Queen" and who did not marry because she didn't want to give a man her name, was the longest-reigning Prime Commander in the history of the Rangers. Starting her reign in 917 AE, the Iron Queen, as she was affectionately known, was deeply loved and respected by all. During her forty-nine-year tenure, the Primus and Savant chose to honor her accomplishments by offering her the Imperator title. Unused in centuries, the title effectively made her first among equals. She wore it with pride until her death at seventy-eight.

In 979 AE, the Rangers received a signal from the descendants of the crew of the missing space ark *Chan*. They had settled on a world light-years away from Nova Prime and reported they had been satisfied with their solitude. Unfortunately, something had gone horribly wrong and once again they needed to abandon a dying planet.

The Savant's people had developed a Faster Than Light (FTL) drive, believed to be even quicker than the original alien Lightstream technology. Prime Commander Atlas Kincaid volunteered to head up the *Explorer I* mission to rendezvous with the *Chan*, which launched in the year 980 AE with an anticipated travel time of less than a year for the round trip. When the vessel was sixteen months overdue, it was assumed that the *Explorer I* was destroyed en route by the Skrel. Cypher Raige, Kincaid's protégé, was named the Prime Commander and remains in office at this time.

The Rangers continue to serve with distinction, but many have fallen in the line of duty. Just beyond Nova Prime City is Rangers Field, the official burial site for the honored Rangers. The headstones are simple: small rectangles of rock with the name of the buried individual chiseled into them. Many soldiers preferred cremation, but others are traditionalists, and the Rangers endeavor to accommodate all preferences.

ABOVE Rangers often have to be ferried to hot spots in a hurry. These straps provide stability during rapid deployment. OPPOSITE Kitai Raige (foreground) is the latest in a family line dating back over a millennium. His father, General Cypher Raige (background), was saved thanks to the young man's actions on Earth.

THE RAIGE ★ ★ ★ ★ ★ ★ ★
LEGACY

In 2065 AD, the role of the Supreme Commander was created with Skyler Raige II as the first to hold the office. Over the next millennium, thirty-four members of the Raige family have held this post, subsequently retitled Prime Commander, making the title and the name Raige almost synonymous. The Raige family has exemplified the highest ideals of public service and commitment to duty. As a result, it is little surprise to Rangers that it was Cypher Raige, the current PC, who first exhibited the ability to ghost or that his son, Kitai Raige, became the first offspring of a ghost to exhibit this skill (see "The Way of the Ghost," page 94).

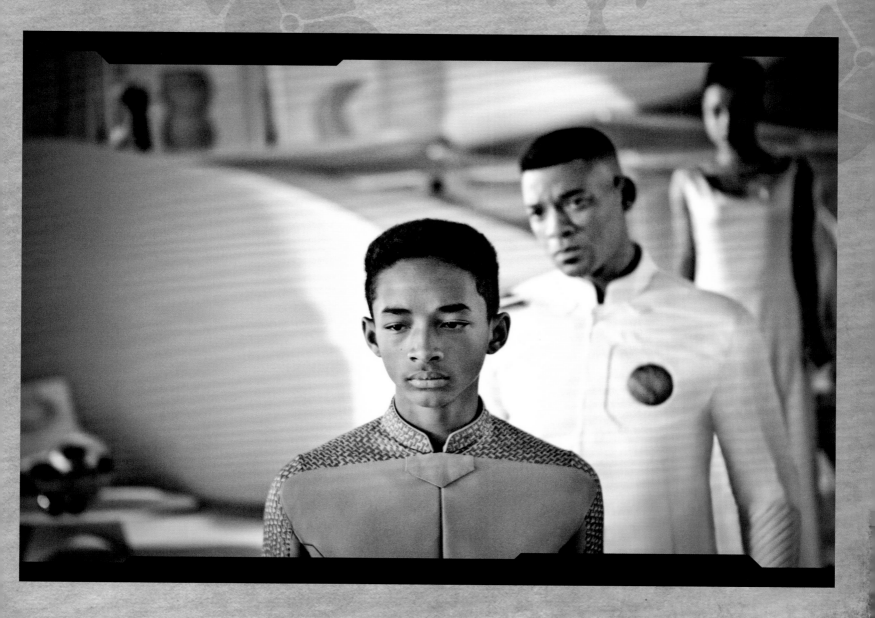

RIGHT The *Hesper* sits in the hangar of the Christopher Rodgers Memorial Ranger Headquarters. The *Hesper* is a Class-C vehicle, rated for interstellar flight. This considerable range of travel allows the Rangers to defend the anchorages scattered throughout space. OPPOSITE RIGHT A look at the launch bay of the Ranger headquarters, neatly incorporated into the natural crevice of a Nova Prime cliff. BELOW A wider view of the hangar and surrounding area. Note how the man-made settlements blend seamlessly with the natural environment.

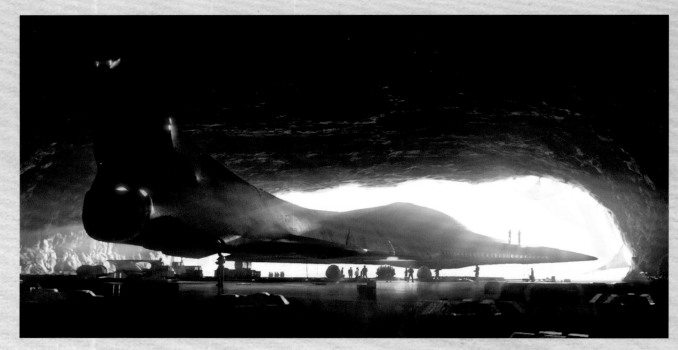

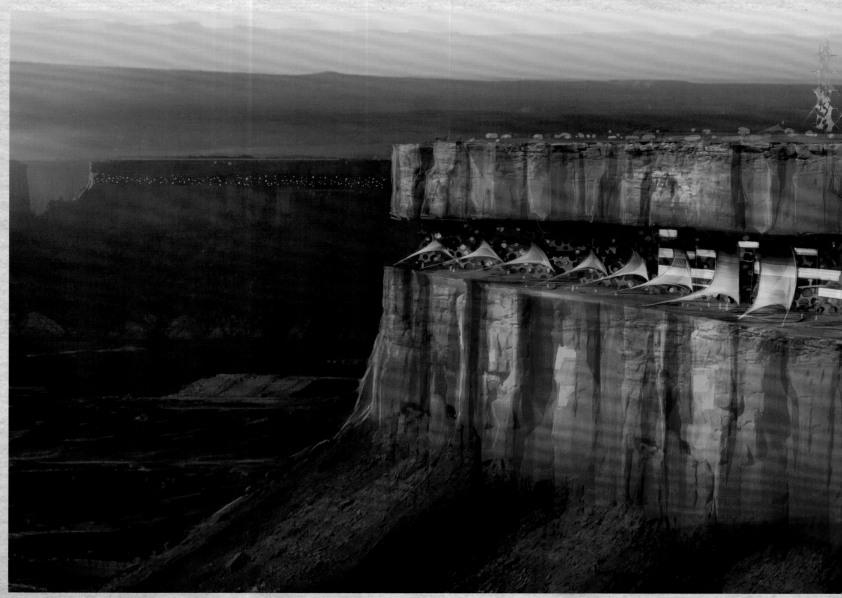

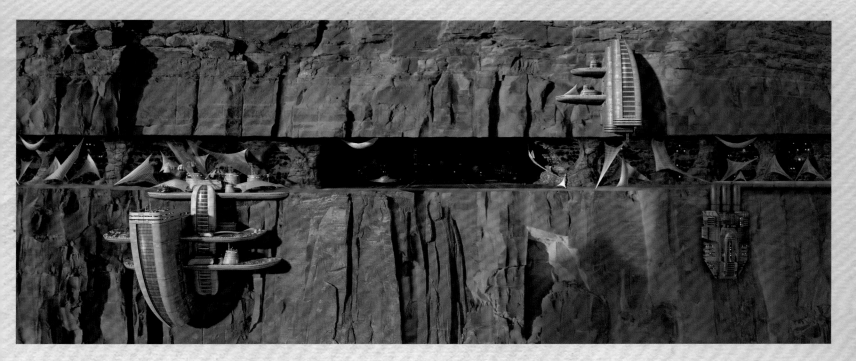

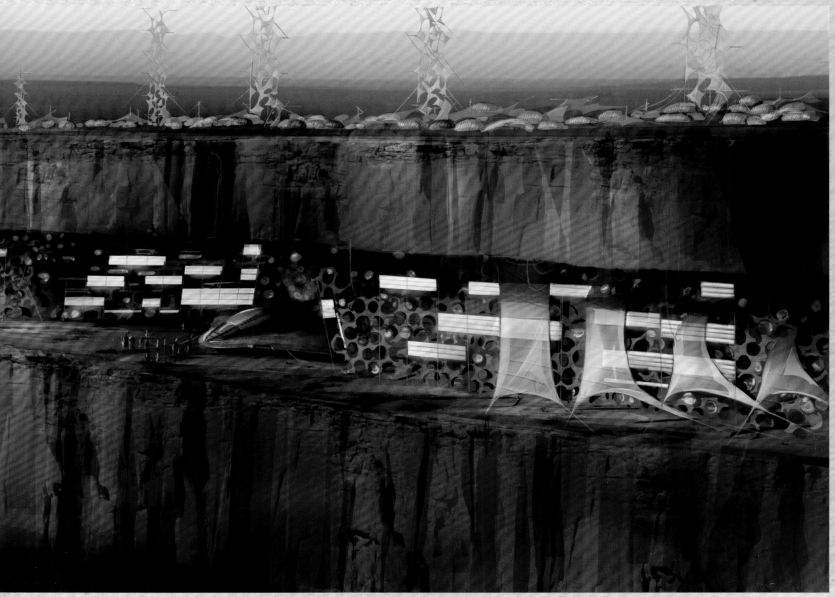

RANGER TRANSPORTATION

The United Ranger Corps employs a vast array of vehicles, each designed for specific tasks. Initially, Rangers used twin-engine single-man flyers to patrol the perimeter of the colonies and help escort exploration vehicles. Over time, Savant Donovan Flint found new ways to harness magnetism to improve flight efficiency and preserve the atmosphere. Flint's work with magnetism in the sixth century AE also meant the flying skipjacks were replaced with mag-lev flyers, much as the skipjacks replaced the all-terrain vehicles after a century of use. Flint's dream was to use the magnetic drives to begin exploring the planetary system, but he died before this could become a reality. Instead, he had to be content with creating easier and cheaper methods for exploring the lands and seas of Nova Prime, greatly adding to our knowledge of this world.

In modern times, Rangers now fly Class-A craft on patrol, while Class-B vehicles are heavy-cargo transports used to fly from Nova Prime to the anchorages throughout the Carina-Sagittarius Arm of the Milky Way Galaxy. There, Rangers oversee the construction of colony worlds as a hedge against the Skrel, ensuring there are places humanity can travel should they be forced from Nova Prime.

Rangers who board Class-B ships need to be fully rated and qualified. Each cockpit is manned by a pilot and navigator. See the Class-B manual for additional details. The most dangerous aspect of flying between planets are asteroid storms, which are categorized from 1 to 4; the higher the number, the fiercer the storm. A category 4, for example, can generate its own gravitational field, effectively acting like a black hole, vacuuming up any matter within its reach. Ships are designed to detect graviton buildups that warn of impending storm activity. A mass explosion could be catastrophic to the ship, its crew, and its cargo.

Class-C ships are modified from a core design to perform specific tasks such as medical transport, mining, engineering, search and rescue, and even riot control. See each vehicle's specifications in their onboard databases. Always familiarize yourself with each version's specs before takeoff to ensure no confusion occurs.

LEFT This mag-lev transport is used strictly for supply runs. It is designed for stability, not speed, and rated to handle 40 tonnes of goods. ABOVE This rapid-deployment transport can ferry a dozen Rangers to an emergency at a maximum speed of 120 kilometers an hour.

A NOTE FROM COMMANDER VELAN

Each mag-lev flyer and space-worthy vehicle has specific guidebooks and maintenance manuals. This is merely an overview; before traveling in any Ranger-transport for the first time, you are advised to consult the appropriate file.

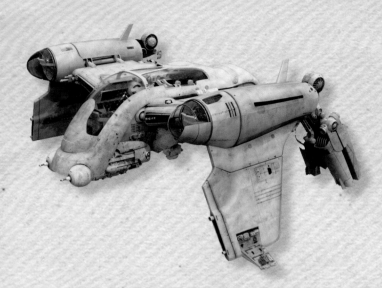

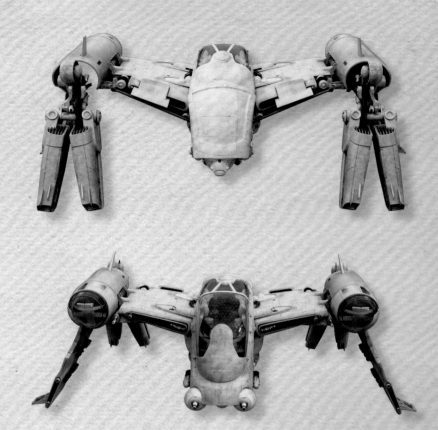

ABOVE & RIGHT A look at the United Rangers' Class-B mag-lev flyer, rated for high altitudes and to carry multiple personnel. Its twin pulser cannons ensure it will maintain the peace. BELOW Two Suijin Fleet skimmers patrol the river flowing beneath Nova Prime City. While the Suijin Fleet comprises the smallest portion of the Corps, its naval services remain vital.

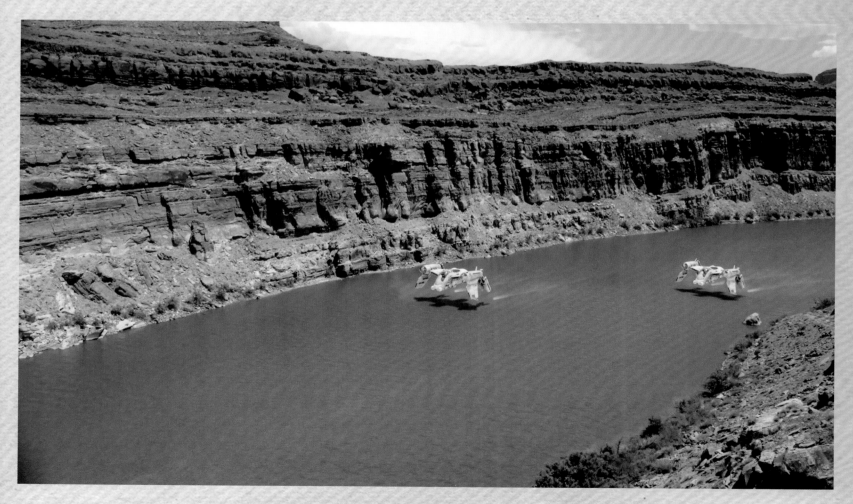

RANGER
CADET
TRAINING

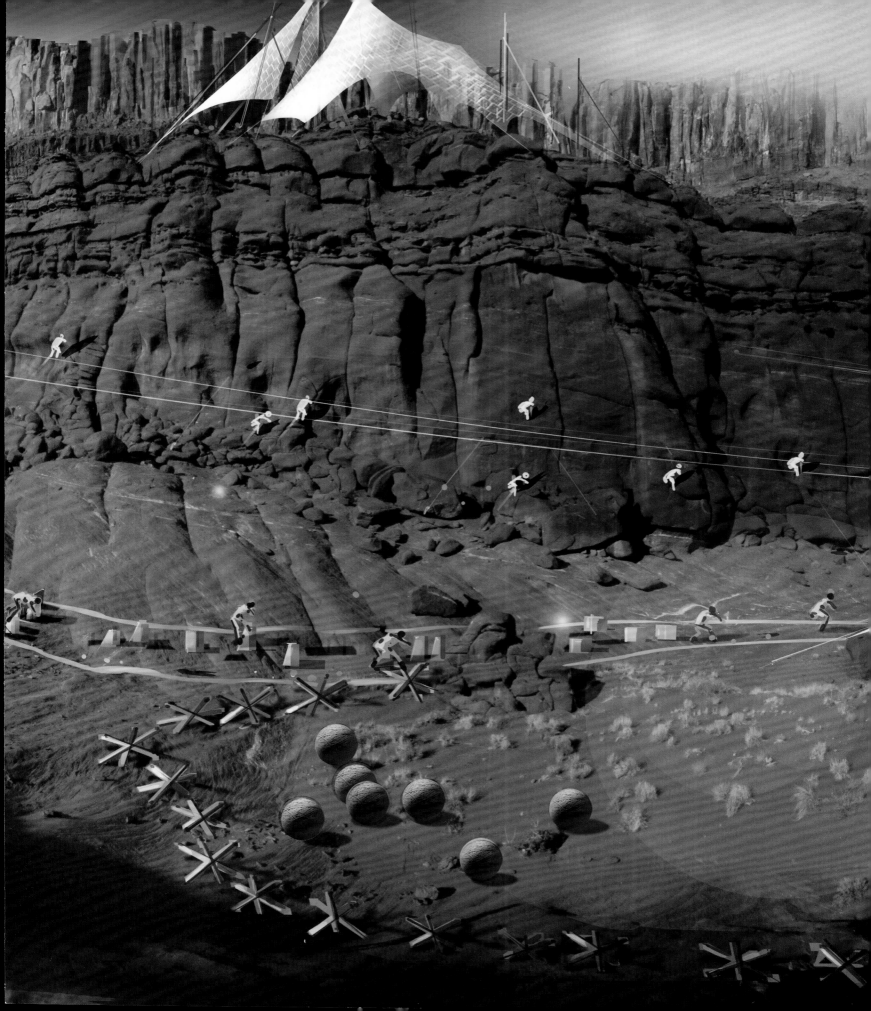

CADET TRAINING

CITIZENS MAY APPLY TO BECOME A RANGER from age thirteen. One parent must countersign applications for those still legally considered minors. People no older than twenty-five may apply for a position with the Rangers. Obviously, acceptance into the Ranger cadet program requires the applicant to pass a battery of physical examinations and one rigorous mental health exam. There are very few restrictions preventing a citizen from becoming a Ranger, although those with felony or higher criminal records are excluded from applying—with certain exceptions.

The guidelines for acceptance into the United Ranger Corps are reviewed and updated on a consistent basis. The most recent revision lifted the prohibition that prevented those with prosthetic limbs from applying, thanks largely in part to the abilities shown by Anderson Kincaid (see "The Way of the Ghost," page 94).

Once an application is accepted, a prospective candidate reports for cadet training and testing.

Phase One is a combination of physical and mental exercises to check everything from endurance to thought processing. Should a cadet make it past Phase One, they are invited back for Phase Two, which is a mixture of additional testing and field training. Should a Ranger cadet pass Phase Two, they are given a uniform and administered the oath, binding the cadet to the standards of being a Ranger.

Training periods occur throughout the year, but if a cadet does not pass Phase One, they must wait one year to reapply. After four failed attempts, prospective Rangers are no longer invited to reapply. Cadet pools are a maximum of thirty-two persons, split into four eight-person squads each assigned Ranger trainers. The entire cadet program is overseen by a Commander who reports directly to the Prime Commander.

Cadets live with one another in a bunk setup, which is also a socialization evaluation and a test of interpersonal skills.

The program begins each morning before first sun with a series of calisthenics. Following a brief breakfast, cadets are then taken out into the field to check their ability to navigate difficult terrain, climb sheer rock walls, and handle heights and confined spaces. Cadets are given a series of tests such as being blindfolded and asked to navigate their way through an abandoned lodestone tunnel or the Aldrin Forest. Other tests determine their ability to deal with harsh climates, from below-zero camping to high-altitude conditions.

Other days are devoted to weapons training and testing. Cadets are given pulser rifles and must demonstrate their familiarity with ordnance and target shooting. Their skills with sharpshooting and various hand weapons—from sidearms to knives—are also judged.

Most importantly, they are given wooden staffs to gauge how well they might handle a cutlass before they are given a fully functioning weapon to work with. C-10s (see "Mastering the Cutlass," page 78) are usually issued to cadets, and time is spent familiarizing them with each iteration the device is able to form. After a day of becoming accustomed to the cutlass, cadets engage in mock battles to see how quickly they can learn and adapt.

Toward the end of Phase One, the cadets are placed in holographic chambers where they are given a cutlass and have to take on a virtual Ursa single-handedly. While Rangers are deployed in eights, history shows that those numbers can be rapidly cut down by an Ursa. How well a Ranger can think on his/her own may mean the difference between life and death.

Out in the field, cadets are given a training staff and special helmet before being taken down a rock canyon. In razor

A NOTE FROM COMMANDER VELAN

It has been my distinct honor to manage this vital aspect of the United Ranger Corps for several years now. Watching young men and women reach this pinnacle of mental and physical perfection assures me our future will be in safe hands. For those reading this and considering applying, you should seriously assess whether you have what it takes just to get through Phase One. If you get that far, your chances of being a Ranger are strong. It is not for the faint or timid, but for those willing to work hard and make considerable sacrifices to keep the people of Nova Prime safe.

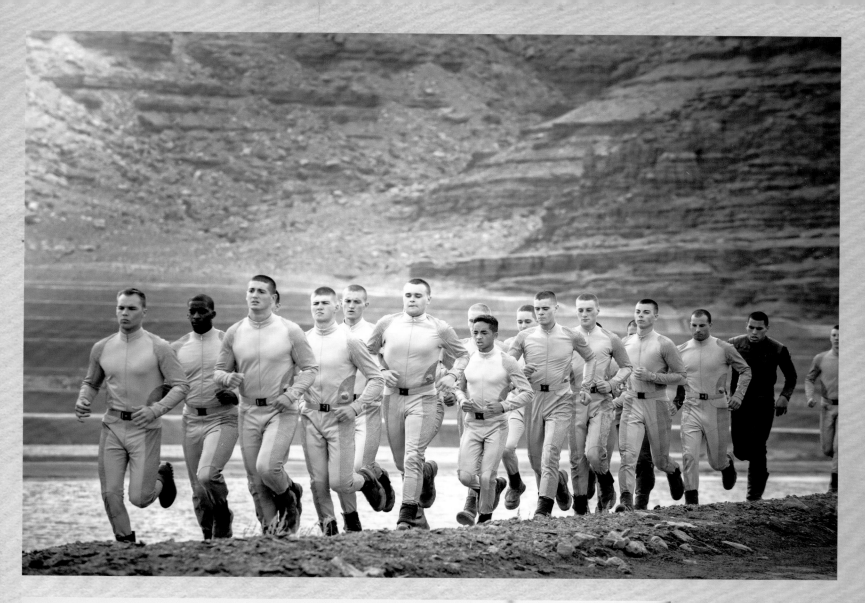

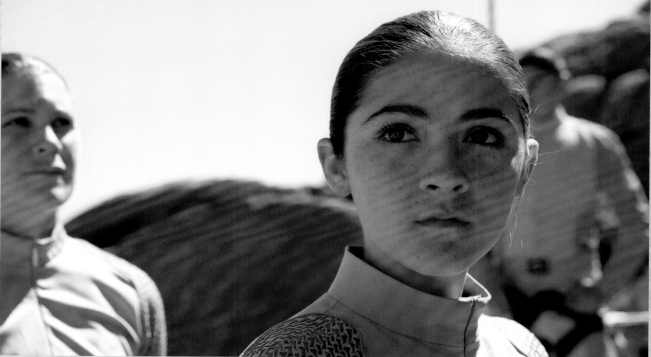

ABOVE Physical fitness and stamina remain the benchmark for cadets. If they cannot manage the physical exertion required, they are quickly washed out. Mastering the planet's terrain follows, with an emphasis on traditional tracking skills.
LEFT While applicants can begin training at thirteen, they have to be exceptionally adept to make it through the program.

formation, the cadets march while the uniform's smart fabric (see "Ranger Uniform & Equipment," page 64) sends signals to instructors that allow them to monitor the trainee Rangers' progress. Along the journey, various obstacles are put in the cadets' path to test their reaction time and how they work both alone and in a team. When they reach the peak, there is a 15-centimeter ledge with a face that tilts out more than 90 degrees into space. This requires every climber's biggest fear: commitment to the void. They will hang 152 meters over the canyon and pull themselves up onto the ridge. The next part requires using a zip line to travel the rest of the way.

In addition to the physical tests, cadets are required to demonstrate a command of history including but not limited to Earth history, the history of the United Ranger Corps, and Nova Prime's history, including the interactions with the Skrel and their Ursa (see "The Skrel & The Ursa," page 102). The randomized oral testing lasts a minimum of twenty minutes unless the artificial intelligence needs to more deeply probe a candidate's knowledge to make a final assessment.

The process had been known to average twenty-five minutes; the longest recorded time was thirty-seven minutes by a cadet who wound up repeating Phase One as a result. Much of this testing occurs within a booth where scanners track breathing, respiration, heart rate, pulse, and other medical signs to judge the cadet's ability to handle stress. Given the Rangers'

experience with the Ursa, those especially fearful may be disqualified for their own safety. The Fear Simulation Analysis washes out more cadets than the physical aspect of Phase One.

Of the thirty-two that begin Phase One together, on average, one-quarter are invited back for Phase Two. After leave, cadets return for Phase Two, in which the difficulty of the obstacles increases.

In simulators, cadets are first taken into a virtual version of Nova Prime's atmosphere, and those who pass that phase are then taken into virtual space aboard the Class-B and Class-C vehicles. Those who demonstrate the requisite skills are then put into actual vehicles and taken out to test their zero-g skills. Those with aptitude are then trained as pilots or navigators. Others are trained as infantry, sea-based forces, or support services. Placing the right cadet in the right training program makes the United Ranger Corps the strongest force imaginable.

Survival training is provided and then tested in a variety of scenarios culminating in a Final Exam.

Problem-solving tasks, puzzles, riddles, and ethical situations are also posed, culled from the long history of cadet training. These test the cadets to see how well they can think on their feet and demonstrate to them what their priorities should be. Cadets are also taken into the field to accompany Rangers on patrol before being quizzed on what they saw. In some cases, Rangers are asked to violate the rule book to test whether the

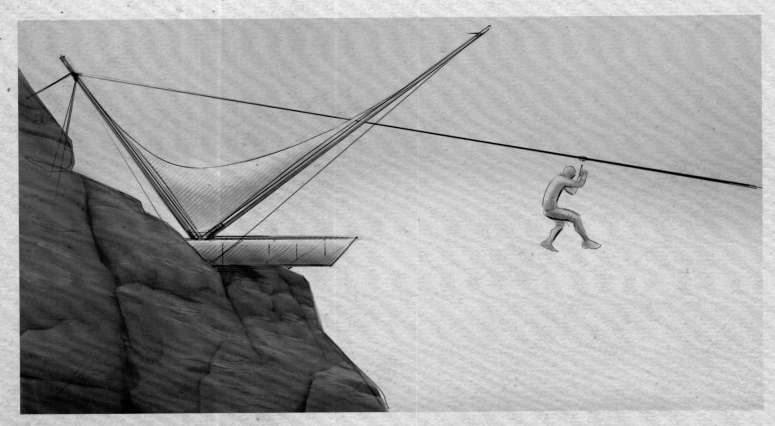

ABOVE & OPPOSITE Before cadets are taken into the air, they are first tested with zip lines and climbing exercises. Rescue operations will require Rangers to be able to scale structures or formations, in addition to dealing with great heights. Those who suffer from vertigo need not apply.

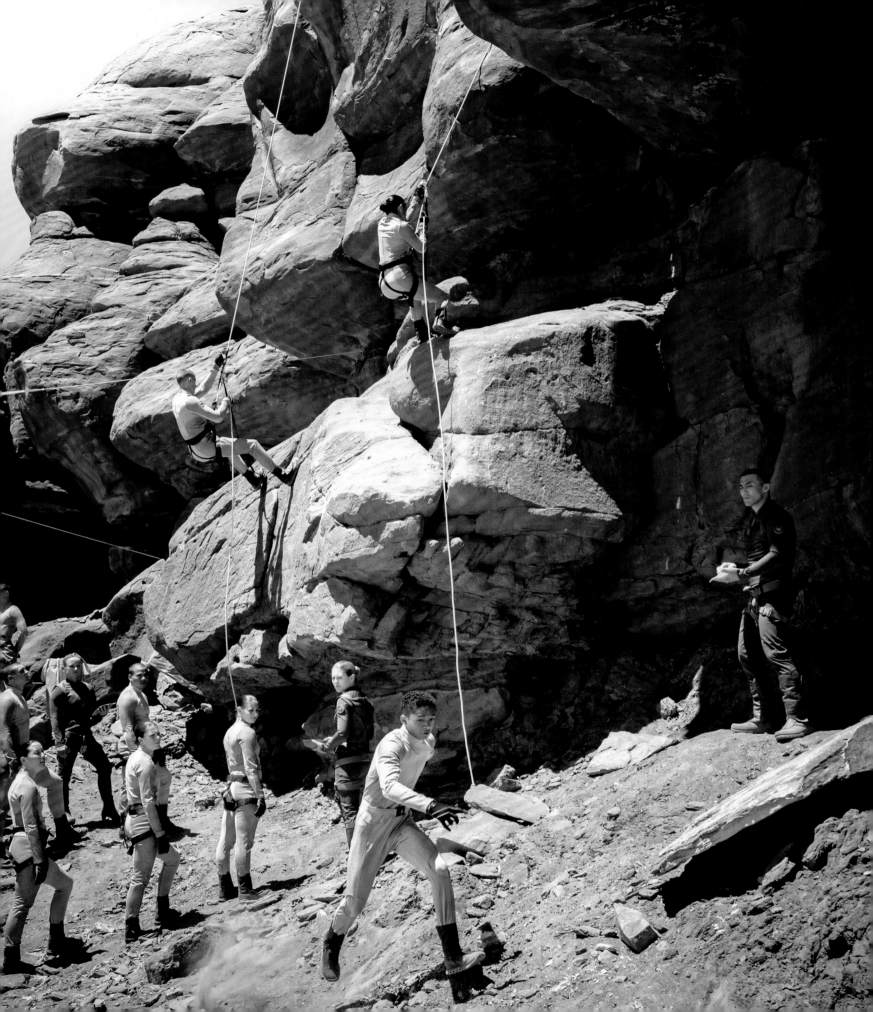

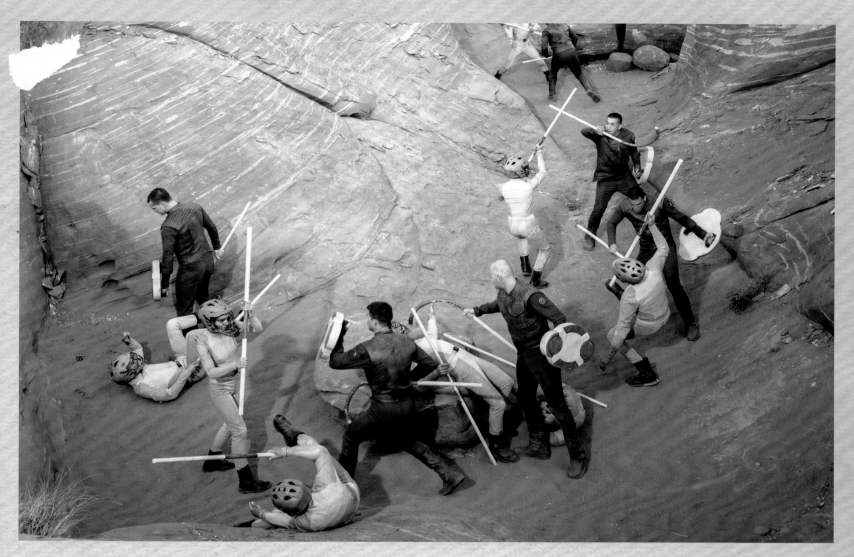

cadet has studied the rules well enough to notice and to test if they will report a Ranger who has violated the rules.

During this period, civilian volunteers working with the Rangers come forward with problems that cadets are asked to help handle. These can involve anything from missing pets to spousal abuse. Their interactions and solutions to the dilemmas are monitored and charted, and follow-up discussions examine how well they handled each situation.

The final portion of Phase Two is a week-long war games scenario. The final thirty-six candidates are invited back for this portion, dubbed "The Ordeal" by cadets but called simply the "War Games" by the Rangers' training staff. The cadets go to sleep only to awake in three predetermined teams on three randomly selected portions of Nova Prime. This process remains a closely guarded instructor secret. It is not customary to ask for explanation. Cadets are strongly advised not to do so. The teams have seven days to find their way back to the barracks using whatever tools they have while pausing to complete tasks

that were sent to them from the command post. They also have to tag or "kill" opposing teams when they encounter each other, in a test of tactics and ingenuity. No two exams are the same, to prevent those who previously survived from giving tips or help.

The challenges faced by the Green, Red, and Blue teams range from the innocuous (bringing back, unbruised, a dozen pieces of fruit) to the dangerous (return to base with the head of at least one poisonous reptile).

The ability to take orders, to get along with comrades, and to merely survive ever-changing circumstances is considered a final judgment of character and skill. Of the thirty-six who begin the Final Exam, only a portion are deemed worthy enough to graduate and become full Rangers.

Once accepted into the Corps, new Rangers are assigned mentors and given a regular assignment, beginning a career of dedication and duty and upholding ideals that stretch back more than a millennium.

OPPOSITE Attention to detail in battle formation, cleanliness of uniforms and equipment demonstrate discipline and respect—hallmarks of the United Ranger Corps. ABOVE Before being given cutlasses, cadets undergo basic bo stick training. They are also taught traditional gladiatorial tactics. This reliance on timeless methods helps make the Rangers a well-rounded battle force.

RANGER
UNIFORM &
EQUIPMENT

UNIFORM & EQUIPMENT

THE UNIFORM AND LIFESUIT

THE RANGER UNIFORM HAS EVOLVED over the years to afford you the maximum amount of flexibility to perform your duties while also protecting you from harm. For the most hazardous of situations, we have developed the lifesuit, which requires an entire course of study and training to ensure you understand its functions. While wearing it you shouldn't have to think about operating it correctly, as you are likely to be occupied with other concerns.

Both the uniform and the lifesuit are worn with pride and set you apart from your peers.

The Ranger uniform is worn in a variety of styles from cadet to Prime Commander, and often means the difference between survival and death. Smart fabric was designed shortly after arrival on Nova Prime, but its lineage can be traced back to 1930 AD. The fabric has organic field-effect transistors woven into the material, harnessing the bioelectric output of its wearer. Prior to the development of smart fabric, human bioelectrical output was measured via the electroencephalogram and electrocardiogram but never fully harnessed, even though this energy was thought to have tremendous untapped potential.

It was scientist Colette Saylor who ultimately found a way to use the humans' electrical output, melded with an organic field-effect transistor, to power a fabric woven with organic semiconductors. The biodegradable material has proven to be lightweight but durable and resistant to the harsh conditions found on Nova Prime.

Saylor was a leading scientist during the first decades of life on Nova Prime, spending countless hours working on adapting human technology to the needs of the new world. A resident aboard the *Pegasus*, she earned a reputation for thinking outside the box and also for her dislike of the word *no*. Saylor built on the sum total of human knowledge and forged it in new ways to create a better future. While many of her techniques are still used in the Savant's offices today, she is still best remembered for inventing smart fabric, which was nicknamed "the savior of Nova Prime." After the fabric was used for Ranger uniforms, Saylor and colleagues found a way to power the material from nonhuman sources, including sun energy. As a result, the fabric was eventually adapted for use in myriad ways, transforming how people lived and worked throughout the new world. Smart fabric can be used in window shades, information tablets, machine control panels, and in many more applications.

Over time, the Savants and their teams found ways to enhance the fabric and its interface with the human epidermis. The fabric basically absorbs the electrical signals produced by the human body or equivalent energy sources and is now able to interpret the wearer's needs. In the desert, the fabric will spread its density to its thinnest reaches in order to allow perspiration to be channeled away and cool the Ranger. In colder climates, the fabric contracts around the body, tightening at every opening, allowing body heat to power an electric charge throughout the suit that warms the Ranger.

When Rangers go into dangerous territories, such as confronting Ursa in the wild, they will always wear an enhanced version of the uniform, appropriately named a "lifesuit." Savant Aduviri Simon modeled the current lifesuit to imitate some of the traits demonstrated by their enemy, the Ursa. His designs in 709 AE became the template for all lifesuits employed today. Whereas an Ursa can sense a human's fear and lock in on that scent for the kill, the lifesuit's smart fabric can react to the unique electric signatures those alien life-forms give off. When an Ursa or other alien life-form is near, the lifesuit will shift color in warning and bulk up to form a hardened exoskeleton. Sensors will also detect a hostile being approaching, shifting the lifesuit to black. This sensor was tested on natural predators now native to Nova Prime and then adapted for the Ursa. The theory holds that should the Skrel ever be encountered close-up, the lifesuit could be programmed to detect their alien biosigns.

A NOTE FROM COMMANDER VELAN

A Ranger's uniform tells others he is there to serve and protect. In turn, the uniform itself both serves and protects those who wear it. The smart fabric that the uniform is created from allows Rangers to perform their duties in maximum comfort, shielding the soldier in many ways—from absorbing harmful ultraviolet radiation of the twin suns to wicking away sweat.

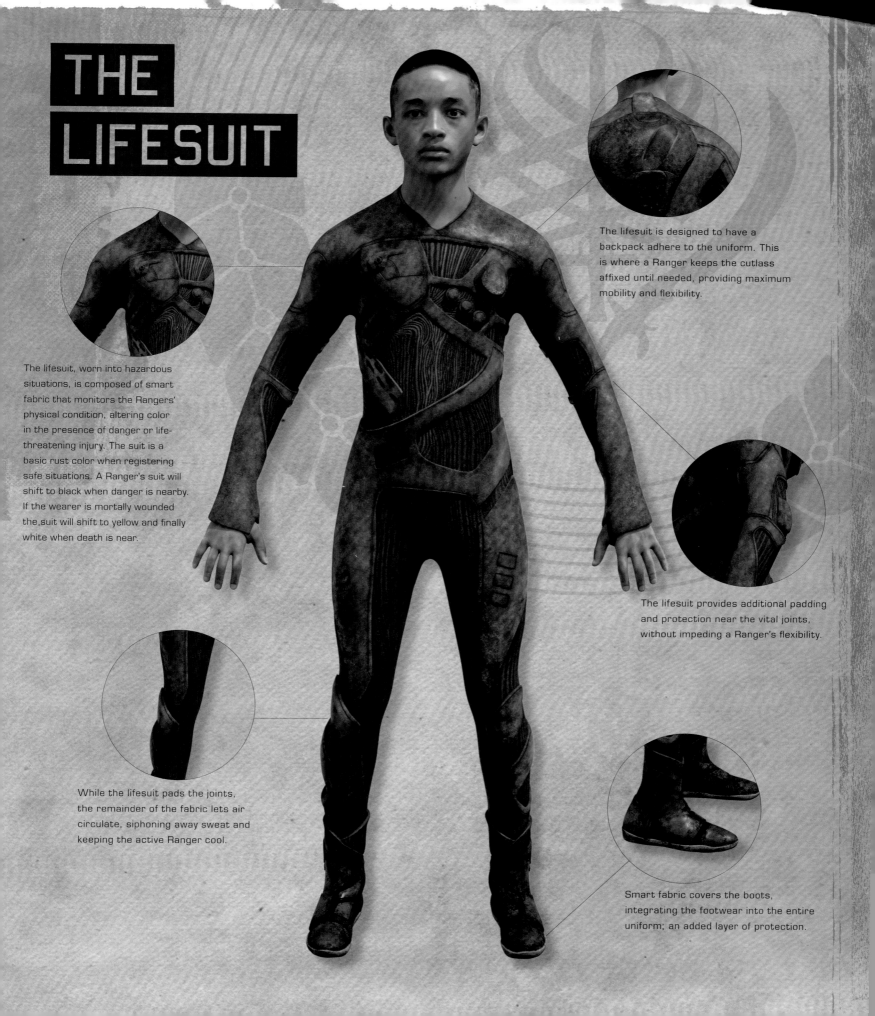

THE LIFESUIT

The lifesuit is designed to have a backpack adhere to the uniform. This is where a Ranger keeps the cutlass affixed until needed, providing maximum mobility and flexibility.

The lifesuit, worn into hazardous situations, is composed of smart fabric that monitors the Rangers' physical condition, altering color in the presence of danger or life-threatening injury. The suit is a basic rust color when registering safe situations. A Ranger's suit will shift to black when danger is nearby. If the wearer is mortally wounded the suit will shift to yellow and finally white when death is near.

The lifesuit provides additional padding and protection near the vital joints, without impeding a Ranger's flexibility.

While the lifesuit pads the joints, the remainder of the fabric lets air circulate, siphoning away sweat and keeping the active Ranger cool.

Smart fabric covers the boots, integrating the footwear into the entire uniform; an added layer of protection.

THE BACKPACK

In addition to the uniform and lifesuit, Rangers are often equipped for missions with a backpack that has basic components and mission-specific tools. All come with digital and virtual imaging capabilities. The cameras have a broadcast range of 100 kilometers under optimal conditions. The signals are encrypted for security and privacy concerns. Lifesuits also have cameras wired within the fabric that act as a backup to the camera attached to the pack. Battery life in both cases is estimated at 120 hours. The signal also carries GPS coordinates and enables the Ranger to check his location with a basic compass setting.

Additionally, the basic backpack contains a 4-liter water container and hydration tube for easy access. Other basic field supplies include a utility knife, flares, and a medical kit.

Mission-specific tools can include riot gear, hand restraints, and specialist tools needed for air, land, and/or sea rescue assignments. These are constantly being upgraded and refined by the Savant branch.

Cadets are trained with every piece of equipment, requiring them to understand how and why they work. This includes correct maintenance, and how to jury-rig equivalent tools should their issued equipment be damaged while on assignment.

PROBES

All vessels, Class-A through Class-C, contain one or more probes that can be deployed for exploration and surveillance purposes. Sunlight-charged, they contain cameras, microphones, and sensors allowing the navigator on board to monitor the telemetry. The Class-C ships designed for interplanetary travel contain many such probes with the computer systems able to translate the incoming data streams into real-time holographic projections. The probes are carried into the air via a missile that is designed to deploy these in a single burst. The positioning of the probes can be preprogrammed in advance or controlled during deployment. They have been designed to withstand the vacuum of space or crushing undersea pressure. Certain versions have been specifically designed with boring tools to drill beneath a planet's crust. Fully charged, a probe can function for up to seventy-five hours before depleting its battery supply but can recharge constantly when near a star source. Each probe also has memory enough to record forty-eight hours' worth of information while sending microbursts of data back to the ship.

TOP The Ranger's backpack is also designed to hold the cutlass for easy retrieval in combat. Supplies and tools are stored within the backpack itself to ensure survival in the wild. ABOVE A cadre of probes is deployed on Earth. Prime Commander Raige used these devices to monitor the progress of his son, Kitai, in a highly dangerous environment.

WEAPONRY

Initially, the Rangers who left Earth on the arks were armed with projectile weapons. However, Ranger leadership was concerned that more advanced firepower might be needed on Nova Prime. After all, no one knew exactly what kind of fauna the survivors of humankind's destruction would be facing on the surface of their new home. Nor did they know how the prevailing conditions on another world—wind, gravity, magnetic fields, and so on—would affect the efficacy of projectile weapons. As a result, as the arks traveled through space toward Nova Prime, a cadre of engineers was tasked with developing a firearm that would be effective in any environment.

Engineers on the arks were already working on an FTL drive that would be powered by nuclear fusion—the same incredible energy-yielding process that takes place in a star—in an attempt to shorten the trip to Nova Prime. After all, the fusion approach—as compared with fission—would produce more energy, require less fuel, and be free of nuclear waste by-products.

Building on the work of the FTL drive project, the weapon-development team began the demanding task of scaling down the fusion process until it was contained enough to provide the power for a relatively small handheld implement.

By the time the arks reached Nova Prime, the team had come a long way in its efforts. However, it was only after the humans had settled on their new homeworld and had room to safely

test nuclear-powered hand weapons that the first fusion-burst prototype was finally developed.

Over the years, fusion-burst tech was refined—despite vehement opposition from the Church of the Book's antiscience movement—until the fusion-burst rifle became an effective and dependable weapon for long-range engagement. Or so the colonists believed until 243 AE, when the Skrel made their violent first contact with the humans. In the battle that ensued, the colonists depended heavily on fusion-burst weaponry in their attempts to repel the invaders. To their dismay, they found that the Skrel craft were equipped with energy-disruption shields that mitigated the effectiveness of fusion-burst barrages. As a direct result of this miscalculation, the colonists took heavy losses.

The development of quantum trapping led to the creation of the cutlass, which is currently the standard weapon used by the United Ranger Corps (see "Mastering the Cutlass," page 78).

Projectile weapons and fusion-burst weapons have been outlawed for the civilian populace, and those found in possession of these classes of weaponry are to be arrested without question.

The Nova Prime Civilian Defense Corps and other designated agencies are able to use energy-burst weapons known as pulsers. Civilians may use pulsers at marksmanship ranges. A sizable selection of holographic targets are often available for users to choose from, but there is no denying that the most popular is always the Ursa.

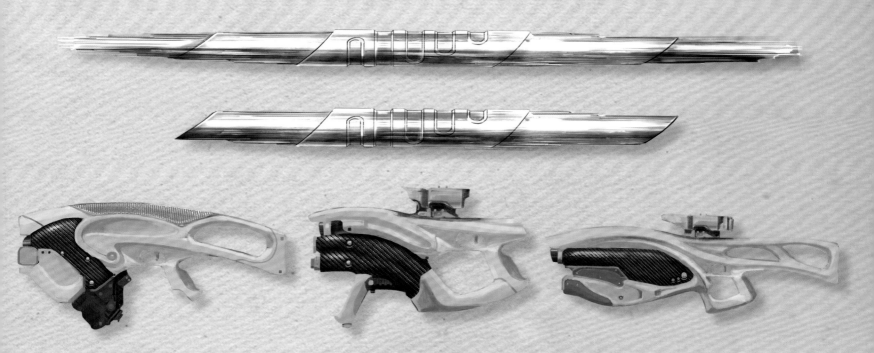

TOP The cutlass fully extended and at rest. ABOVE A variety of pulser hand weapons used by the Rangers. They vary in power, charge, and range; assigned as circumstances require.

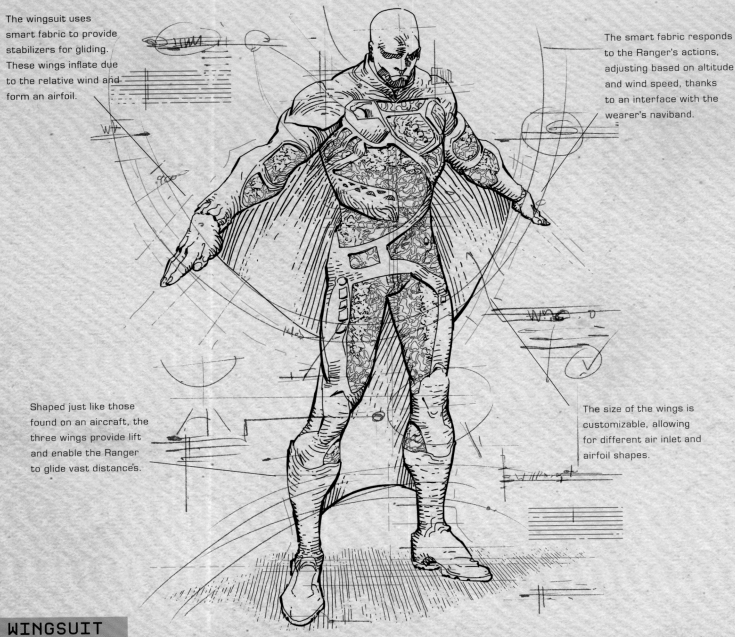

The wingsuit uses smart fabric to provide stabilizers for gliding. These wings inflate due to the relative wind and form an airfoil.

The smart fabric responds to the Ranger's actions, adjusting based on altitude and wind speed, thanks to an interface with the wearer's naviband.

Shaped just like those found on an aircraft, the three wings provide lift and enable the Ranger to glide vast distances.

The size of the wings is customizable, allowing for different air inlet and airfoil shapes.

WINGSUIT

A lifesuit is designed specifically to protect the Ranger from all manner of danger, either internal or external. Modifications and upgrades to the smart fabric have been introduced through the years, but few provide a Ranger with more of a thrill than the wingsuit configuration.

The smart fabric will sense altitude shifts, and as the atmosphere thins from standard readings to 200 meters above sea level, it can literally reweave itself to provide the Ranger with glider wings as a precautionary measure. The wings have been currently rated as effective to an altitude of 610 meters above sea level.

Cadets training with the wingsuit work in simulators before embarking on conjoined jumps with experienced instructors. Part of the Phase Two trials involves testing how well a Ranger can manage a solo flight before making a safe landing on the surface.

The thrill and adrenaline surge involved in such activity can make even the most experienced Ranger a danger to himself. Part of the psychological testing rules out those Rangers who may choose this option in a reckless manner when there are safer alternatives.

Rangers are rated annually on their ability to successfully make a jump and land safely. Should a Ranger fail, they are given a second chance a week later. The consequences of a second failure can include denial of promotion, reduction in rank if in a leadership role, and forced retirement.

While the wingsuit can often mean the difference between life and death, it is not to be used frivolously, given the toll it takes on the fabric and the body itself. Wingsuits remain structurally intact for approximately six jumps and then require replacement. A torn wingsuit cannot be repaired but must be recycled and replaced.

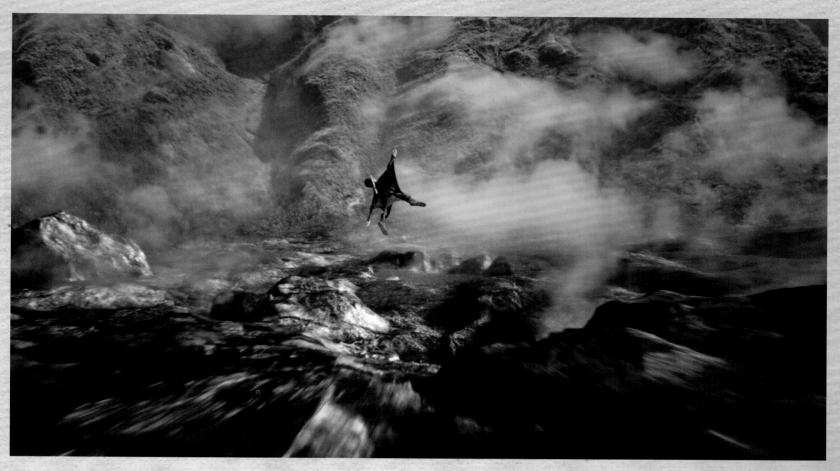

ABOVE In these images captured by probes, cadet Kitai Raige deploys the wingsuit in a life-or-death situation on Earth. The wingsuit can be used to rapidly traverse great distances but should be utilized only during emergencies. Great caution must be exercised each time this is attempted.

THE NAVIBAND

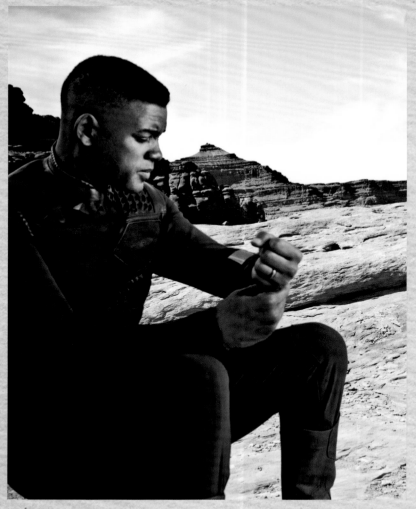

Each Ranger is equipped with a naviband that is loaded with all pertinent data for the mission along with default data regarding Nova Prime. The band can then generate holographic maps and directions to enable Rangers to travel to locations by foot or in their mag-lev flyers. The device can also hold detailed information culled from computer memory cores, providing a Ranger with all the data required for an assignment.

The naviband is synced between the wearer and a central computer, allowing the Ranger's activity to be monitored in real time. Each band also sends out a powerful tracking signal allowing Command to pinpoint the location of their troops. Off-world missions often require use of navibands with star charts and planetary topography on a case-by-case basis.

The naviband is equipped with a holographic display of the human anatomy. This can be synced to the status probe to help guide the Ranger through whatever emergency medical procedure is required.

Without a lifesuit, a Ranger's vital signs are monitored as part of standard Nova Prime communications gear. The naviband is more powerful and more vital during dangerous missions on and off Nova Prime.

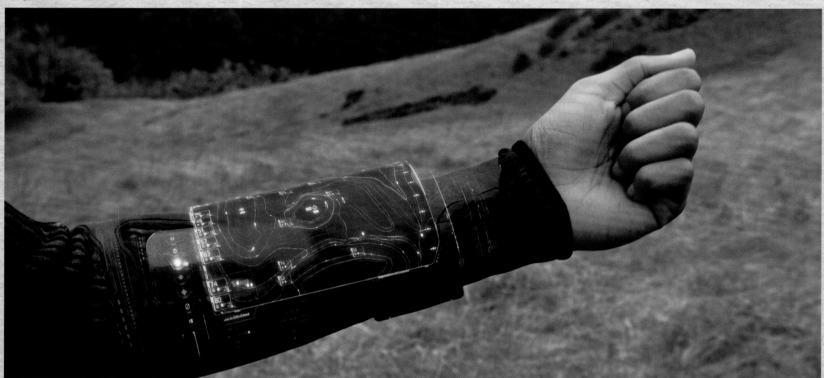

TOP Prime Commander Cypher Raige uses his naviband in the field. ABOVE A Ranger's naviband is a vital component to his well-being. The naviband is detachable and can be magnetically clipped to any Ranger uniform or lifesuit. When attached, it automatically connects to the microweave of the smart fabric to access the wearer's biosigns.

UNIVERSAL AIR FILTRATION GEL

Under extreme circumstances, such as when deep below the surface of Nova Prime or offworld, Rangers may find themselves in need of additional oxygen. The Universal Air Filtration Gel was developed to coat the lungs, increasing oxygen extraction, and allowing the user to breathe comfortably in many atmospheres. Each backpack contains a metal case with six vials, and the duration of the vials' effectiveness is based on a Ranger's height and weight. An average male Ranger can expect each vial to sustain them for twelve to eighteen hours, while female Rangers can expect each vial to last twenty to twenty-four hours.

The gel is to be utilized only in emergency situations and can sap a body's stamina and endurance if prolonged usage occurs. Due to the dangers, training with the gel is brief and theory-based, and a Ranger's first use of this life-saving measure will be in the field.

TOP Kitai Raige had to rely on the UAF Gel when stranded on Earth.
RIGHT The UAF Gel should be used only when there are no other options.

HOMING BEACON

Each mag-lev flyer on Nova Prime and all vehicles that traverse space are equipped with at least one emergency beacon. Interplanetary vessels carry one beacon fore and one aft. The rounded silver top is like a saucer that tapers at the bottom and measures approximately 20 centimeters.

When activated, a powerful signal radiates 360 degrees, which all Ranger communications systems are equipped to receive. The signal carries directional coordinates including a transponder code that will instantly identify the source.

Rangers have to be aware that atmospheric conditions might inhibit a signal from radiating. Ionic layers can create electrical interference, requiring the Ranger to acquire a higher altitude to successfully summon assistance.

Spacecraft are equipped with much more powerful systems that are designed to be received by the satellites that ring the planetary system, along with the "bread crumbs" left behind by the arks during their voyage from Earth. This way, a signal from anywhere in space should be able to reach a probe, which would then amplify and repeat the transmission along the chain back to Nova Prime.

Both terrestrial and extraterrestrial vehicles are equipped with a beacon in the command cabin and one in the aft section as a redundancy.

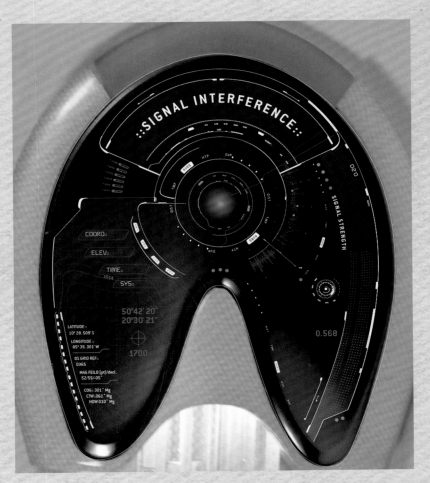

TOP The display found on a standard homing beacon, this one showing the kind of signal interference that can often be overcome by moving to higher ground.
ABOVE Homing beacons are required on all Class-A, B, and C craft. On Class-C interstellar vehicles, there are beacons located fore and aft as a precaution. Its signal is a powerful quantum burst, picked up and enhanced by satellites in the vicinity. OPPOSITE Kitai Raige attempts to activate a homing beacon on Earth.

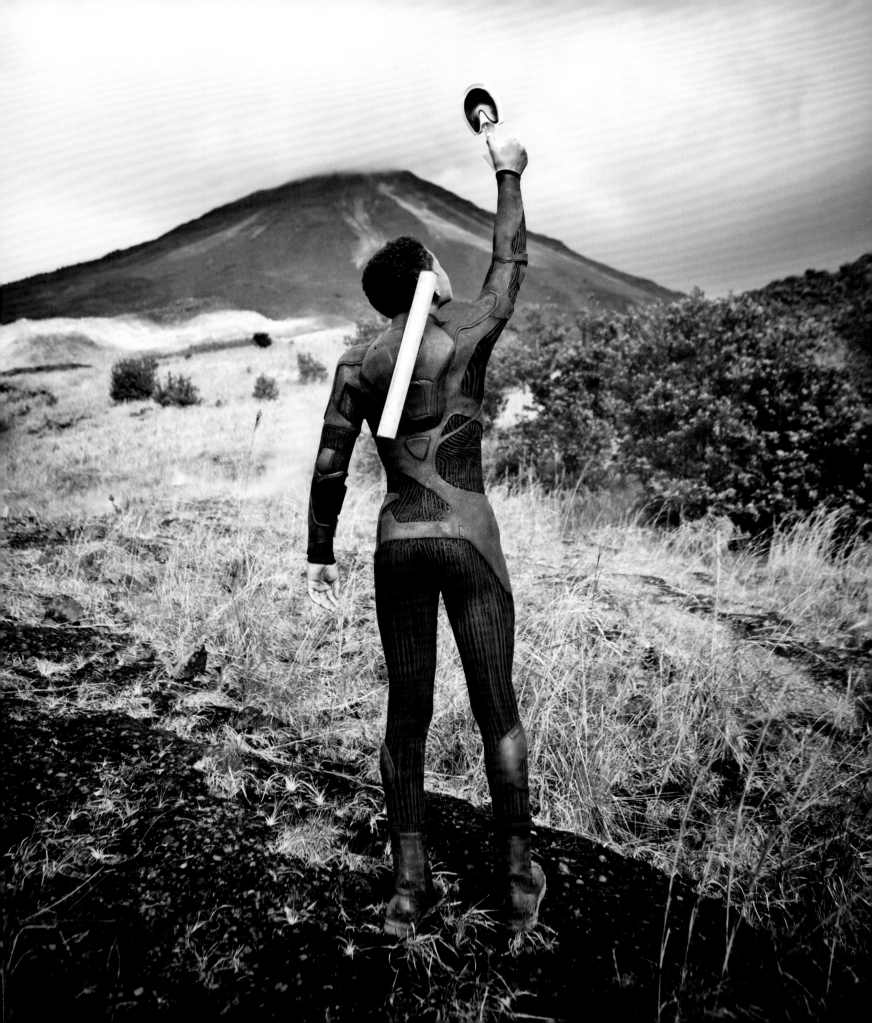

MED-KITS

Class-B and Class-C vessels come equipped with medical data banks that can provide detailed instructions on performing emergency procedures in the field. The med-kit interfaces with the ship's mainframe and performs an analysis, displaying a holographic study. The computer then provides a diagnosis and a recommended course of action.

Touching key words on the display will automatically shift to an explanation, graphic, and step-by-step procedure. Three-dimensional anatomy studies are displayed, walking the Ranger through the process with the Ranger controlling the speed of the data flow. The procedure and recommended medicinal treatments are based on a real-time inventory of materials on hand, so the advice is able to be accurate on a case-by-case basis. As a result, the med-kit can assist Rangers in performing life-saving treatment with very little medical equipment until emergency personnel can take over.

During Phase Two training, cadets are taught basic field medic techniques, from checking vitals on the lifesuit to manually checking temperature, blood pressure, and respiration. Standard-issue tools in the med-kit include status probe, Steri-gel, a variety of elastic sterile bandages, invisible sutures, pocket breathing mask, aspirator, sterile pads, occlusive pad, saline, antiseptic gel, hemostatic spray, eye mask, rubbing alcohol, laser trauma scissor, microbeacon, narcotics, and epinephrine patch.

Before graduation, cadets are required to perform field surgery on cadavers during their Final Exam, learning how to close wounds, humanely euthanize the terminally wounded, and other variables. The ability to perform field surgery is a vital component in the search-and-rescue aspect of being a Ranger. Attacks from the Skrel and Ursa throughout the centuries have made it vital that Rangers can get past any squeamishness and perform life-saving procedures on themselves or their comrades.

Rangers are required to take refresher courses to remain current and comfortable with the process, which often means the difference between success and failure. It is recommended Rangers review the separate medical guidebook before going on assignments where medical personnel may not be available.

ABOVE LEFT Some of the medical tools used to perform life-saving field surgery. Every Ranger is rated and retrained with regularity to ensure comfort and confidence in using these instruments. ABOVE RIGHT In Earth's toxic environment, Kitai Raige injects himself in the heart with an antitoxin after being bitten by a poisonous leech. OPPOSITE TOP & BOTTOM The medical scanners interface with the nearest computer to generate a holographic image of the injury. Instructions are then given to guide the surgeon through the necessary procedures needed to preserve life and limb.

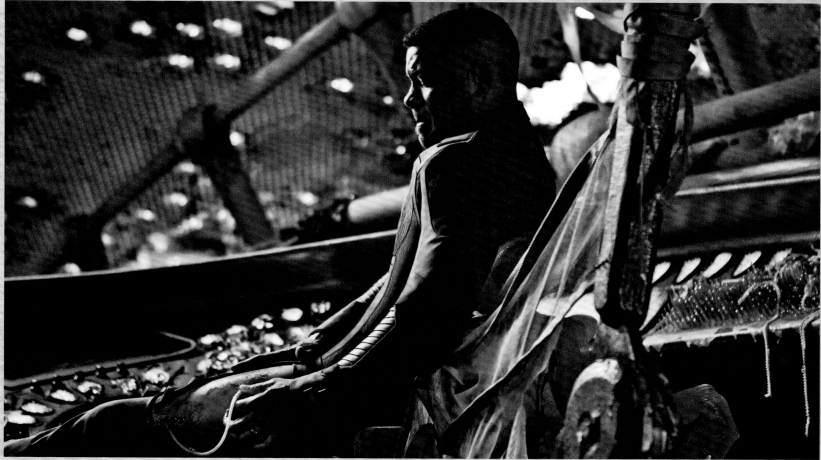

MASTERING
THE
CUTLASS

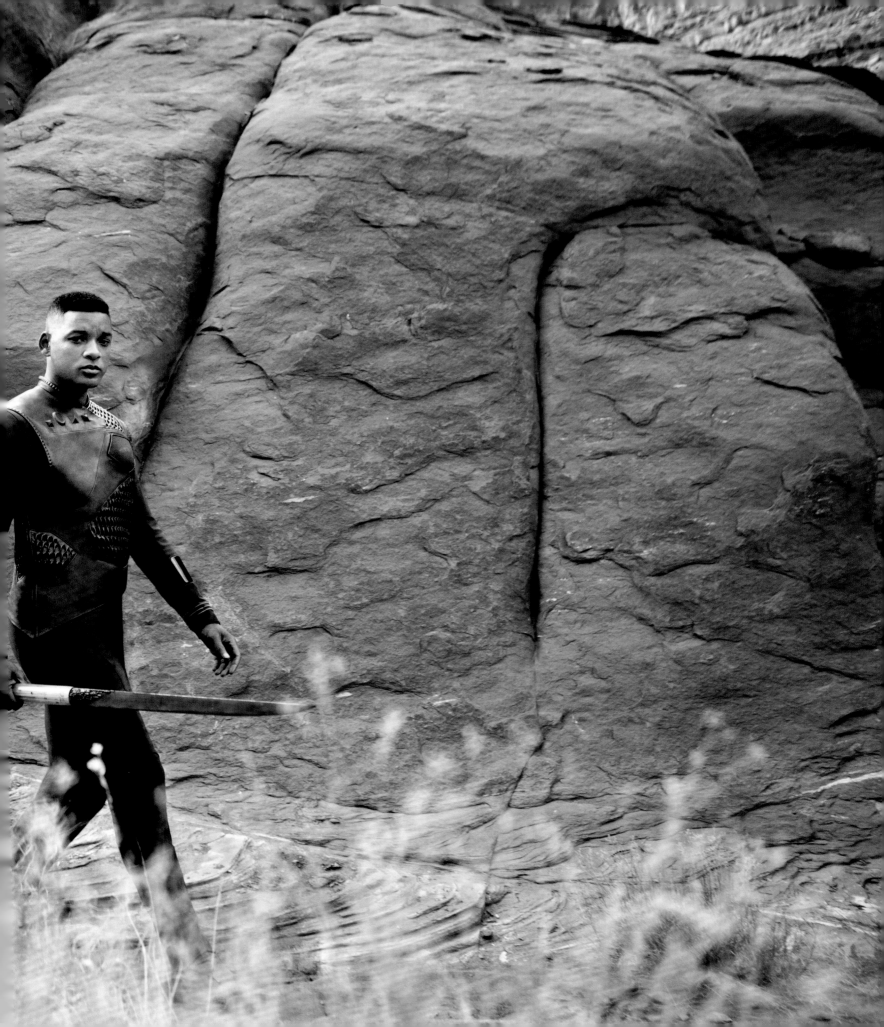

THE CUTLASS

A NOTE FROM COMMANDER VELAN

There was never anything like the cutlass back on Earth, where combatants relied mainly on projectile and bladed weapons for millennia. Over the last five hundred years we have benefitted from a breathtaking new technology that has given us not only an advantage over our intergalactic enemy but also a tool to help maintain the peace on Nova Prime. This weapon requires the utmost discipline and training, which is one reason we start with the basic model before promoting you to full Ranger and assigning you the current field model.

NECESSITY IS THE MOTHER OF INVENTION, and when the Skrel first made their presence known, the United Ranger Corps needed an edge. At the time, fusion-burst weaponry was considered but proved ineffective against the Skrel's shielding. Jack Kincaid, a member of the Savant's inner circle, came up with a solution to ward off the attacking spacecraft. His breakthrough allowed further refinements until the quantum-trapping process was miniaturized into a handheld weapon containing F.E.N.I.X. technology. In time it became known as the cutlass.

No other invention has proven as effective as this multipurpose tool. Measuring just over 43 centimeters, each new model has expanded on the capabilities of the cutlass. During a Ranger's career, he or she will be constantly tested to prove their proficiency with the weapon. Working together, the Savant and the Rangers continue to improve the device's efficacy, knowing that the Skrel are constantly creating new and more resilient versions of the Ursa.

At rest, the cutlass appears to be a simple rod or baton, but triggering one of a selection of options will quickly transform it into a deadly weapon. The current cutlass can be affixed to the back of a Ranger uniform and quickly retrieved for use. The device can reconfigure itself into multiple shapes thanks to thousands of filaments harnessing quantum energy in a process that has been refined through the centuries. These multiple configurations will see each end form different tools or defensive weapons, such as a spear/staff or a spear/blade.

The current model can snap into twin pieces capable of forming a finite number of configurations including eskrima sticks, ice picks/pitons, cutting blades, and sickles.

Given that the weapon forms a fresh shape with each command, the edges of the blades remain razor sharp and it would take prolonged use for them to be blunted. Of course, rather than sharpening the weapon, the Ranger needs only to reconfigure its shape to get a newly keen blade. Combined with its unparalleled sharpness, the considerable metallic mass of the cutlass means it can cut through most substances, from metallic walls to rocky formations.

CUTLASS HISTORY

As mentioned, it was Jack Kincaid who first realized that he could use an approach known as quantum trapping to generate the energy necessary to take down Skrel spaceships. Quantum trapping involved two components: a superconductor cooled with liquid nitrogen and a magnet. Normally, an object coated with a layer of supercooled superconductor would have simply repelled a magnetic force and wobbled around. However, in a quantum-trapping situation, tiny flaws in the superconductor coat called "flux tubes" allowed some magnetic forces to penetrate and "trap" the object in three dimensions. The result was that it floated motionless in space.

The group working on the quantum-trapping project was aiming to use the technology to establish suborbital weather beacons that would remain in place in any circumstances and alert the colony to dangerous meteorological phenomena. However, Kincaid had seen the potential of quantum trapping as a weapons application, and through the help of his cousin, Savant Bree Kincaid, he received the resources to pursue the idea. During the long days and nights of the initial Skrel attack, Jack rushed to finish a single working model.

THE CUTLASS

BLADE

As envisioned by Lyla Kincaid of the Savant's staff, the filaments of the cutlass alter shape, allowing it to take the form of a number of different weapons.

HANDLE

Later designs led to the cutlass being modified so that it could split into identical pieces, doubling its effectiveness in certain situations.

CONTROLS

The controls on both ends allow each separate piece to form different or identical configurations, depending on what the wielder requires.

NEW ADVANCEMENTS

The cutlass has been slowly refined over the last half millennium. New improvements are constantly being made.

F.E.N.I.X. TECHNOLOGY

When the project was complete, Kinkaid named the technology F.E.N.I.X., which stands for Fe (the chemical symbol for Iron, derived from the Latin word *ferrum*) Novan Instrument of Execution. The device was made up of thousands of individual steel filaments, each one coated with a supercooled layer of superconductor material and suspended in a magnetic field–induced quantum trap. By manipulating the magnetic field through strategically distributed flux tubes, the user could arrange and rearrange the filaments to create a variety of shapes.

But Kincaid hadn't initially intended the F.E.N.I.X. technology to be modified into a hand-to-hand combat weapon. He had developed it as a projectile that could be launched at aggressors and manipulated via remote control. With the Skrel seemingly content to attack from their ships rather than engage Nova Prime forces on the ground, there was no reason to diverge from the projectile approach.

Immediately, the F.E.N.I.X. system went into production. As soon as the Prime Commander had a few dozen of the devices at his disposal, he ordered their deployment. The colonists held their breath, knowing the F.E.N.I.X. systen was their last hope.

Fortunately for them, it worked. The Skrel's energy shields, which had been utterly impervious to the Rangers' fusion bursts, were useless against the F.E.N.I.X. powered projectiles. As each one made contact with a Skrel hull, it changed its shape to locate, penetrate, and disable the Skrel's operating systems. Before long the Skrel fleet was in ruins with the surviving vessels retreating. The colonies were saved.

THE FE IN F.E.N.I.X.

The F.E.N.I.X. system, unlike fusion-burst ordnance, depended on the nuclear fission of iron atoms rather than the fusion of lighter elements. After all, iron (in the form of hematite) was the most plentiful element on the surface of Nova Prime—even more plentiful than it was on Earth—as evidenced by Nova Prime's red-rock surface. What's more, iron was easily surface-mined, eliminating the need for deep excavations. By comparison, radioactive isotopes were rare and inaccessible. These were real considerations, given that the Rangers planned on mass-producing projectiles, fearing the possibility of an even larger-scale attack.

Shielding against nuclear fission, which had been a problem when fusion-burst tech was first introduced, was no longer a problem. In the intervening two centuries, humanity's engineers had come up with a shielding system both strong enough and light enough to be practical in a handheld weapon.

In 576 AE, the Skrel returned to Nova Prime, depositing the first wave of Ursa on the surface. These living, breathing killing machines had been developed specifically to hunt down humans, and they quickly ran roughshod over the population, which was poorly equipped to defend itself against such a threat.

Narrowly escaping death at the hands of the Ursa, Lyla Kincaid, a descendant of Jack Kincaid, informed Prime Commander Meredith Wilkins that she had an idea: to utilize the F.E.N.I.X. system in a handheld weapon, which she dubbed the cutlass. She immediately got the go-ahead to proceed, but, unfortunately, there was one figuration that she couldn't debug, and using it would cause the weapon to explode. Tragically, she was killed by an Ursa before her work could be completed. Just as it looked as if the colony might not survive the Ursa invasion, the first batch of handheld weapons containing the F.E.N.I.X. system was completed by Lyla's colleagues and distributed to the surviving complement of Rangers.

Despite their lack of familiarity with the untested weapons, the Rangers made good use of them. Almost immediately, the tide turned in the defenders' favor. Although the Ursa were still formidable adversaries, small groups of cutlass-equipped Rangers began to eliminate them one by one. Once again, Nova Prime had found a way to survive.

LEFT A cutlass constantly monitors its power source and condition, and alerts a Ranger should a defect be detected.

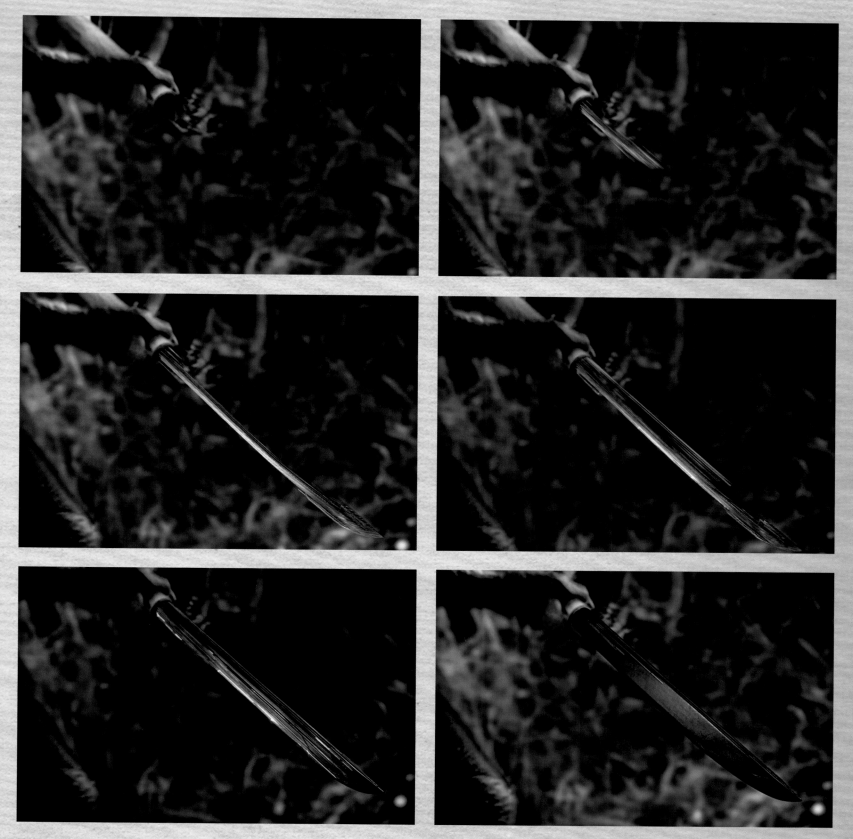

ABOVE A step-by-step look at how the filaments extend and wrap around one another, forming the battle-ready cutlass blade. The blade can slice through almost any material and a touch of the controls can alter its shape within seconds.

IMPROVEMENTS IN THE CUTLASS SYSTEM

Early on in the development of the cutlass handheld unit, it was suggested by a focus group of Rangers, all veterans who had survived confrontations with the Ursa, that it would be helpful if the device could be separated into two units. Of course, this alteration required that Nova Prime's engineers build future cutlass systems with *two* nuclear-fission units rather than one. This way, when the staff was split in two, both halves could remain functional.

The original handheld cutlass devices that saved Nova Prime from the Ursa in 576 AE weighed slightly more than 4.5 kilograms each and gave their user a mere three options with regard to shape modifications: point, flat blade, and hook. As the weapon was refined and gained the permanent name of cutlass, additional shapes were added to its repertoire, some designed to take advantage of the Ursa's peculiar physiology. Also, the weapon was made lighter as its power source was further miniaturized.

CURRENTLY, THERE ARE FOUR DIFFERENT CUTLASS MODELS IN USE ON NOVA PRIME.

» The C-10 is the model given to cadets and is the lightest at 2.5 kilograms. It is also the simplest to master, and all cadets train with this model until they become full-fledged Rangers. As a homage to the Rangers who used the F.E.N.I.X.-based system so admirably in their first encounter with the Ursa, the C-10 provides its user with only the original complement of three shapes: point, flat blade, and hook.

» The C-20, until recently the weapon of choice for newly appointed Rangers, is seldom used anymore because it is heavier and less versatile than the C-30 model that replaced it. The C-20 weighs 3.3 kilograms and boasts an array of twelve configurations, including a point, flat blade, hook, oar, and sickle. Despite its drawbacks, the C-20 is still spoken of in reverent terms since it was the model used by Cypher Raige when he became the first Ranger to single-handedly kill an Ursa.

» Rangers today are issued a C-30 cutlass. This relatively lightweight weapon, at 2.75 kilograms, provides its user with sixteen distinct configurations. It takes quite a while to master so many options, and realistically most Rangers will only use eleven or twelve of them.

» The most sophisticated model, the C-40, is reserved for the Prime Commander, field leaders, and veterans who have passed rigorous testing. After all, it boasts an array of twenty-two configurations—many more than most Rangers can effectively handle. It also weighs a hefty 4 kilograms, which some Rangers consider a drawback in an Ursa encounter, where a hundredth of a second can mean the difference between life and death.

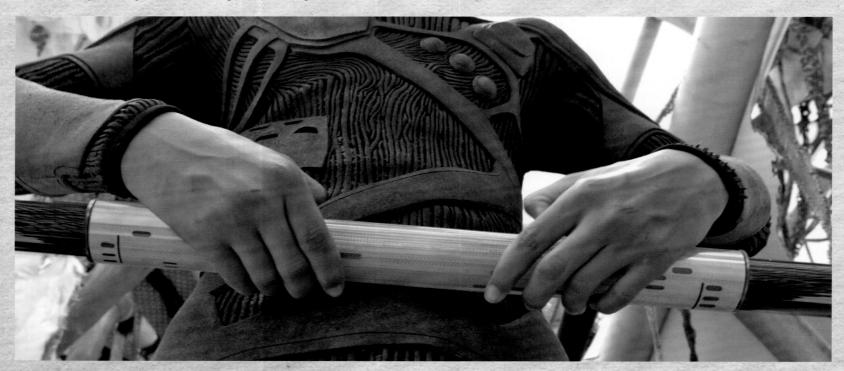

ABOVE With a quick movement of the fingers, one of the most powerful weapons ever invented comes to life.
OPPOSITE The cutlass is a possession of extreme pride for each Ranger in the Corps.

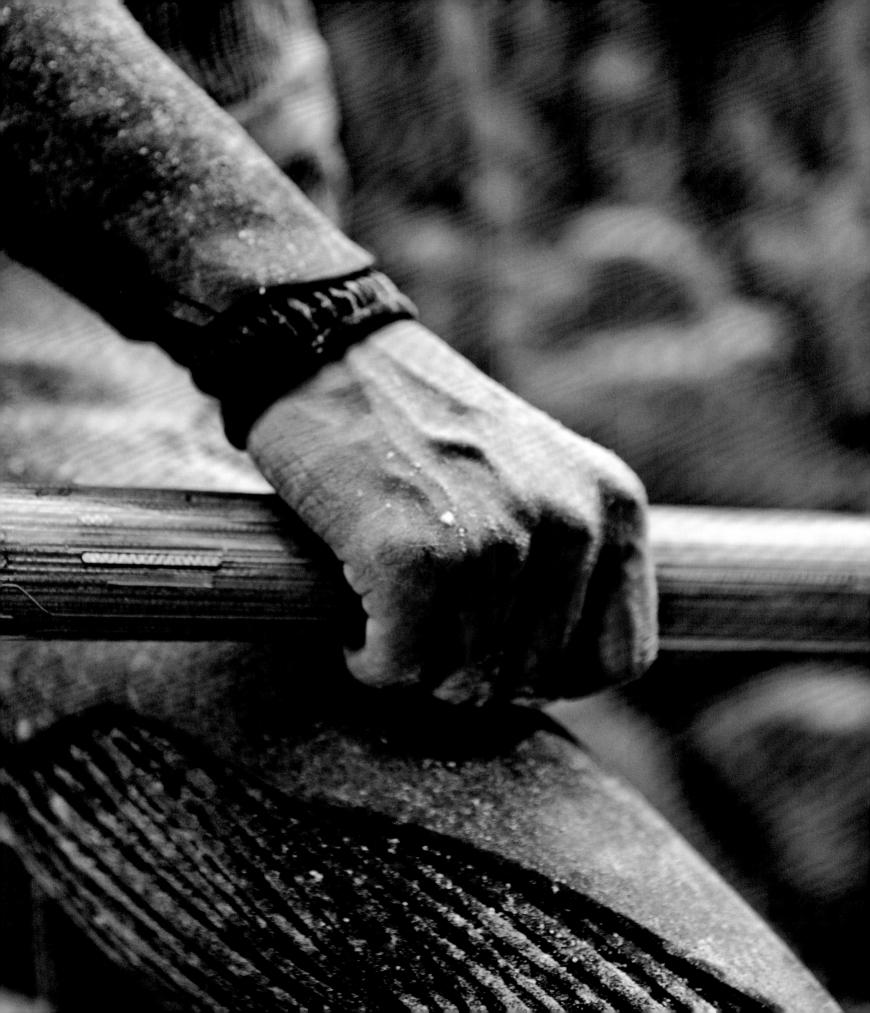

THE C-40 CUTLASS

A WEAPON WITHOUT PEER

The C-40 cutlass can be turned into a maximum of twenty-two configurations. On these pages are the most popular styles favored by Rangers during their normal duties.

The twin-edged blade is good for close-quarters fighting.

The long and short pike configurations have proven most effective with the Ursa.

The scythe configuration is good for slashing Ursa limbs or cutting openings during emergencies.

The cutlass can be easily snapped into two separate pieces.

Rangers are drilled repeatedly to ensure they use the twin pikes with equal effort, not favoring their natural inclinations toward being right-handed or left-handed.

Few Rangers, even among the most veteran combatants, ever use more than a dozen of these configurations, although cutlass methods vary from Ranger to Ranger.

In current development is the C-42, which will have some long-desired but only recently attainable new capabilities, directly commissioned by Prime Commander Cypher Raige. His previous input led to the relatively rapid upgrades seen in the C-30 and C-40 models. He had, after all, become the preeminent authority on fighting Ursa.

The initial specifications show it has been reduced in weight to 3 kilograms despite its new functions. However, the most battle-hardened veterans will still prefer the C-40, insisting that it is more durable and dependable than the C-42 and therefore worth the extra weight.

THE CUTLASS'S WEAKNESS

In the ten years since its invention, the cutlass has displayed only one weakness, which the Skrel have either failed to notice or have been unable to take advantage of: It is vulnerable to strong magnetic fields. Because the manipulation of the cutlass's steel fibers depends on the magnetic forces that move through the device's flux tubes, any powerful competing magnetic force has the potential to temporarily disrupt the weapon's operation. Anyone who wields a cutlass has to be wary of artificially created magnetic fields and must try to avoid the naturally occurring variety.

CUTLASS 101

The cutlass's balance is precise and requires practice to adjust to each setting. Cadets train at least six hours per setting on the C-10s before moving ahead. They have to manage melding their personal fighting style with the cutlass until it naturally becomes an extension of themselves. Training starts with metal replicas of the cutlass in its resting state before the three variants are introduced.

Through a series of simulations at the training range, cadets must practice adjusting from one setting to another during combat and while in motion. Cadets do not engage one another in mock combat until they have passed a proficiency test during Phase Two.

Cadets may be trained on the C-20s and C-30s for brief periods, but the majority of their training is done with the C-10 model. Toward the end of Phase Two training, cadets are given a C-20 to begin working with. Normally, cadets need at least a week of practice to adjust to not only its greater weight but also the increased number of shapes it can take.

C-20 practice does not involve other cadets except during a competition at the tail end of Phase Two training. The cadet must demonstrate the ability to adjust the cutlass from its resting state to any of its dozen forms while blindfolded. If they pass that stage, they must perform the same task but this time under duress from auditory distractions (explosions, sirens, Ursa screams, avalanches). After that stage, they are dispatched to varying locations to practice, including aboard naval vessels and Class-A flyers in addition to the Tangredi Jungle near Nova Prime City.

If a cadet passes the C-20 tests, they will then move up to train with a C-30, now requiring mastery of the additional configurations. Similar testing proceeds here at an accelerated pace, further testing a cadet's character, judgment, and reaction times.

Only upon graduation to full Ranger does a member of the Corps receive their own cutlass. This then becomes a prized possession, fiercely protected, cleaned, and worn with pride. Often, those who retire have their cutlass embedded into a service plaque rather than have it turned over to another Ranger. Rangers have been known to be buried with their cutlasses.

The cutlass becomes a reflection of the Ranger who holds it. Cutlasses, worn on the back, become as familiar as a limb. The weight is a reminder of the tremendous responsibility that comes with being a Ranger.

Even after a cadet graduates and becomes a full Ranger, practice with the cutlass continues. These devices need constant calibration and maintenance to remain in peak operating condition.

Additionally, given the nuclear radiation involved in operating the cutlass, any time they are employed in action, full medical testing is done remotely thanks to the lifesuit's smart fabric. At any time, should a cutlass be damaged and radiation leak out, the device is taken away for safe disposal and Rangers may find themselves undergoing medical treatment as a precautionary measure.

Given the potential for a cutlass to malfunction when exposed to magnetic fields, they tend not to be used while in space transit. Should a Ranger be called into action between Nova Prime and its neighboring worlds, the cutlass becomes a weapon of last resort.

Similarly, regulations require that when landing on an unexplored world, Rangers must make a thorough study of the planet's magnetic fields before anyone disembarks. In some cases, modifications to the cutlass can be made that lessen the risks of damage and radiation exposure. However, it is vital that Rangers are able to perform their jobs, and in at least three cases, promising colony worlds have been abandoned due to their unsuitable magnetic fields.

COMBAT TUTORIAL

Training with a cutlass requires an understanding of form and function, matching the right body formation with the right cutlass configuration, while being ready for instantaneous analysis and action.

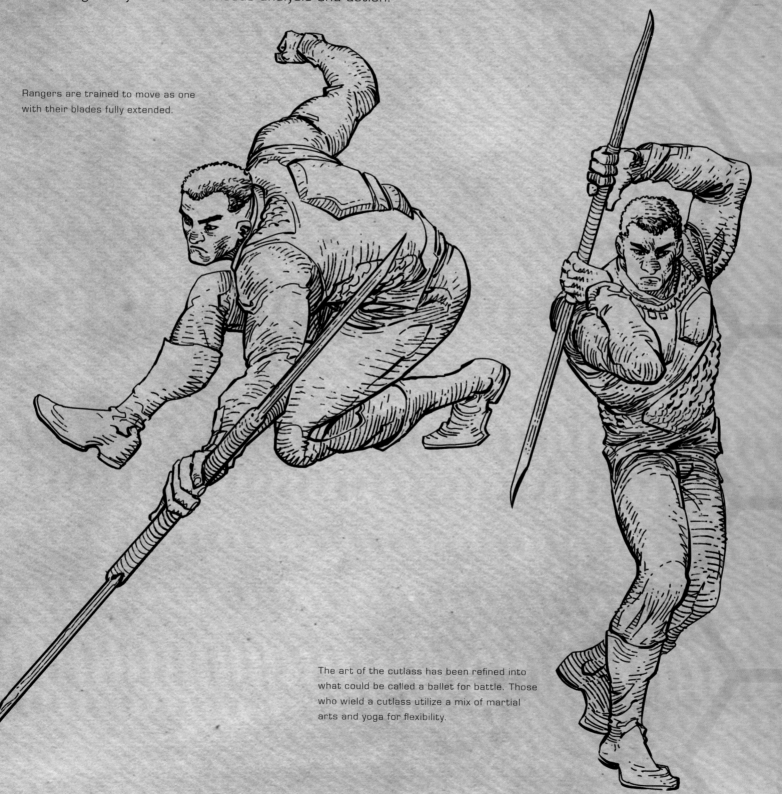

Rangers are trained to move as one with their blades fully extended.

The art of the cutlass has been refined into what could be called a ballet for battle. Those who wield a cutlass utilize a mix of martial arts and yoga for flexibility.

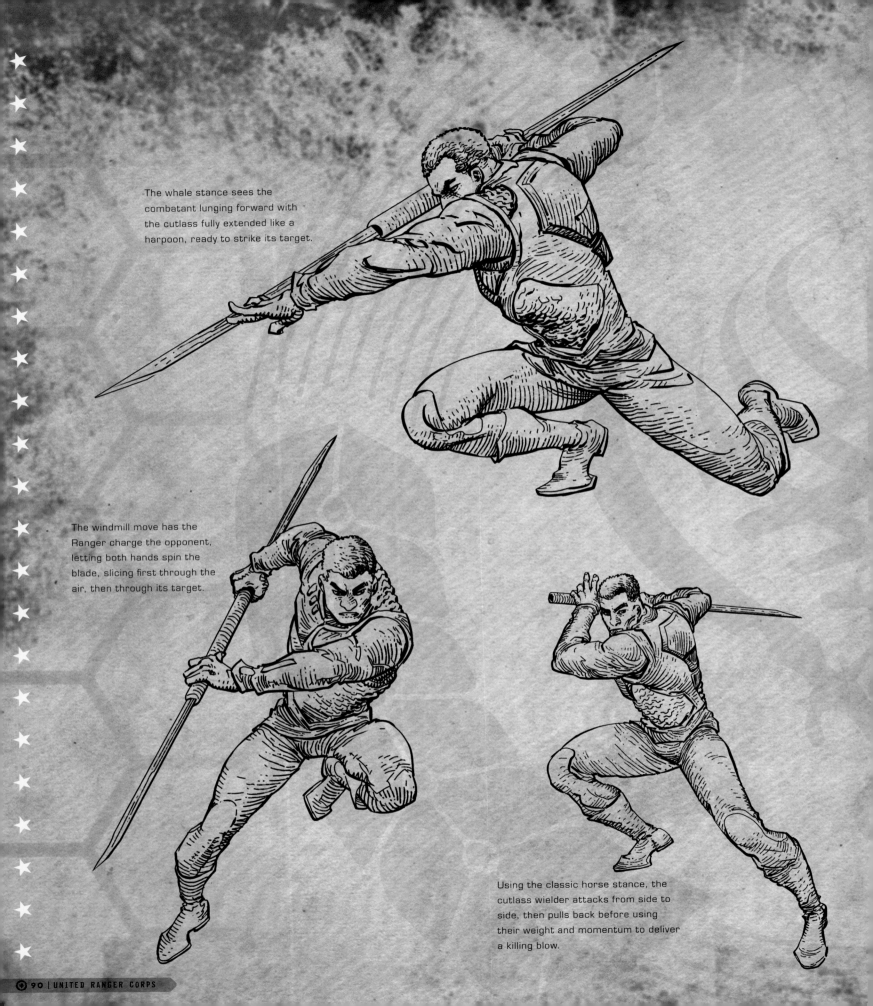

The whale stance sees the combatant lunging forward with the cutlass fully extended like a harpoon, ready to strike its target.

The windmill move has the Ranger charge the opponent, letting both hands spin the blade, slicing first through the air, then through its target.

Using the classic horse stance, the cutlass wielder attacks from side to side, then pulls back before using their weight and momentum to deliver a killing blow.

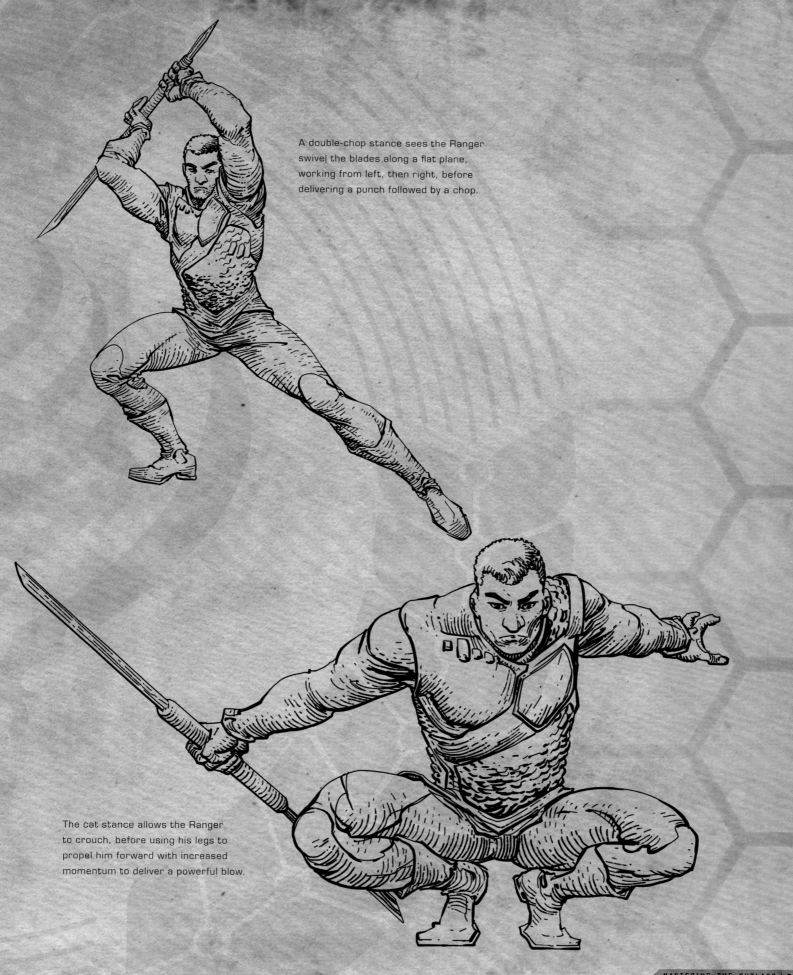

A double-chop stance sees the Ranger swivel the blades along a flat plane, working from left, then right, before delivering a punch followed by a chop.

The cat stance allows the Ranger to crouch, before using his legs to propel him forward with increased momentum to deliver a powerful blow.

THE C-40 ENERGIZED

The quantum trapping allows nearly limitless energy to flow through the filaments, making the cutlass a weapon without need of sharpening or reloading.

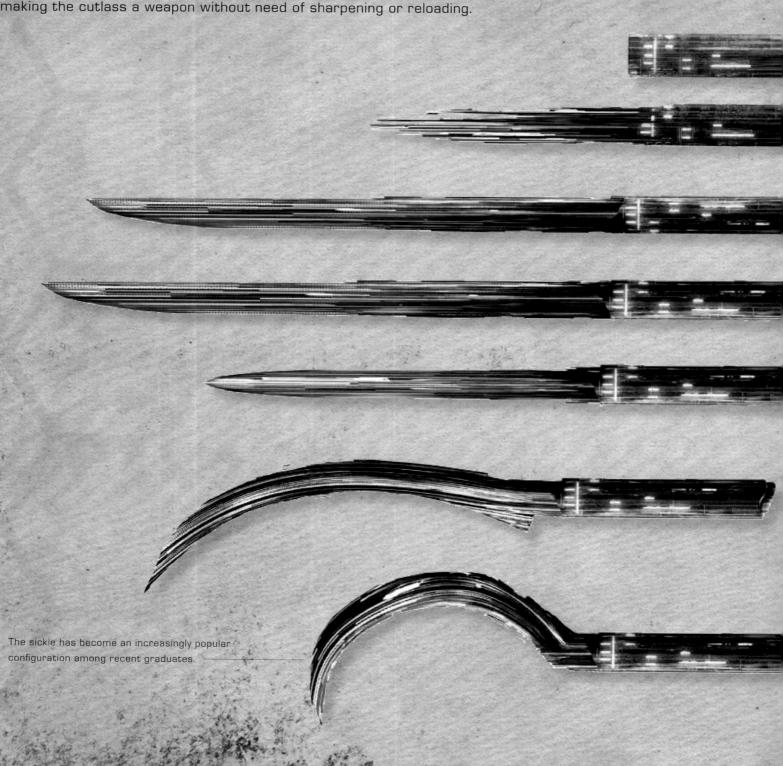

The sickle has become an increasingly popular configuration among recent graduates.

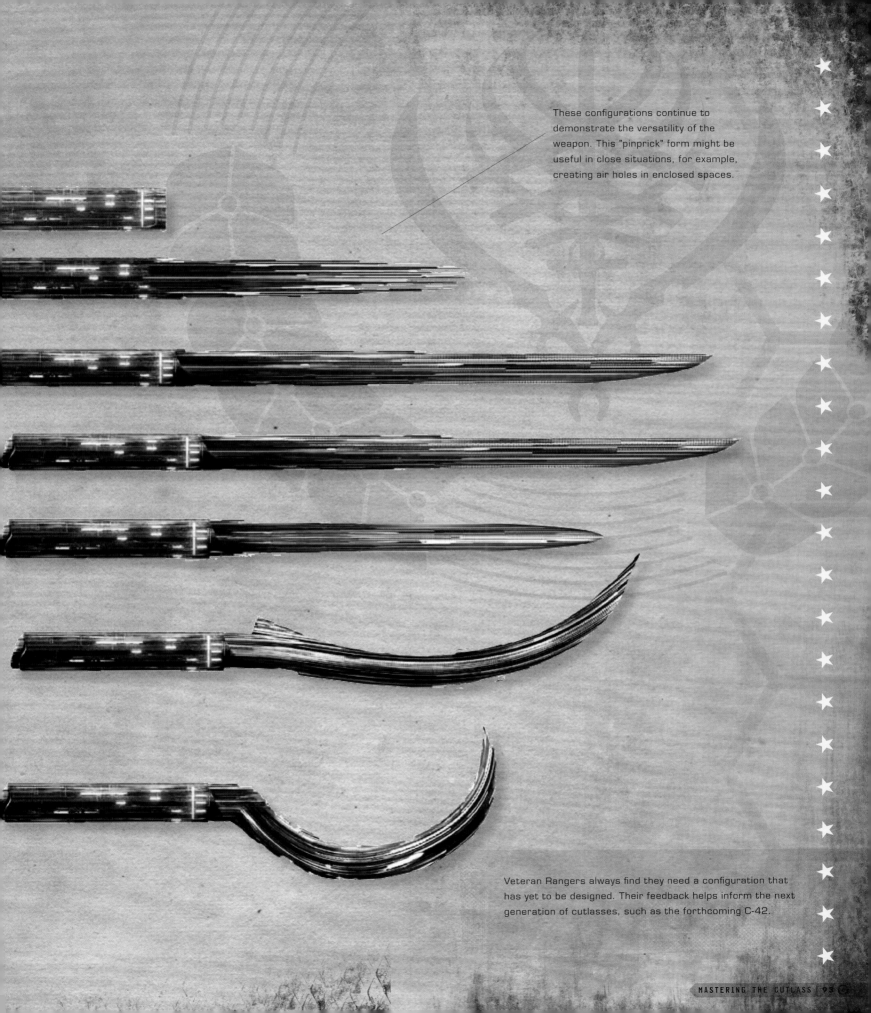

These configurations continue to demonstrate the versatility of the weapon. This "pinprick" form might be useful in close situations, for example, creating air holes in enclosed spaces.

Veteran Rangers always find they need a configuration that has yet to be designed. Their feedback helps inform the next generation of cutlasses, such as the forthcoming C-42.

THE WAY OF THE
GHOST

A NOTE FROM COMMANDER VELAN

It used to be that *ghost* meant a specter, the stuff of fairy tales and horror stories. Recently, however, the word has taken on an entirely new meaning. While for years there was just one ghost, we now have the benefit of eight living ghosts, giving us hope that our fear of the Ursa is something we can conquer and outgrow. Now that the Ursa are a part of Nova Prime's ecosystem, the edge that the ghosts afford us will be vital.

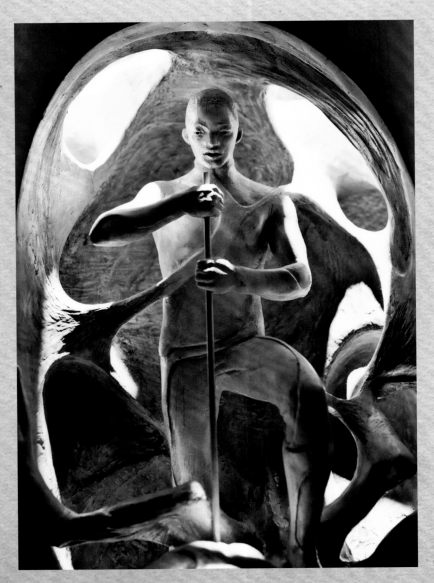

LEFT A sculpture commemorates the moment when Cypher Raige first used his ghosting abilities to slay an Ursa.

GHOSTING CANNOT BE TAUGHT. Ghosting is not genetic. Ghosting didn't even exist until Cypher Raige became the first human being to screen himself from an Ursa, getting close enough to single-handedly kill the creature. Ghosting is the total elimination of fear, which the Ursa can smell, and at the time of writing, only seven men and one woman have been documented ghosts.

This section will briefly detail the eight recorded ghosts and outline how this technique has made the difference between life and death for many Rangers.

To ghost, an individual must be so free from fear that they become invisible to the Ursa. Fear is territorial in your heart. It refuses to share space with any other virtues. You must force fear from your heart and replace it with any other virtue. It could be love or happiness or faith, but the virtue is specific to the individual and comes from the deepest part of that person.

Given the number of encounters with Ursa through the last century, fear has become a decisive factor in judging people ready to become Rangers. It is also why the Elite are usually first to respond to Ursa sightings and the ones to accompany captured Ursa to Iphitos for study.

I WENT FOR A RUN. ALONE.
SOMETHING WE ARE NEVER SUPPOSED TO DO.
AN URSA DE-CAMOS RIGHT IN FRONT OF ME.
I GO FOR MY CUTLASS, AND IT SHOOTS ITS
PINCER RIGHT THROUGH MY SHOULDER.

NEXT THING I KNOW, WE'RE FALLING OVER THE CLIFF.
FALLING. 30 METERS.
STRAIGHT DOWN INTO THE RIVER.

WE SETTLE ONTO THE BOTTOM. IT'S ON TOP OF ME,
BUT IT'S NOT MOVING. I REALIZE IT IS TRYING TO
DROWN ME. I START THINKING, "I AM GOING TO DIE.
I'M GOING TO DIE. I CANNOT BELIEVE THIS IS HOW
I'M GOING TO DIE."

I CAN SEE MY BLOOD BUBBLING UP, MIXING WITH
THE SUNLIGHT SHINING THROUGH THE WATER,
AND I THINK, "WOW. THAT'S REALLY PRETTY."

EVERYTHING SLOWS DOWN, AND I THINK TO MYSELF,
"I WONDER IF AN URSA CAN HOLD ITS BREATH
LONGER THAN A HUMAN?"

I LOOK AROUND, AND I SEE ITS PINCER THROUGH
MY SHOULDER, AND I DECIDE I DON'T WANT THAT
IN THERE ANYMORE. SO I PULL IT OUT, AND IT LETS
ME GO, AND MORE THAN THAT, I CAN TELL IT CAN'T
FIND ME. IT DOESN'T EVEN KNOW WHERE TO LOOK.

AND IT DAWNED ON ME: FEAR IS NOT REAL.
THE ONLY PLACE THAT FEAR CAN EXIST IS IN OUR
THOUGHTS OF THE FUTURE. IT IS A PRODUCT OF
OUR IMAGINATION, CAUSING US TO FEAR THINGS THAT
DO NOT, AT PRESENT, AND MAY NOT EVER, EXIST.
THAT IS NEAR INSANITY.

DANGER IS VERY REAL, BUT FEAR IS A CHOICE.

WE ARE ALL TELLING OURSELVES A STORY.
THAT DAY, MINE CHANGED.

THE EIGHT GHOSTS

Since the Ursa first arrived on Nova Prime in 576 AE, only eight men and women have managed to achieve the state of fearlessness necessary to prevent the Ursa's sensory organs from detecting them. As a result, they have become the Elite in the United Ranger Corps.

You cannot be born a ghost, nor can it be drilled into you. Each of the eight ghosts had a unique experience that gave them insight into the technique, and some were not even Rangers when they first ghosted. You can learn how the original ghost, Cypher Raige, first ghosted in the extract from his journal on the previous page. The stories of the other seven ghosts follow and are just as inspirational and instructive.

DANIEL SILVER: Silver had always been something of a drifter, not worried about much of anything and not having any sense of the world around him. After breaking up with his girlfriend over his aimlessness, however, he was so despondent that he signed on to join an Ursa-hunting party put together by an influential member of the Nova Prime community. As luck (albeit bad luck) would have it, they encountered an Ursa, who maimed and killed every member of the group except for Silver. When the responding Rangers arrived, he was literally the last man standing, the Ursa having ignored him and moved on. The Rangers extended an invitation for him to join their ranks, and he accepted, having no other viable options. As he grew into the position, he worried over whether or not he could continue to ghost. After all, it happened at a time of extreme depression, when he didn't care whether he lived or died. The true test came when he found himself confronting the Ursa that got away, with his squad counting on him. Just when things were looking bleak, he summoned up the image of his ex-girlfriend and tapped into how her loss made him feel. This has worked for him ever since.

KEVIN DIAZ: Born into a family that revered simplicity, humility, and inner peace, Diaz rejected his parents' teachings, letting anger fuel him. Diaz exceled during Ranger training and graduated in the top 10 percent of his class. He was on active duty when the Ursa attacked in 997 AE. His squad was winnowed down by a single Ursa until Diaz was among three survivors. Without backup to achieve the requisite eight Rangers needed to confront an Ursa, Diaz was depressed and discouraged. A wave of calm washed over Diaz as he thought about his family and remembered all the lessons he had rejected. That gave him the inner calm required to ghost and slay the Ursa entirely on his own.

MALLORY McGUINESS: Ranger Mallory McGuiness's husband, fellow Ranger Janus McGuiness, died while on duty. Rather than grieve, she remained on duty, and during an Ursa incursion she ghosted. This was a surprising development because McGuiness had never displayed any such ability before. After a series of examinations, the Savant discovered that McGuiness's previously undiagnosed pregnancy may have been the cause of her newfound ability. She was now torn between the duty she felt to Nova Prime and her responsibility to protect the life growing inside her. After some soul-searching, she reported to Prime Commander Cypher Raige and informed him that she intended to continue to serve for as long as she was physically able. After a series of "soft" assignments, she wound up part of a three-person squadron bringing emergency supplies of water to a small scientific outpost. Upon arrival they discovered an Ursa. Concern for the baby within her caused a momentary distraction, enough to capture the Ursa's attention. As it approached, the baby kicked—a reminder. And for the first time, she perceived her child as a strength, not a weakness, an asset to her life, not a liability. Cleansed of fear by this insight, McGuiness was able to slay the Ursa single-handedly.

ANDERSON KINCAID: A member of the proud Kincaid lineage, Anderson Kincaid was expected to follow his ancestors into the Rangers. However, an Ursa attack in 980 AE cost young Anderson his left arm. He mastered his prosthetic replacement and trained himself to the peak of physical conditioning in the hopes he could still join the Corps. Unfortunately, regulations forbade anyone with a prosthetic from joining. When this rule was instituted centuries earlier, the thinking was that even the most advanced prosthetic device could still fail during a critical moment. Instead Kincaid joined the Nova Prime Civilian Defense Corps and served with distinction. He was on patrol in 997 AE when a wave of Ursa attacked and he wound up being the only one in the vicinity as one of the creatures stalked a market. He fought as best he could and when it appeared he might die, Kincaid realized he had served a good life and, if this was the end, he could meet his death satisfied. That epiphany flushed away his fear, enabling him to ghost and mortally wound the Ursa. Prime Commander Cypher Raige offered Kincaid membership as a Ranger and personally saw to it that the rules were revised, lifting the archaic restriction on prosthetics. Kincaid, though, realized he was content with his life and rejected the offer. The door has remained open should he change his mind in the future.

JON BLACKBURN: A Ranger, Blackburn had volunteered for an experimental procedure that involved excising the amygdala portions of his brain, where a person's fear centers reside. While his fear was excised, it turned out his other emotions were truncated, leaving him unable to laugh, cry, or experience the joys and sorrows of regular life. His memory was also severely affected, leaving him feeling nothing at all. The Primus visited the afflicted Ranger and was disappointed to see what science had done to the soul. After all, at this point Blackburn had as much in common with other human beings as he did with his cutlass. While he was able to ghost, his lack of feeling cut him off from his fellow man so deeply that he went into exile in an effort to restore his lost humanity.

CADE BELLAMY: Bellamy was orig[inal]ing his living trading in Nova Prim[...] black market and had raised reck[...] the level of an art form. Bellamy's [...] life was upended when the United [...] Corps broke up his latest illegal t[...] but everything changed when an Ursa suddenly attac[...] apathetic approach to life had resulted in such a dis[...] himself that fear wasn't something he felt anymore. [...]

ignored him and went after the Rangers, allowing Bellamy to grab a fallen cutlass and use it to seriously wound the creature. Rather than arrest him, the surviving Rangers offered Bellamy amnesty for all past misdeeds if he agreed to become a Ranger and put his natural gift for ghosting to good work. Training proved harder than anticipated and he hadn't foreseen the resentment his "easy" recruitment engendered among the other cadets. Allies proved hard to come by, and when his only friend perished in battle, it became a turning point. The Corps was ready to wash him out, but he refused to go, insisting he needed a second chance. The despair of losing his only friend in battle—an anger borne out of knowing what it means to love someone other than himself—allowed him to ghost. Bellamy made the most of it, rising to the rank of Commander.

ABOVE It is unknown who the next ghost will be, but we rema[...]
INSERT Reproduction of a page from Prime Commander Cyph[...]

THIS IS A CAUTIONARY NOTE. PERSONAL VENDETTAS DISTRACT A RANGER FROM HIS MISSION.

MOBY DICK 183

→ Small reason was there to doubt, then, that ever since that almost fatal encounter, Ahab had cherished a wild vindictiveness against the whale, all the more fell for that in his frantic morbidness he at last came to identify with him, not only all his bodily woes, but all his intellectual and spiritual exasperations. The White Whale swam before him as the monomaniac incarnation of all those malicious agencies which some deep men feel eating in them, till they are left living on with half a heart and half a lung. That intangible malignity which has been from the beginning; to whose dominion even the modern Christians ascribe one-half of the worlds; which the ancient Ophites of the east reverenced in their statue devil;—Ahab did not fall down and worship it like them; but deliriously transferring its idea to the abhorred white whale, he pitted himself, all mutilated against it. All that most maddens and torments; all that stirs up the lees of things; all truth with malice in it; all that cracks the sinews and cakes the brain; all the subtle demonisms of life and thought; all evil, to crazy Ahab, were visibly personified, and made practically assailable in Moby Dick. He piled upon the whale's white hump the sum of all the general rage and hate felt by his whole race from Adam down; and then, as if his chest had been a mortar, he burst his hot heart's shell upon it.

It is not probable that this monomania in him took its instant rise at the precise time of his bodily dismemberment. Then, in darting at the monster, knife in hand, he had but given loose to a sudden, passionate, corporal animosity; and when he received the stroke that tore him, he probably but felt the agonizing bodily laceration, but nothing more. Yet, when by this collision forced to turn towards home, and for long months of days and weeks, Ahab and anguish lay stretched together in one hammock, rounding in mid winter that dreary, howling Patagonian Cape; then it was, that his torn body and gashed soul bled into one another; and so interfusing, made him mad. That it was only then, on the homeward voyage, after the encounter, that the final monomania seized him, seems all but certain from the fact that, at intervals during the passage, he

I HAVE TRIED AGAIN AND AGAIN TO DRUM THIS SENTIMENT INTO KITAI. ANGER, LIKE FEAR, IS A DEADLY DISTRACTION AND HAS NO PLACE IN A RANGER'S HEART

OLD-STYLE SHORT GUN FOR FIRING BOMBS AT HIGH ANGLES, WE NEVER USED THIS ON NOVA PRIME.

THIS REFERS TO EARTH'S AFRICAN CONTINENT, SPECIFICALLY CAPE HORN AT ITS TIP WHERE THE WEATHER WAS DANGEROUS AND UNPREDICTABLE, SIMILAR TO REGIONS HERE ON NOVA PRIME.

KITAI RAIGE: Son of the original ghost, Cypher Raige, the thirteen-year-old attempted to join the United Ranger Corps in 1000 AE but was passed over due to his impulsive nature. The young man had much to prove in the wake of his older sister Senshi's death just three years before. She was a Ranger herself, carrying on the family tradition, when an Ursa attack in 995 AE resulted in one of the creatures entering the Raige home and killing her as she protected her brother. While Kitai was accompanying his father on a trip to Iphitos, where the Prime Commander was scheduled to supervise training, a powerful meteor storm resulted in their ship crashing on Earth. Both Raiges were the only survivors of the crash and the Prime Commander was critically injured. It fell to Kitai to traverse the hostile environment to locate the rear of the spacecraft and the spare emergency beacon. He then had to climb high enough to pierce an ion veil that blocked the signal. The Ursa had also survived and had locked in on Kitai's scent. Despite his inexperience, Kitai mastered his conflicting emotions and finally came to understand that Senshi's death was not his fault; he was too young to protect her. Now, though, he could protect his father. It was this realization that helped him find the will to control his emotions and kill the beast.

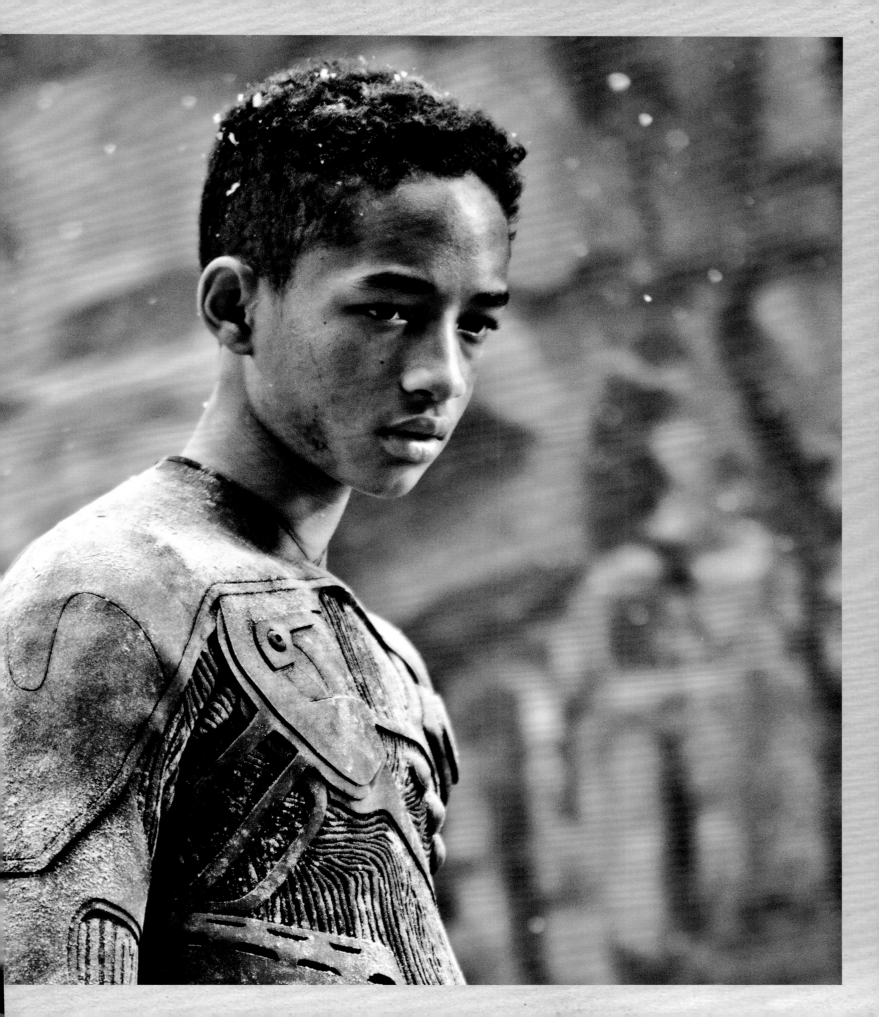

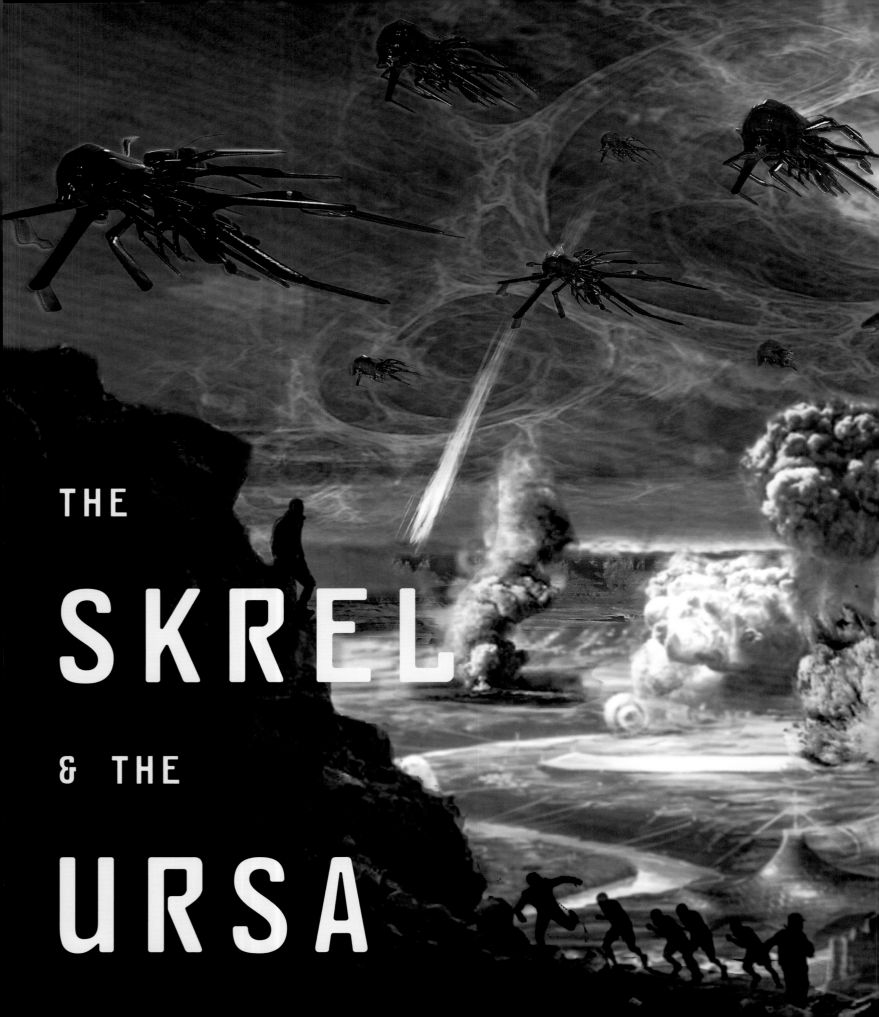

THE
SKREL
& THE
URSA

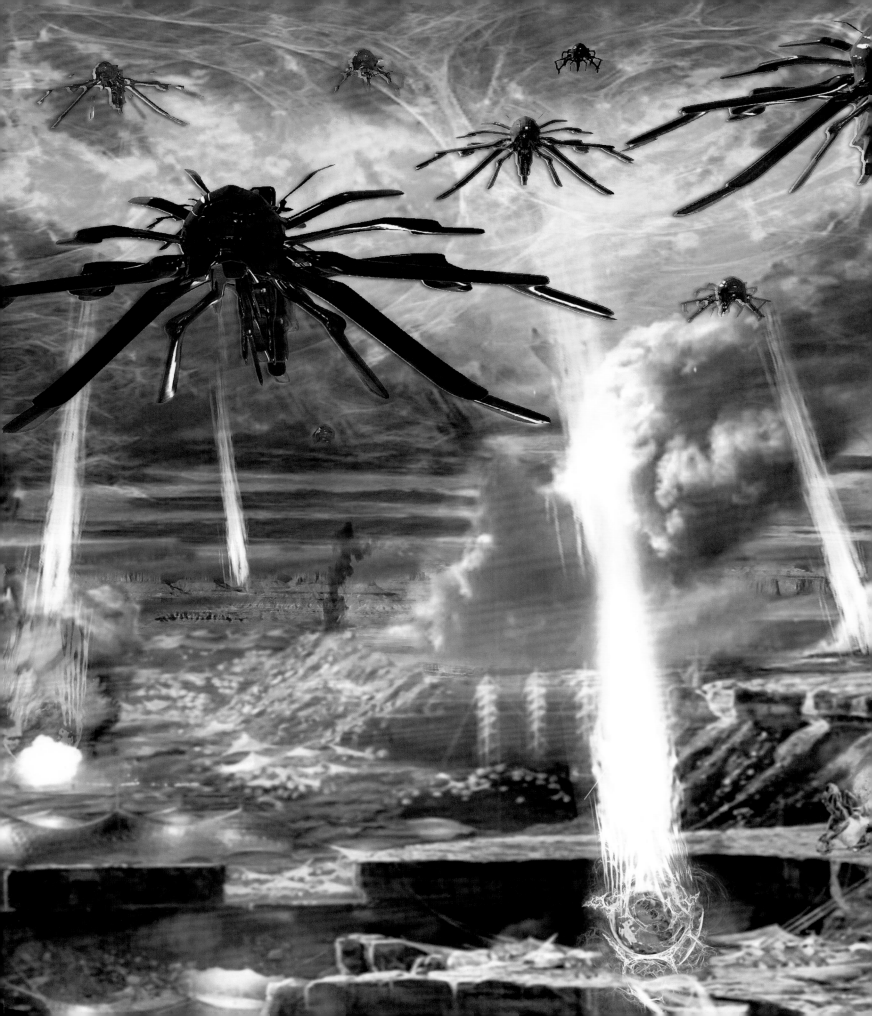

THE SKREL

A NOTE FROM COMMANDER VELAN

We had no knowledge of the Skrel before we left Earth or during our voyage between the original homeworld and our new planet. The first attack came as a terrible surprise and the Skrel have since proven themselves to be tenacious and crafty. As a result, Rangers must remain in a constant state of alert since we can never predict when the Skrel may return. While they have ceded the land war to their Ursa, we can never lessen our vigilance and always have to anticipate that the Skrel themselves may be back. We had always hoped we were not alone in the universe, but no one could have predicted that our first contact with another sentient race would be both so enigmatic and hostile.

OPPOSITE This artist's interpretation depicts two fearsome Skrel ships in the skies over Nova Prime City.

HUNDREDS OF YEARS AFTER an alien spacecraft crashed in Russia, the public was still in the dark over the incident, and debate over the existence of other life in the universe still raged. This controversy was settled the dark day the Skrel fleet arrived in the skies over Nova Prime City. Despite steep odds, the Rangers defended the populace and the alien threat was routed. Little Skrel technology survived the battle, robbing scientists of a chance to thoroughly study the enemy. Only in the aftermath of this devastating attack were the humans on Nova Prime told about the alien origins of Lightstream technology.

No one has yet seen a Skrel, and no information exists on where they hail from. What is clear is that they want humankind eradicated from Nova Prime and the reason why remains a hotly debated point of contention.

When it was selected during Earth's final years, astronomers were absolutely certain that Nova Prime was a world without intelligent life. Those studies were confirmed when the three arks first arrived, and over the last several centuries, geologists have sought in vain to find evidence civilizations ever flourished on this world.

As a result, the arrival of the Skrel in the skies over Nova Prime came as a total surprise. The United Ranger Corps in 243 AE relied entirely on fusion-burst cannons for defense but they proved ineffective against their hulls. Metallurgical studies of the fragments found after the initial attack yielded mystifying results: alloys of a type never seen before, fueling fresh speculation regarding how far across the universe the Skrel had traveled.

Many believe that perhaps there had to be a reason they showed up when they did, blackening the sky with their ships. Maybe they were monitoring us, waiting for the right moment to strike. In truth, we still have no idea.

Carter Raige, an ancestor of Cypher Raige who, like his descendant, would grow up to become a Prime Commander, was in the canyons beyond Nova Prime City when the ships arrived. The first to be close enough to read the alien characters on the ships, he reported back that they read *Skrel*, and so the enemy was named.

That devastating days-long attack confounded the Rangers, commanded at the time by Patrick Wulf. The troops braced themselves for a ground assault to follow the airstrikes, but it never came. In the end, not a single Skrel vessel intentionally landed on the surface.

Instead, the Skrel bombarded Nova Prime City and the outlying colonies with a soul-crushing death toll. What baffled the tactical experts was how selective the shots were, attacking the man-made structures and almost reverently leaving the world itself untouched. That alone saved countless lives.

The Rangers were stymied and the people were panicking. The Primus, M'Liss Cornetta, told the worshippers seeking answers, "We have strayed, my friends. We have strayed from the precepts our people have long embraced. And *this* is the result. Death. Destruction. The pain of knowing our loved ones are lost to us. But remember—this is *not* the first time we have been tested. Our ancestors took off from Earth with nothing but the unknown ahead of them. Despite everything, they survived. And we will survive as well—by finding the strength our ancestors discovered on the arks. We have grown complacent, my friends. We allowed ourselves to believe that we have conquered every challenge—that we were the masters of our house. But there is always someone greater."

While the Primus saw it as some form of cosmic punishment, the Prime Commander wondered if the planet held some strategic importance, implying other life lurked among the stars

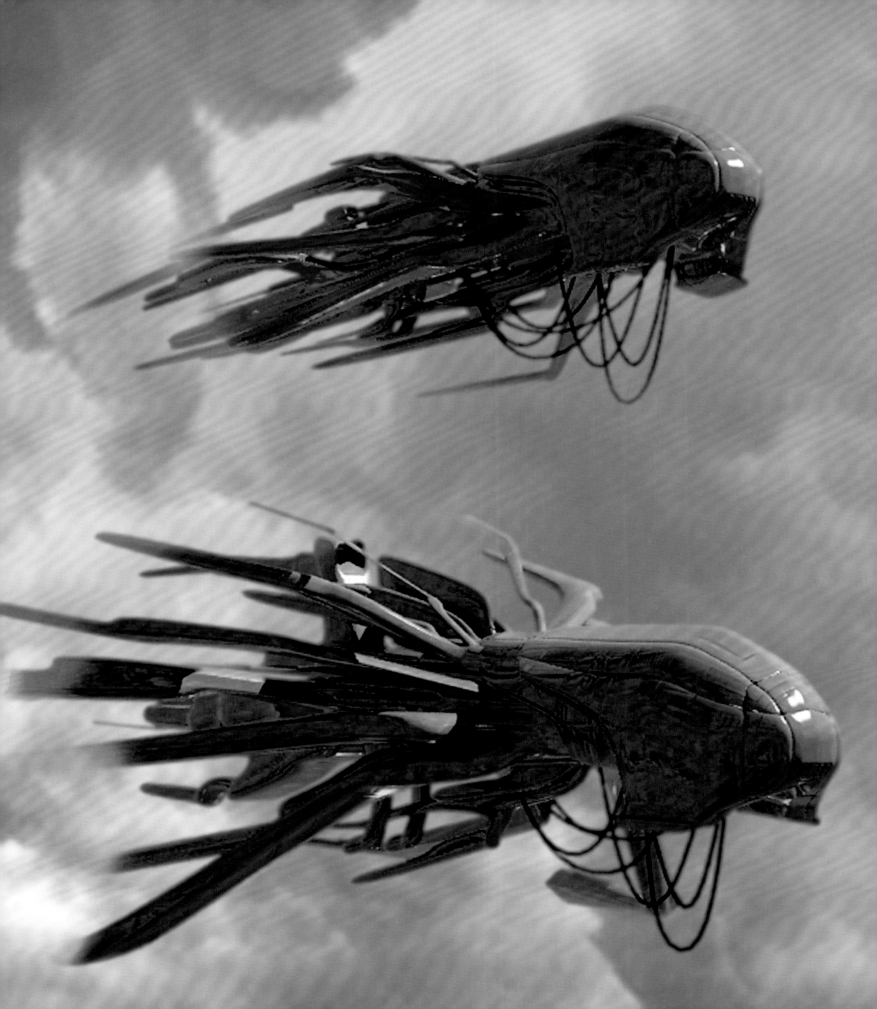

and posed new, unimaginable threats for the people. Savant Bree Kincaid conjectured the technology on display didn't match that of the alien race that accidentally bequeathed Lightstream technology to humans, but she saw the attack patterns as showing an almost reverent desire to leave the world's ecosystem untainted. Could the Skrel be some sort of intergalactic police force?

During those dark times, Carter Raige was convinced he saw a Skrel vessel crash, and his father, Jason Raige, led combat flyers in search of the wreckage, hoping to find clues as to the enemy's appearance, intentions, or technology. While the flyers found nary a piece of shrapnel, Carter Raige went deep within a crevasse where he soon found the ship. What he discovered of the craft was badly burned, while its crew had been incinerated, depriving Savant Kincaid of alien corpses to study. Carter Raige, though, found intact, pulsing modules that he took from the ship and brought back to the Savant.

Those modules tuned out to be energy-field generators that were capable of blocking up to 80 percent of the fusion-burst cannon fire. Additionally, studies showed the fields also interfered with the Ranger flyers' sensors, which explained why the aircraft never located the wreckage.

When studies showed the fusion-burst cannons would remain ineffective against the Skrel, Savant Kincaid accepted her cousin Jack Kincaid's recommendations, and that turned the tide. As soon as the quantum-trapping weapons were deployed, the Skrel were speedily shot down. Within a day, the remaining Skrel ships withdrew from Nova Prime airspace and vanished.

While the new weapon was modified into what has become the cutlass, the alien energy modules served as a warning that humanity now had an enemy with unknown motivation and superior technology. Preparation became the new watchword for the United Ranger Corps. Starting with Savant Bree Kincaid and her successors, efforts were made to begin salting the planetary system with satellites that would act as early warning beacons. Resources were diverted to study the Skrel's approach and retreat, trying to determine where in the galaxy they had come from, which might suggest their motivation for attack. Additional concerns were raised over whether or not other races were out there and which ones might also harbor designs on Nova Prime or humanity.

What was certain is that the technology displayed by the Skrel was different enough than that found on the spacecraft that crashed on Earth centuries earlier to suggest there were now three known sentient races populating the universe.

Jason Raige, who succeeded Wulf as Prime Commander, reconfigured the United Ranger Corps, creating an Elite Response Squad that would be prepared to defend humankind should the Skrel return. Additionally, Response and Recovery Squads were created to deploy wherever the Skrel attack. Based on their study from the initial attacks, unscheduled drills occurred with brutal regularity until Raige was satisfied the people would be protected.

It was not until 350 AE that the Skrel returned. The attack was brief but destructive. What turned out to be robotic drone craft arrived, fired, and self-immolated. There was still significant loss of life, including that of Prime Commander Esteban O'Hara. How the Skrel eluded the satellite system was of concern, and in the aftermath Savant Tak Kawasaki insisted the entire fleet of satellites be upgraded or replaced in addition to doubling their number.

Additional studies during the years following this brief attack yielded nothing concrete about the Skrel.

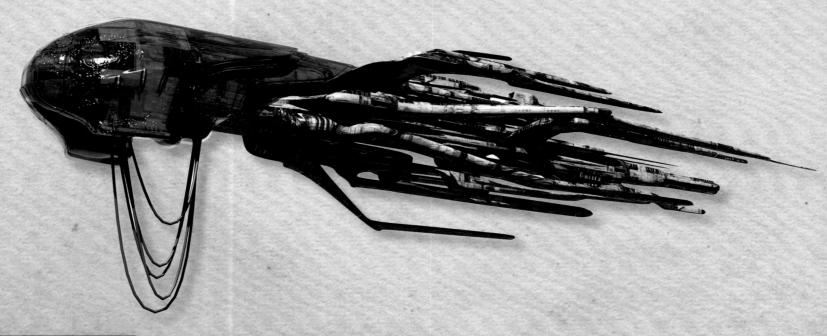

They had clearly not been idle, though, as they did return, bringing the Ursa with them.

Ever since that first infiltration of Ursa in 576 AE, the Skrel avoided direct attacks on Nova Prime until an unexpected and particularly brutal attack in the early tenth century AE. Nothing about the assault matched the few previous events, confounding military strategists. It was repelled but not before a wide swath of destruction befell our major cities. The Skrel's long-standing enmity toward humanity remains the subject of academic speculation and has spawned countless works of fiction about who they are and what they desire.

The United Ranger Corps remained vigilant, drilling and training to protect the growing human race on Nova Prime and its colony worlds. The operating theory remained that the Skrel are an ever-present danger and consistent threat to our well-being. Regardless of the Skrel's motivation, the Rangers will continue to fight to the last man or woman to safeguard humanity.

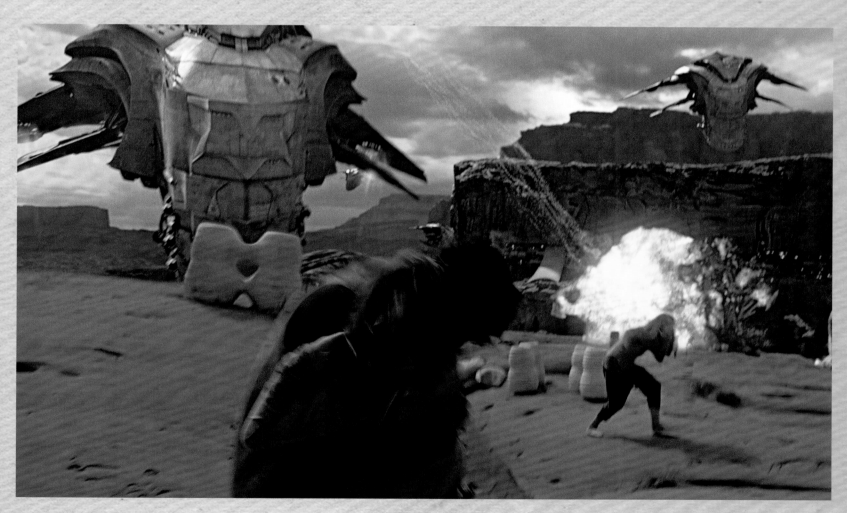

OPPOSITE This is an example of the Skrel warship that attacked in 243 AE. When the Skrel returned unexpectedly in 933 AE, it was noted how little their design had changed. TOP The coloring and lighting of the Skrel ships, plus the Ursa's lack of eyes, has led the Savant to believe the Skrel themselves may lack optical organs, seeing the world in some unfathomable manner. ABOVE Skrel ships make fiendishly precise attacks on the people of Nova Prime, while leaving the surrounding area untouched, for reasons that remain a mystery.

THE
URSA

A NOTE FROM COMMANDER VELAN

It used to be that the United Ranger Corps existed to protect humankind from itself, preserving the species. Then, we were forced to add the Skrel to our agenda, followed every few centuries by yet another wave of their monstrous creations, the Ursa. Over the last few decades, these foul creatures have taken hold on Nova Prime, becoming our deadly neighbors. As a result, under Prime Commanders Atlas Kincaid and Cypher Raige, our training regimen has been modified to emphasize cutlass use along with understanding how a team of eight can subdue and kill an Ursa. The training is rigorous and one of the few areas where failure to meet expectations will mean automatic dismissal from the program. Make no mistake, underestimating these omnivorous engines of destruction will bring your career to a bloody end.

The Ursa were genetically engineered to hunt and kill humans. The Skrel studied us and determined the common denominator shared by all humankind is fear. The Ursa see humans based on the pheromones we secrete when frightened. They smell our fear. Once an Ursa imprints on an individual, it will hunt that person until it has killed that person.

THE DEADLIEST PREDATOR ON NOVA PRIME, the Ursa is a genetic creation of the Skrel, bred specifically to kill human beings. For nearly five hundred years, the Ursa have been modified and upgraded to be deadlier than the generation before. How the Skrel have learned so much about humankind remains a cause for speculation, but Rangers have to concern themselves only with being prepared to fight and destroy them.

Much as we do not know what the Skrel call themselves, we do not know their word for the Ursa. They were given this name by a member of the Savant's team during their first incursion. The creatures reminded him of *Ursus arctos horribilis*, the grizzly bear, and the shortened form of the Latin name stuck.

At the time of this edition, only three Ursa have been captured alive. Each has been placed in a biostructural organic armor, strapped and suspended in a gel that inhibits their sense of smell while within the pod. Each Ursa has been taken to a holding facility on Iphitos, far from the civilian population.

Experience shows that it takes eight dedicated, motivated, and highly trained Rangers to kill one Ursa. The method was based on the ancient Roman fighting style to attack and withdraw in formation, constantly barraging the beast with weaponry and keeping it from successfully lashing out in any one direction. This battle tactic is the one requiring the most hours of practice because the formation must be flawless. As a result, when an Ursa is sighted, predetermined squads of eight are assembled for action. Rangers will move together—if not, they will die together. Each one is responsible for the other seven members of their team.

Drill instructors make it clear during the holographic simulations used in cadet training that mastering your emotions can save your life. To fail is to fail humanity. The main attributes of the first generation of the Ursa were strength and ferocity. It was carnivorous with an almost insatiable hunger, had four clawed appendages, and was sightless, as we presume its creators, the Skrel, are also. Lacking ocular vision, they tracked humans through a sense of smell estimated to be more than a hundred times more acute than that of humans.

Three dozen of the creatures were released on the surface of Nova Prime in 576 AE. The citizens, who initially had no adequate defense against the creatures, were slaughtered at every turn until the Rangers found weaknesses that could be exploited.

In an effort to refine their killing machine, the Skrel improved on their work, adjusting the skeleton to be a hollowed-out bone structure that would allow the Ursa to move more quickly and with less energy expenditure. Also, additional joints were added for the sake of flexibility, along with muscle. But they also removed one of the legs, letting the forelegs do most of the attacking while the thicker rear leg would provide stability or be used almost like a scorpion's tail.

Another three dozen specimens were sent to Nova Prime in 651 AE. The three-legged configuration was baffling, but the Ursa's undiminished ferocity soon convinced the Rangers they were no less deadly. It did require significant changes in the Rangers' battle tactics though, slowing their initial successes.

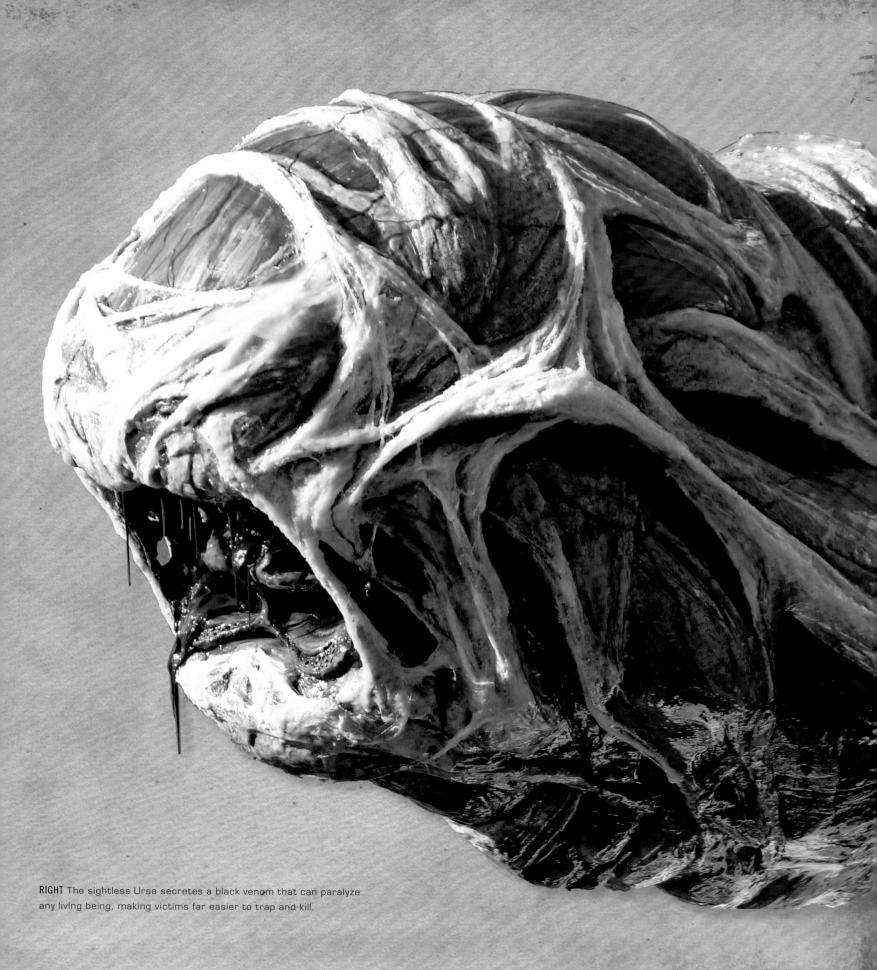

RIGHT The sightless Ursa secretes a black venom that can paralyze any living being, making victims far easier to trap and kill.

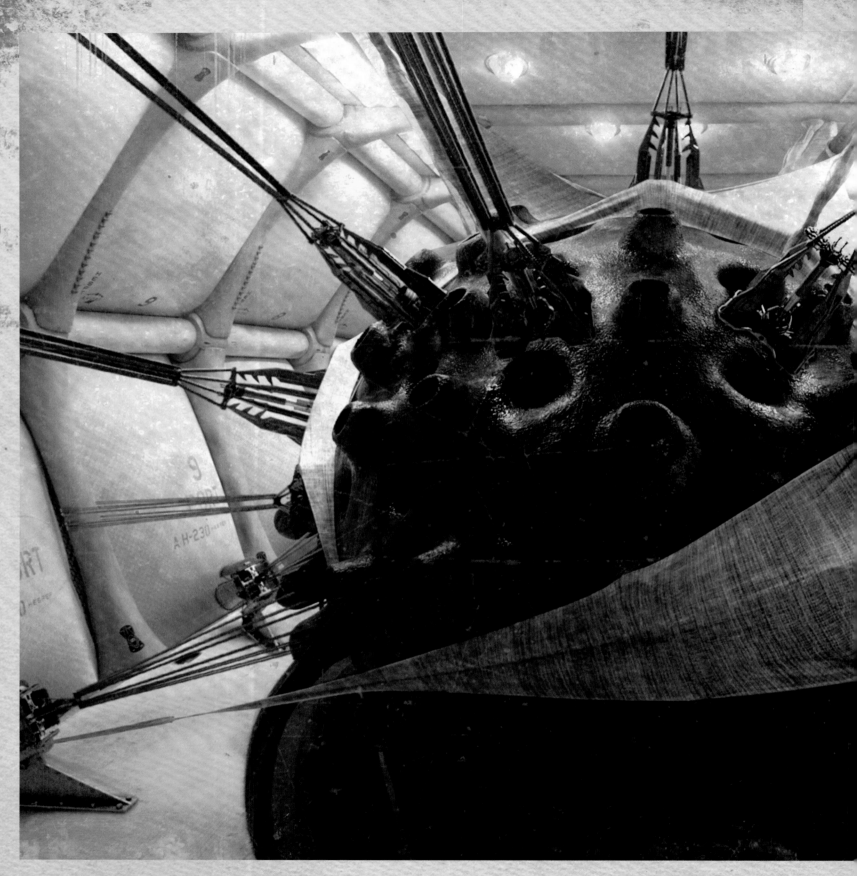

ABOVE Organic pods, filled with anesthetic gel, keep an Ursa alive for study and create a perimeter, outside of which the Ursa cannot smell a human's fear.

However, the Rangers were better prepared for the Ursa attack this time and prevailed against this wave as they had the first one.

The Skrel clearly went back to the drawing board, reverting to the four-legged configuration, adding two armlike appendages and sharpening the Ursa's claws, wrapping the bony protuberances with densely packed keratin. They again upgraded the Ursa's musculature. But more importantly, they gave the creature the ability to secrete and spew black, oily venom from glands in its mouth. This venom, when it makes direct contact with the skin, is capable of paralysis.

Five dozen Ursa were dispatched to Nova Prime, making planetfall in 726 AE and wreaking havoc and heartbreak. However, the United Ranger Corps again proved equal to the task of eliminating them.

By this time, the Savant's biologists determined that the Ursa were genetically manufactured specifically to deal with human beings. Much as antibodies are tailored to specific infections, the Ursa have been constantly upgraded to more successfully attack human beings.

Somehow, the Skrel determined that humans excrete pheromones when fearful and designed the Ursa to lock in on that scent. The pheremonal targeting made them exceptionally dangerous to humankind since almost everyone experiences fear at some point or another.

The other major advancement in the Ursa development program appeared to be that, for the first time, they were capable of reproduction. Clearly, the intention was to make the Ursa self-perpetuating and a permanent part of the planet's ecosystem. Examinations of corpses indicated they were designed to reproduce asexually.

Six dozen, in two waves of three dozen each, arrived in 801 AE, cutting a wider swath of destruction than any of the other iterations, but they weren't quite the ultimate predator the Skrel had expected. Recognizing the threat posed by reproductive Ursa after several specimens were dissected, the mandate of the United Ranger Corps was to destroy the last of the predators before they had a chance to multiply.

The fifth generation of Ursa saw the introduction of a new kind of venom, corrosive enough to eat through human flesh and bone. Another was a more efficient digestive system that allowed anything the Ursa consumed to be converted immediately into energy. In addition, this new generation was faster and stronger and able to leap higher than its predecessors.

Perhaps the biggest change was that the Ursa could now camouflage themselves. The Skrel had added chromatophores under each layer of Ursa skin and placed a transparent outer layer on top of them all. The Ursa now had the ability to blend into their surroundings, remain effectively invisible until their human prey was almost right in front of them—and then attack.

THE EVOLUTION OF THE URSA

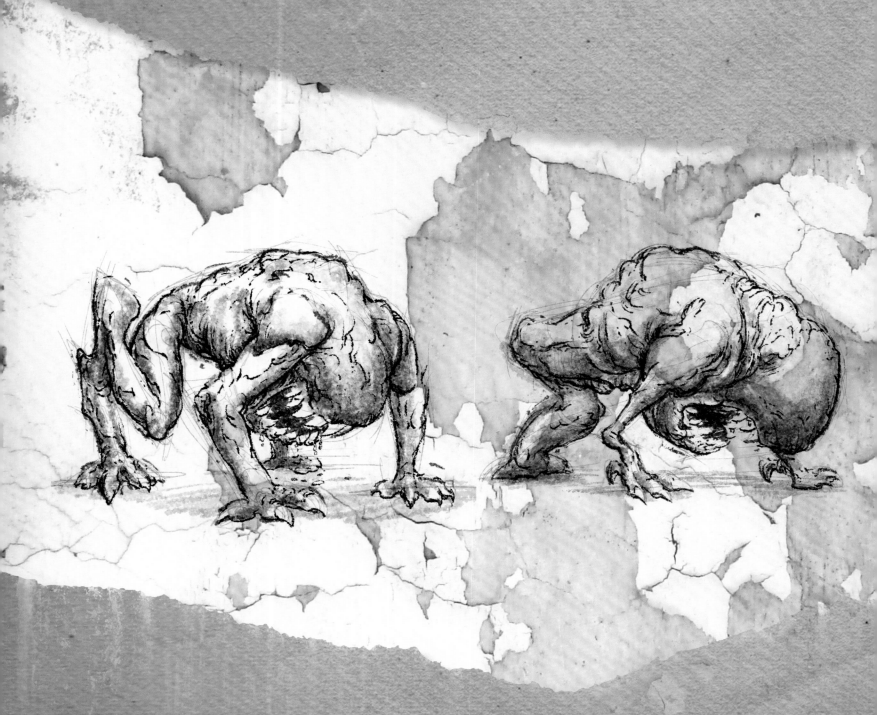

The first Ursa, arriving in 576 AE, were four-legged engines of utter destruction, and it was not until the invention of the cutlass that they could be eliminated.

The second iteration of the Ursa was a three-legged model that was designed for speed and maneuverability. It clearly failed, as the Skrel went back to making both four-legged and six-legged versions.

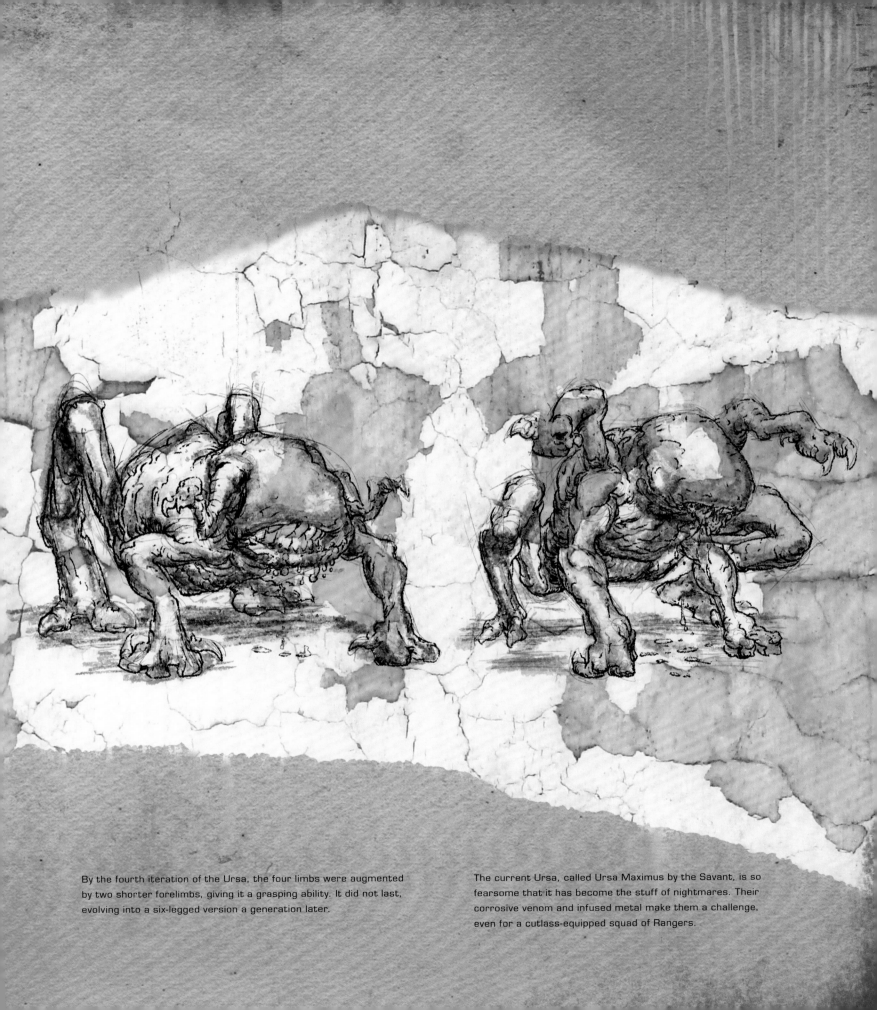

By the fourth iteration of the Ursa, the four limbs were augmented by two shorter forelimbs, giving it a grasping ability. It did not last, evolving into a six-legged version a generation later.

The current Ursa, called Ursa Maximus by the Savant, is so fearsome that it has become the stuff of nightmares. Their corrosive venom and infused metal make them a challenge, even for a cutlass-equipped squad of Rangers.

This new generation of Ursa, a hundred strong when it landed in 876 AE, was more fearsome and more deadly. The residents of Nova Prime were endangered as never before. But they were also more heavily populated and better equipped. Despite heavy losses, the Ursa continued to survive, however, and it took the Rangers more than a decade to destroy all one hundred improved Ursa and the first of their offspring.

By the time the next generation of Ursa was introduced to Nova Prime, the Skrel had carried out a massive redesign of the Ursa's skeletal structure, raising the body off the ground with four elongated limbs. Some form of metal was bonded at the molecular level with the Ursa's organic skeletal structure. This took the form of a virtually indestructible carapace that protects the Ursa from our weapons in all but a couple of places—specifically, a small spot on the creature's back and a larger area beneath it.

The Ursa's venom was made thicker and more corrosive and now manifested in the form of black globules that could stick to even a metallic surface and burn through it.

This breed of Ursa was bigger as well. It towered over the tallest human and outweighed him by at least 90 kilos. Still, at a full run, it is far faster than a human and can easily outrun you with its overall enhanced endurance.

At the same time, the creature's sleeping time was reduced. Rather than requiring a full night's rest, these Ursa needed only five one-hour rest periods per Novan day.

One hundred specimens of this new breed of Ursa landed on Nova Prime in 951 AE and, benefiting from their ability to imprint on their targets, laid waste to everything in their path. The imprinting was new, targeting a single person's fear pheromone and becoming the beast's sole target until it was destroyed. Caught off guard by the improvements in the Ursa, even experienced Rangers became easy prey. Winning most encounters with the humans, the Ursa survived long enough to reproduce this time.

Of the hundred Ursa sent to Nova Prime, eighty-eight were killed over time. Twelve remain unaccounted for. They have since bred and launched numerous attacks on humans in and around Nova Prime City. Among their victims during this time was nineteen-year-old Ranger Senshi Raige, daughter of the Prime Commander. Despite scouting parties and drone aircraft, the enclaves of these now-native Ursa have remained elusive, allowing the Ursa numbers to swell over time.

Recently there have been repeated waves of Ursa attacks on the city, notably the attack in 997 AE that led to the "birth" of several new ghosts.

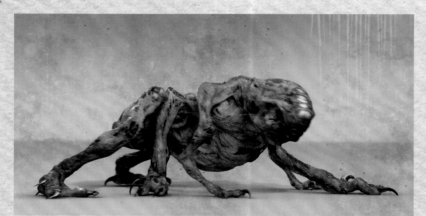
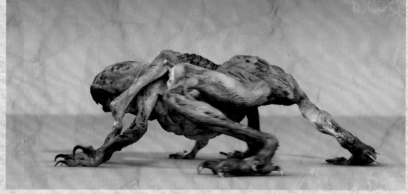
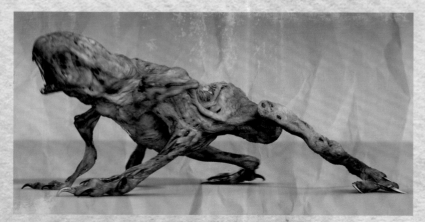
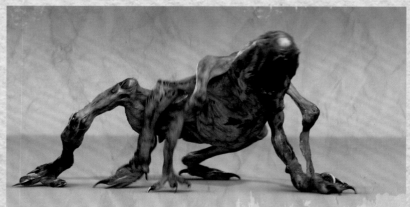

ABOVE Various views of the fearsome Ursa. OPPOSITE Kitai Raige exercises caution around a broken Ursa pod following his crash landing on Earth.

THE URSA ★★★★★★
ON EARTH

When the third Ursa to be captured by Rangers was transported from Nova Prime, it wound up accidentally crash-landing on Earth. After-Action Reports by Prime Commander Cypher Raige and Ranger Kitai Raige indicated the Ursa had little trouble adjusting to Earth's increased gravity. Similarly, it had no trouble blending in with Earth's color palette, as the Ursa's chromatophore array is adaptable to any environment.

The Ursa requires oxygen to metabolize what it eats and turn it into energy at a cellular level. The oxygen content in Earth's atmosphere is only about 15 percent, as compared with the 21 percent to which humans were accustomed in the latter part of the twenty-first century AD. The Ursa would feel that difference without benefit of chemical assistance.

The Ursa would also have felt the impact of Earth's subfreezing nighttime temperatures, which are drastically different from the dry heat the creature was designed to endure on Nova Prime. It would not suffer as much as a human being would, thanks to its accelerated metabolism, but it would still be affected. If it were lucky enough to find a hot spot, it would welcome not only the heat but also the plentitude of prey.

Though the Ursa has a hardy constitution, there is nothing in its makeup to keep it from falling victim to toxins; in that regard, it is like any other organism.

In the same vein, the Ursa might be plagued by bacteriological parasites it has not encountered before, which may be present in the prey whose flesh it eats. As a result, its entire digestive system might be compromised.

It is also possible that the Ursa's water supply on Earth would contain poisons of one kind or another. The indigenous fauna might have acclimated to these poisons, but the Ursa has not. Metals like mercury and lead wreak havoc on human nervous systems, causing lethargy, cognitive problems, and death over time. In the Ursa, with its high rate of metabolism, the onset of these problems may be sped up. With all these challenges to deal with, the Ursa may require more rest on Earth than it does on Nova Prime.

SPACE
TRAVEL

A NOTE FROM COMMANDER VELAN

Over the last century, space travel has achieved a commonplace role in Novan society. Back on Earth, any hope of exploring beyond its moon and Mars was abandoned as the Ark project commenced. Wanderlust, though, has remained a part of our makeup and we now travel from our homeworld in an attempt to uncover the mysteries of the galaxy. This can be like catnip to the Savant division, but for us it means new dangers and methods of preparation. As a Ranger, you will be studying zero-g effects on the body in addition to alterations in circadian rhythms, and you will be taken on a lunar voyage, visiting both moons orbiting Nova Prime. This will be important preparation, and many Rangers will choose to undertake additional training for voyages beyond our system to the anchorages that are maintained to ensure the survival of the human race.

THROUGH THE YEARS, the Prime Commanders, Primuses, and Savants have recognized that the Skrel want human life gone from Nova Prime. As a result, once resources were available, space exploration began in earnest in the hope that a new home for humanity could be found. Improvements to the LST technology meant slightly faster speeds, reducing travel time between worlds with wormhole bridges connecting Nova Prime to worlds in the Carina-Sagittarius Arm. These bridges between galactic arms have allowed the establishment of anchorages in habitable planetary systems acting as outposts for humanity. Iphitos, the furthest habitable world, is where live Ursa have been taken for study.

At first, the ships were small five-person vessels, designed for exploration of the planetary system and maintenance of the satellite warning array. While studying the rich asteroid belt in the planetary system, new minerals and resources were discovered, catalogued, and mined for use back on Nova Prime. This process helped minimize the ecological impact of our energy needs on the new homeworld. Asteroid mining grew into a major economic business, with catapult technology, theorized on Earth before The Departure, finally becoming reality. Pieces were literally hurled toward Nova Prime, letting physics and gravity do the heavy work of bringing the space rocks to the planet.

In time, the Savant's people secured support for larger vessels to go to nearby planetary systems for further exploration. These were studied at length, and several worlds were identified as harboring rudimentary life or being capable of it. These became outposts for Novans and a possible sanctuary should they eventually be forced from their world by hostile races like the Skrel.

The outposts were called anchorages and were deliberately kept small in scope in an effort to concentrate efforts on making Nova Prime humankind's primary home. Several anchorages were established beginning with Lycia and including Olympus, Asgard, Avalon, and Heliopolis. The farthest habitable world located as of this writing is Iphitos, which is twenty-two hours' flight from Nova Prime. Iphitos is a research outpost/station, remote enough to allow study of predators as dangerous as the Ursa.

This drive to explore the universe led to the development of a robust aeronautic business as new types of vessels were designed and built for a variety of needs. These included transports, cargo haulers, and Ranger patrol craft.

All extraterrestrial vehicles are equipped with LST technology, allowing them to pierce three-dimensional space and enter a wormhole where faster-than-light travel can happen without inertial consequences.

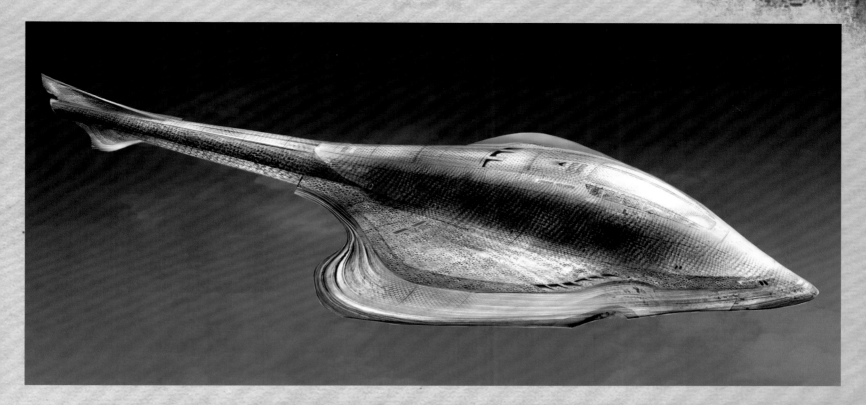

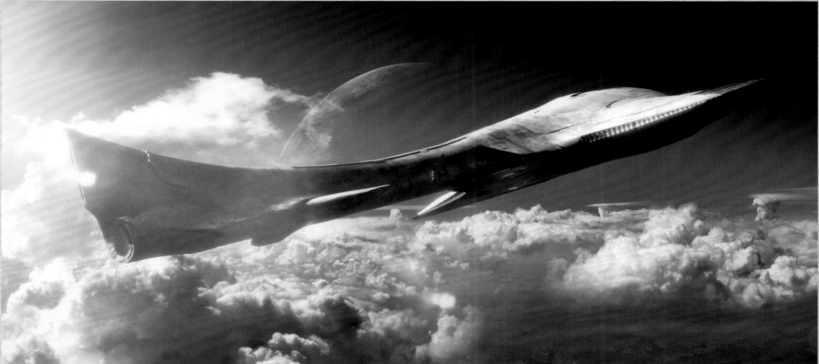

TOP The *Hesper* is the latest generation Class-C ship, capable of transiting wormhole space and accessing the anchorages along the adjacent spiral arm of the Milky Way Galaxy. ABOVE After picking up Cypher and Kitai Raige, another Class-C ship, the *Hercules*, prepares to leave Earth's atmosphere.

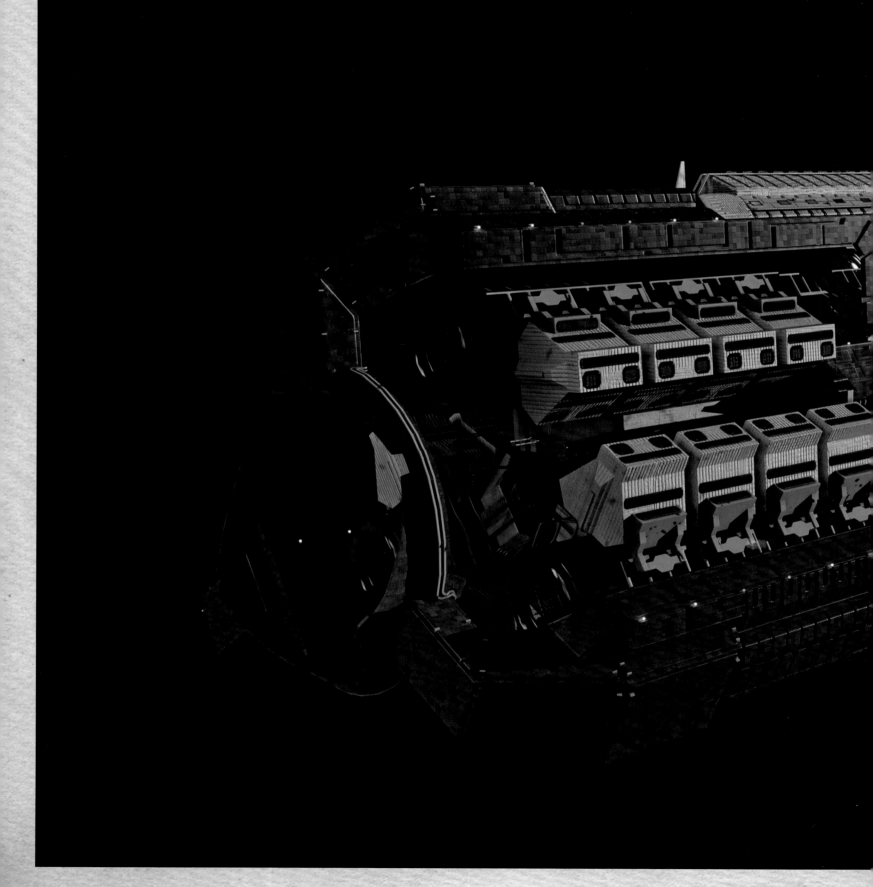

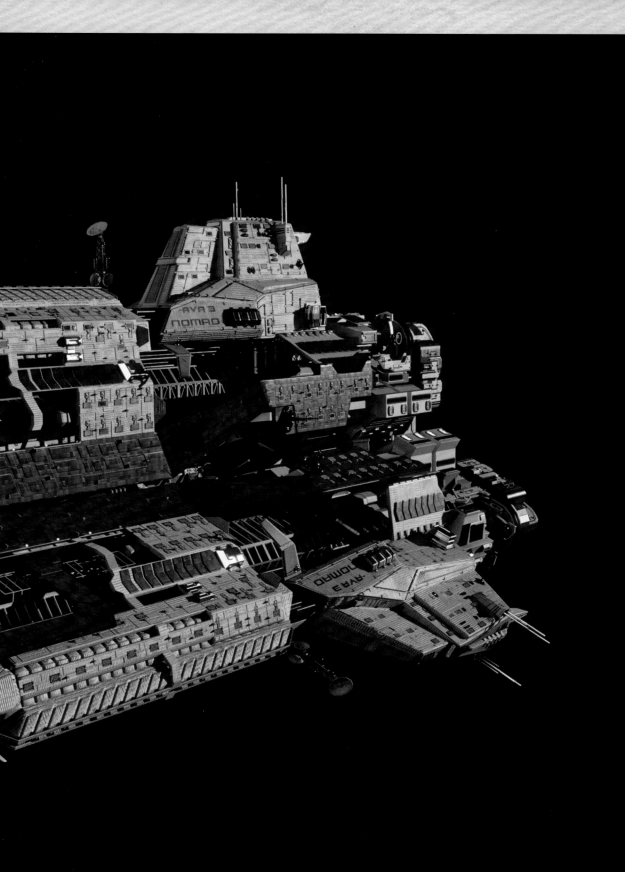

LEFT This is a close-up of one of the transport ships that seamlessly fit together with other craft to form an ark. The ships are able to enter wormhole space thanks to their powerful Lightstream Engines. While the goal had been to create ten such arks, only six were completed and launched in time.

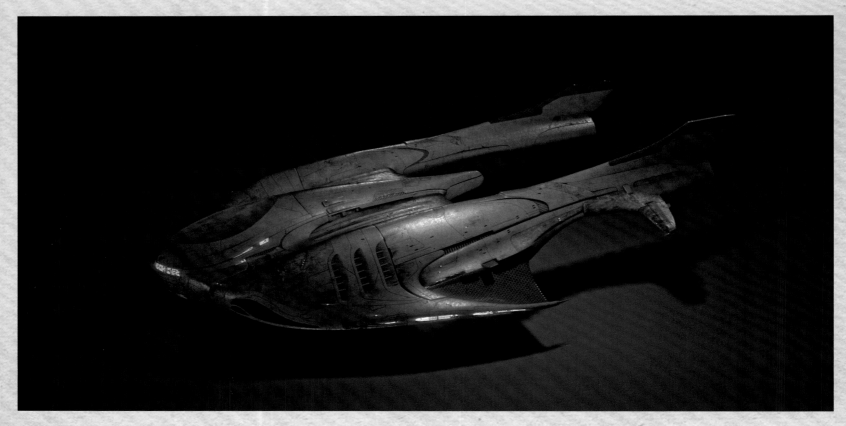

ABOVE An earlier version of a Class-C ship, now used to patrol the solar system, repairing or upgrading the satellite defense system.

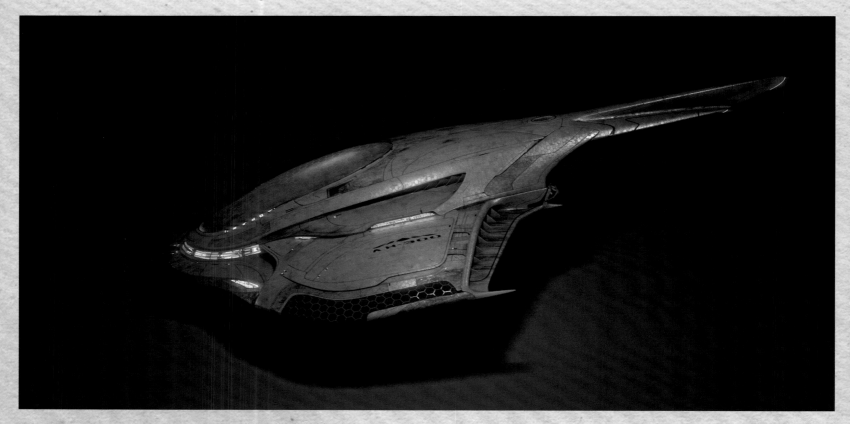

ABOVE This Class-B transport can ferry up to one thousand Rangers to a danger zone, traveling at Mach 8 without strain, thanks to its Flint Magnetic Engines.

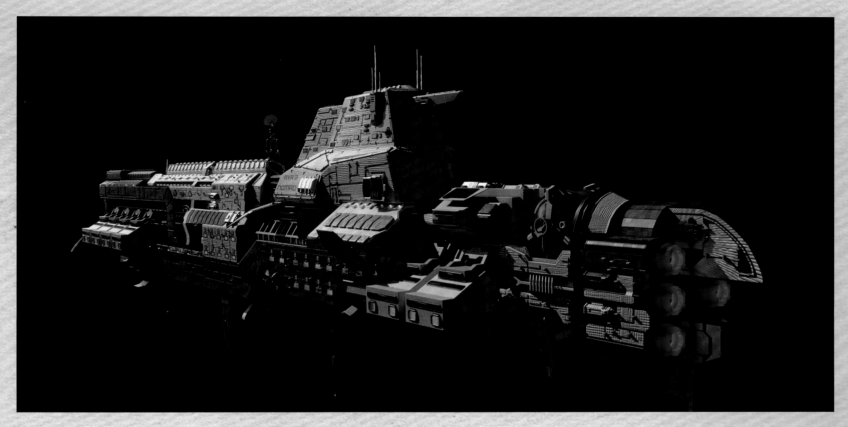

ABOVE The design of the many transport ships was unique to its cargo. This one was shaped to handle some of the largest mammals on Earth, from elephants to whales.

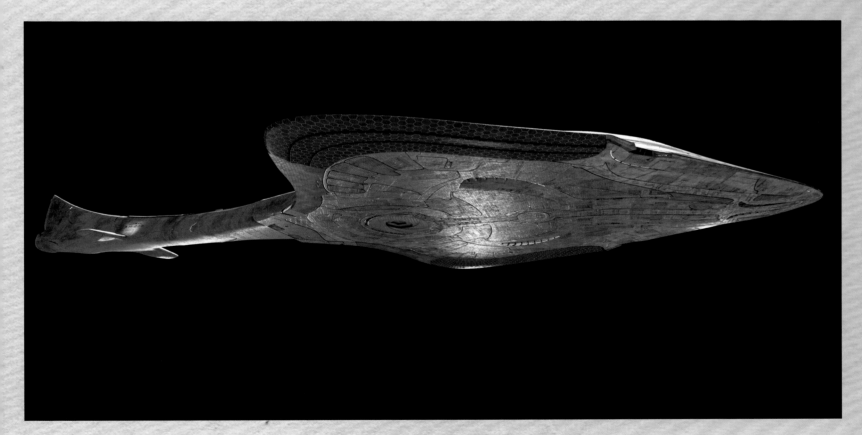

ABOVE Current plans call for the Class-C to be modified to carry smaller fighters to danger zones, be they natural disasters or Skrel attacks.

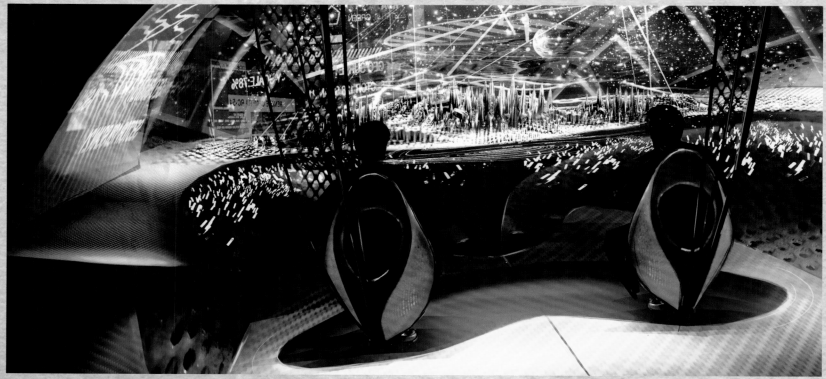

LEFT This artist's depiction of the *Hesper* shows it flying over canyon formations on Nova Prime. BELOW LEFT & RIGHT The holographic heads-up display shows not only celestial navigation but also a constant running status check on environmental and engine units. Using hard-light technology, the holographic controls respond to a touch.

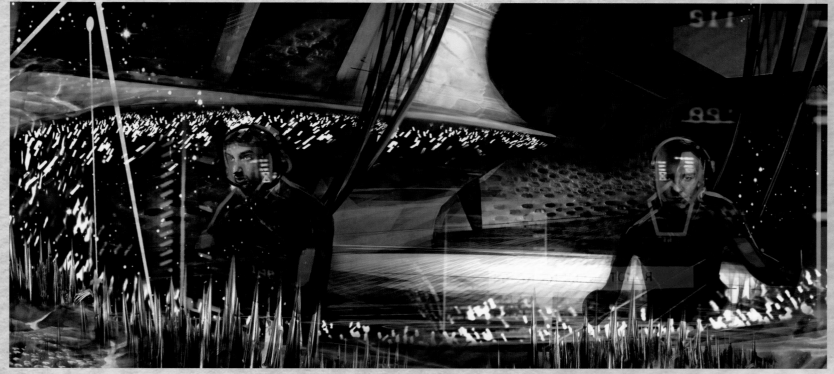

SURVIVING
EARTH

WARNING.

This planet has been declared unfit for human habitation. Placed under Class-1 Quarantine by the Interplanetary Authority. Under penalty of law, do not attempt to land.

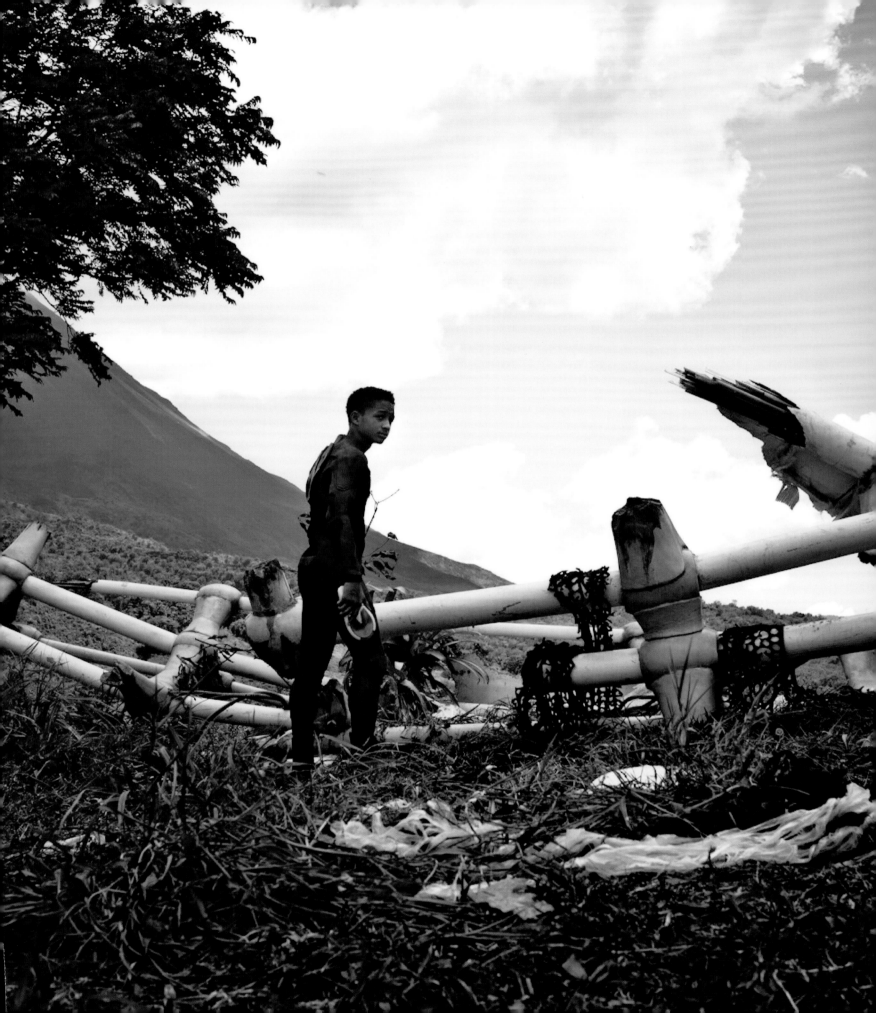

EARTH

A NOTE FROM COMMANDER VELAN

I don't think anyone expected we would return to the mother world, and such a voyage was never planned by the Rangers or the Savant divisions. However, due to an unfortunate accident, our ancestral planet was recently visited. Had it been anyone else traveling other than Prime Commander Raige and his son Kitai, it's likely we'd never know what became of the *Hesper*. Instead, we now have a treasure trove of stellar navigational information to study while the Savant's teams analyze the terabytes of data recorded during the unplanned visit. There is little likelihood this accident will be replicated, therefore the following information should be read as a series of lessons illustrating how a Ranger must be resourceful regardless of circumstance. This final lesson is a deadly reminder of how precious our ecosystem is and how it needs to be protected and preserved at all costs.

BELOW Cadet Kitai Raige holds on for his life as the *Hesper* makes a crash landing on Earth. OPPOSITE Cadet Raige regains consciousness in the wreck of the *Hesper*.

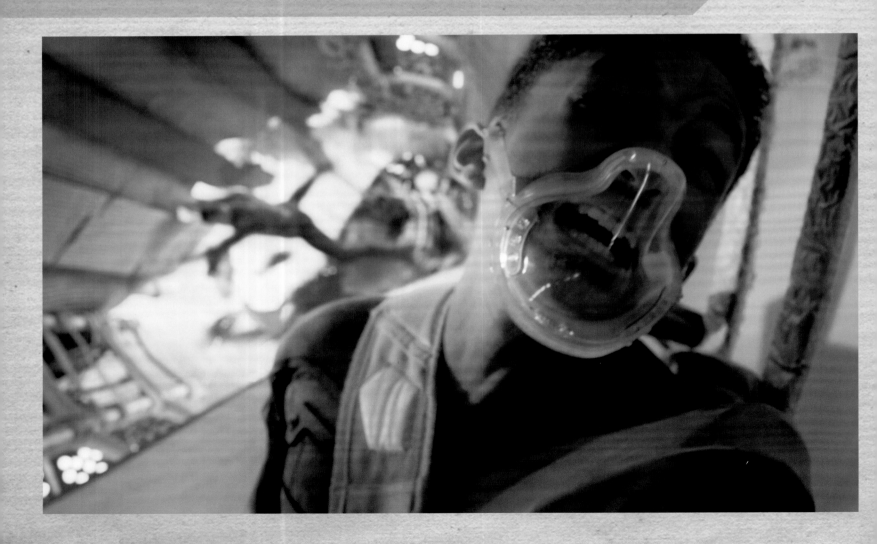

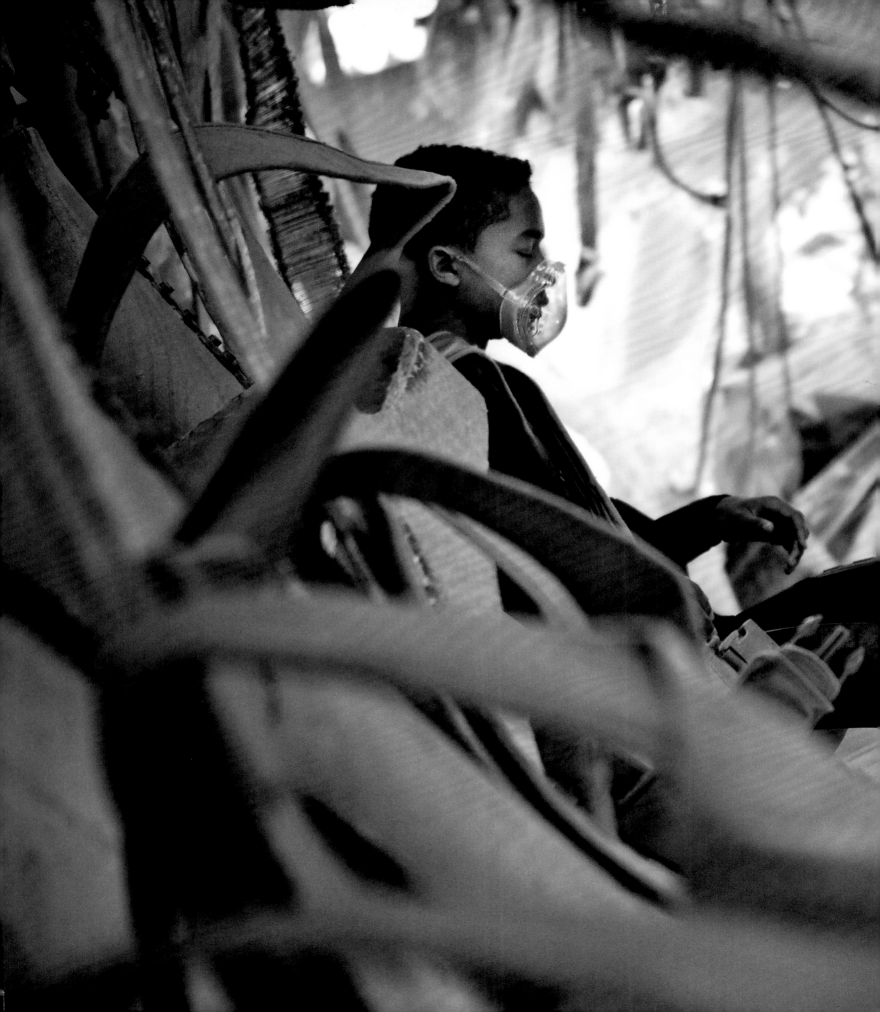

MAN'S IGNORANCE AND ARROGANCE pushed the planet along a path of destruction until a tipping point of no return was reached ahead of schedule in 2020. The next fifty years became a race against extinction, hastened along by the technology gleaned from an alien craft that had crashed into Earth's surface a century earlier.

Between departure in 2072 AD and the inadvertent return in 1000 AE of Prime Commander Cypher Raige and his son Kitai Raige, no one had any idea what had befallen the stricken world.

The Earth's rotational cycle is shorter than that of Nova Prime. Its orbit has shifted as a result of changes to the planet itself. Tectonic plates continued to shift with greater rapidity as the magnetic field weakened further before it resumed a cycle of strengthening, estimated at five hundred years ago. The plates ground against one another with such force that the African continent collided with that of Europe, creating an escarpment with a breathtaking waterfall.

While the planet could no longer sustain twelve billion humans, it did allow other life-forms to evolve, adapting to the new circumstances. While many species of flora and fauna vanished, most managed to eke out a meager existence.

TOP This declassified image shows cadet Kitai Raige surveying the damage following the crash on Earth. ABOVE Cadet Raige evaluates the injuries of his badly wounded father, Prime Commander Cypher Raige. OPPOSITE Kitai Raige en route to the homing beacon, in an image captured by one of the probes.

The planet itself continued to change under the lingering effects of trapped greenhouse gases, long after the manufacture of carbon dioxide ceased. Still, the changing makeup of the atmosphere, along with the ever-shifting magnetic poles, appears to have left Earth with extreme weather conditions. Direct sunlight was intensely carcinogenic, requiring limited exposure. The rain used to be acidic but no longer appears to be a problem now.

During the Raiges' stay on Earth, sensors detected that most of the surface cools to below-freezing temperatures after sunset, dropping a dramatic ten degrees every five minutes. Thankfully, there were also geothermal nodes that could keep a human warm during the freeze-over.

The planet returned to its natural roots, as jungles and profound forests overtook where humankind once had cities and roadways. Trees retuned to enormous sizes, some 4 meters in diameter, reaching dozens of meters tall.

This has led to a series of evolutionary leaps for many species as they adapt or die. As a result, Kitai Raige's cameras have given zoologists and related scientists new data to see how once-familiar species have changed. Notably, most have grown in size as a defense mechanism, so life-forms from leeches to reptiles have grown beyond their average sizes by a factor of two or three.

LEFT Earth's animal and avian life proved challenging enough, but an Ursa prowling the forests also meant Raige's cutlass had to be kept battle-ready.

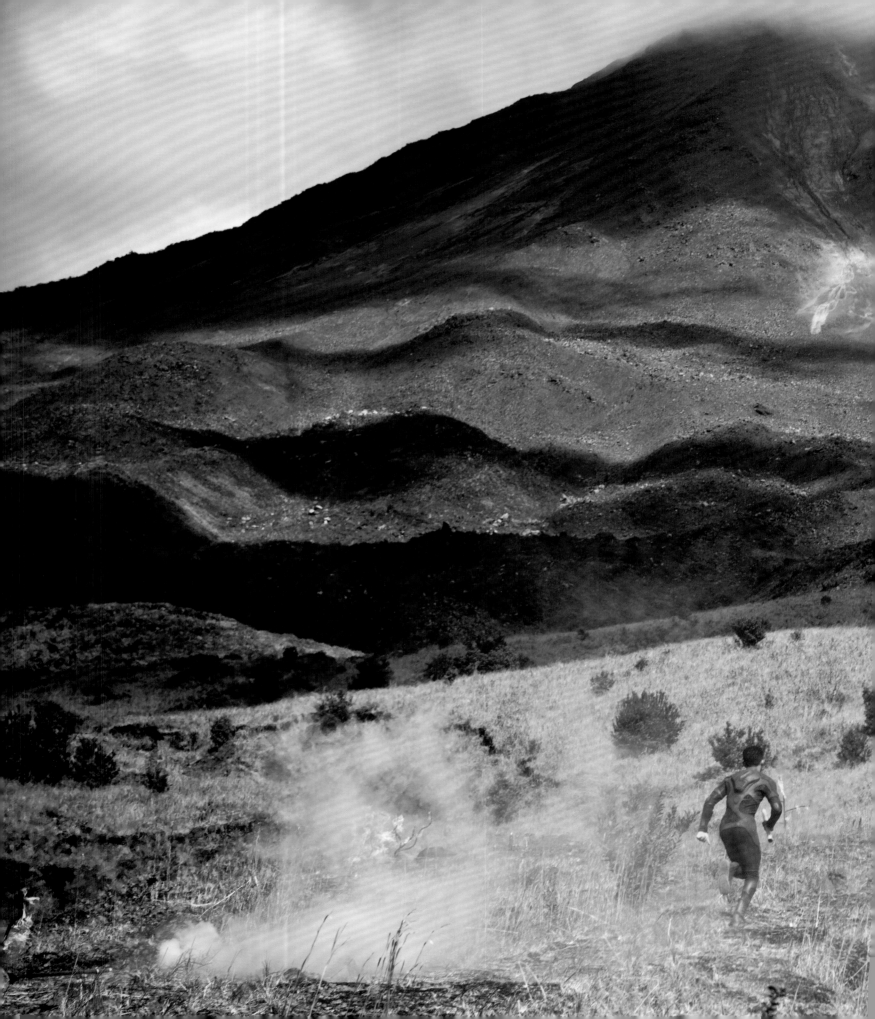

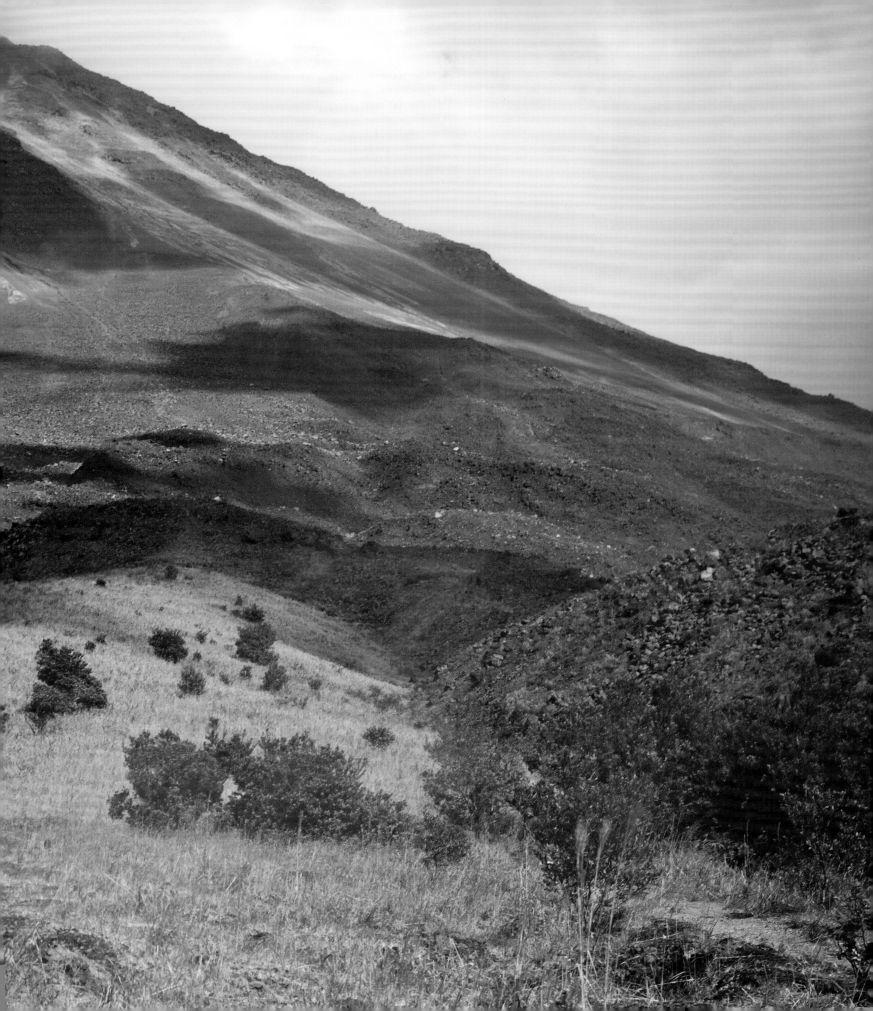

A NOTE FROM COMMANDER VELAN

All Rangers are expected to file After-Action Reports on a timely basis. This information is thoroughly analyzed and has allowed our training and mission preparation to be refined over the centuries. For some this may be seen as busywork, but trust me, every word is studied and considered. We've received special permission for this classified document to be shared with Rangers to demonstrate the style of reportage we expect. Additional details about Earth can also be gleaned from the following, which, along with being fascinating reading, will prepare you for a similar emergency situation all the more.

BELOW & OPPOSITE TOP Cadet Raige flees from attacks by Earth's highly evolved creatures. **OPPOSITE BELOW** Caves on Earth proved eerily familiar to Kitai Raige, offering protection from the planet's harsh, unpredictable elements.

TO: Primus Liliandra Quen, Savant Gerard Martinelli
FROM: General Cypher Raige
SUBJECT: Earth, 1000 AE
DATE: 3 Russia 1000 AE

RETURNING TO EARTH was never on the Rangers' agenda, and I do not think anyone imagined a reason we would return—but, it seems, Fate wanted us to come back and see what has become of humankind's birthplace. Although I was physically unable to leave the *Hesper* and explore the world, I was able to deploy the full complement of probes to study and record what Earth is like today. The Savant's biologists, zoologists, and anthropologists have already been copied on the data, which will no doubt keep them occupied for several years.

What I want to do is share with you my personal observations and recommendations going forward.

Whatever forced the planet's magnetic core to malfunction in 2072 AD seems to have settled or reversed itself, and the planet's physics appear to operate as one would expect. I will leave it to the geologists to tell us why, but some time after we left Earth, the planet's tectonic plates shifted violently and now the globe is encircled by active volcanoes. Given the activity, I surmise this might have been a fairly recent turn of events—recent in the larger scheme of things. Regardless, this has meant unexpected eruptions that disrupt life around the site. It also means fresh amounts of volcanic ash have been added to the atmosphere, possibly slowing down the healing process and keeping the greenhouse gases trapped.

The probes also observed major land mass changes such as the formation of what Cadet Raige has named the Eternal Falls. Two tectonic plates ground against one another for an undetermined length of time, but long enough to form a waterfall the length of the Grand Canyon in the area of Earth once known as North America. While a spectacular sight, it certainly demonstrates the upheavals that ravaged the planet after humanity left.

While the last of humankind died off in what we believe to be 2077, it is interesting to note that other life, from microbes to mammals, did continue to live and adapt to the changing surroundings.

Life found a way to survive.

And not just survive—but grow, adapt, and evolve. Much of the world matches the videos and pictures we brought with us aboard the arks. But it is greener, with more extremes everywhere I scanned. The polluted atmosphere seemed to force the trees to stretch higher than ever before, seeking both sunlight and fresher air, in order to survive. Life reduced concrete and macadam to rubble, and great forests and jungles have reclaimed the cities and countries. The only remnant of human ingenuity spotted by Cadet Raige was a massive dam.

I saw precious little to determine which cultures and societies once existed where the *Hesper* crashed and where Cadet Raige walked to obtain the homing beacon. Borders were easily erased, and without the old maps, it was as if we were surveying a brand-new world.

There is a terrible beauty to the planet, achieved at an unimaginable price.

To match the scale of the flora, the fish, reptiles, insects, and mammals grew in size. Species threatened by extinction when we departed Earth had an opportunity to reassert themselves. There is a haunting quality to the cries of countless species greeting the rising sun (although I kept expecting a second sun to follow the dawn).

Cadet Raige's reports made mention of a condor, many times the size we last believed it to be. In addition to increased size, it seemed to have an evolved intellect and treated Cadet Raige as one of its own. It nourished him and accompanied him on a portion of his mission and then protected him during the harsh cold night, at the expense of its own life. This condor sacrificed itself to keep Cadet Raige alive—and that is a debt I will never be able to repay. There is a remarkable resiliency borne out of the threat of obliteration. We saw it happen to humankind on Earth and I witnessed it in the evolved creatures that remained on Earth. They displayed a nobility, when left alone—something I believe our ancestors may have lost sight of. But I will leave those thoughts to the augurs.

Other animals have also evolved, growing stronger, faster, and tougher to beat. The current version of a lion, for example, appears to have less of a wild mane crowning its head, though it is more muscular. Thankfully, the computer databases were able to help identify some of these altered creatures.

Among the mammals closest to humans on the evolutionary scale, simians, apes, baboons, and related creatures are far more feral than records indicate. They continue to travel in packs, as much for community as for protection. We witnessed evidence of fierce battles that left dozens if not hundreds of mammals dead.

Given the harsh temperature shifts and the frigid cold nights brought on by the ash-filled skies, most life finds shelter once the sun sets. Night predators have grown increasingly thicker hides so that their feeding and mating patterns remain undisturbed.

What stands out in my mind is that it took generations to push the planet to the tipping point, but when that point came, and the dangers became a reality that could no longer be debated, every nation on Earth found the strength to ignore their differences and come together to find a way off a dying world, and then remained united until a new home could be reached. The need for mutual survival also meant that we stayed together as one, as we fought to tame our new world and build on it.

When we lost our way, the Skrel reminded us of our need to remain unified and even sent the Ursa with regularity to reinforce the point. Unfortunately, the Ursa are here to stay, so the question I must next consider is, How can this integrated state remain in perpetuity? There has to be some way we can do this for ourselves, without a hostile alien race effectively serving as our conscience.

There are philosophical and moral questions about returning to the homeworld, ones I do not feel qualified to answer. However, as Prime Commander of the United Ranger Corps, I do get to weigh in on the practical and security concerns presented by an expedition to Earth. There are recorded and unknown dangers that continue to make it a hazardous planet, along with the inherent cost of an expedition crossing the vast distance between Earth and Nova Prime.

It took millions of years for life to assert itself on this world, and it has taken just one thousand years for Mother Nature to begin repairing the damage we caused. It is my recommendation that the Class-1 quarantine remain in force in perpetuity.

We have done enough.

Let the planet be.

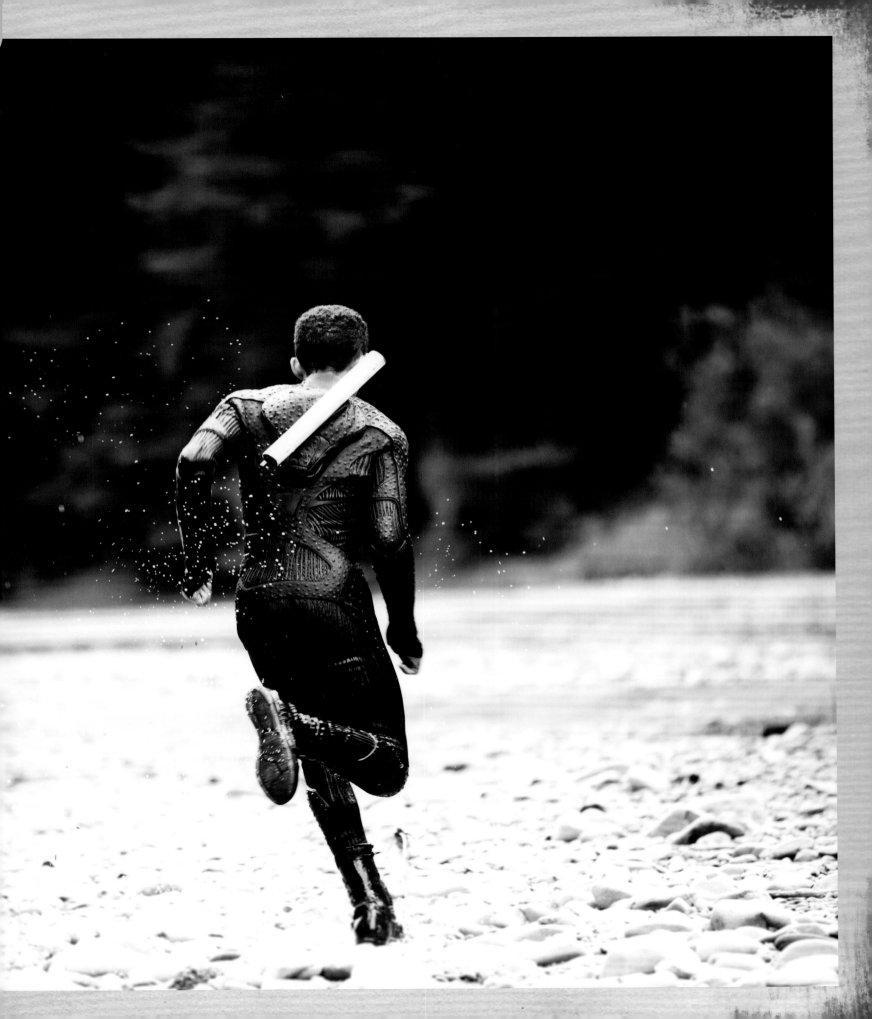

CONCLUSION

Knowledge is often the difference between survival and failure. Mastery of the information contained within this guide, along with the detailed instruction manuals for the weaponry and craft you will use during your career as a Ranger, is a vital component of your training. This is why you are tested annually, and thoroughly. It is one thing to wield a cutlass with deadly accuracy, but knowing how to reconfigure it while under enemy fire is equally vital. Even more important is knowing why you wield your weapon: to Preserve Humanity.

Lessons forgotten on Earth led to the loss of billions of lives and the extinction of countless species. Upon arrival on Nova Prime, our second chance, we dedicated ourselves to always remember and to do better. We can never forget the lessons we painfully learned more than a millennium ago, and this is why we continue to include studies of Earth and its tragic end in your training.

Keeping humankind alive, letting us grow and flourish now that we have established ourselves across the stars, is our prime mission. We serve, protect, and die holding the ideals of a millennium of our brethren in the forefront of our thoughts. Their successes and failures are a lesson to us.

Rangers proudly protect the human race and on a daily basis ensure that we have a chance to do better, and not squander this second opportunity. Remember that, each morning, as you don the uniform and endure grueling, yet necessary, training. Remember that, each evening, as you clean your weapon and brush the dust off your uniform. You are a symbol of human resiliency and perseverance. You are our best and brightest.

You are a Ranger.

Commander Rafe Velan
Commandant, Ranger Cadet Training
7 Russia 1000 AE

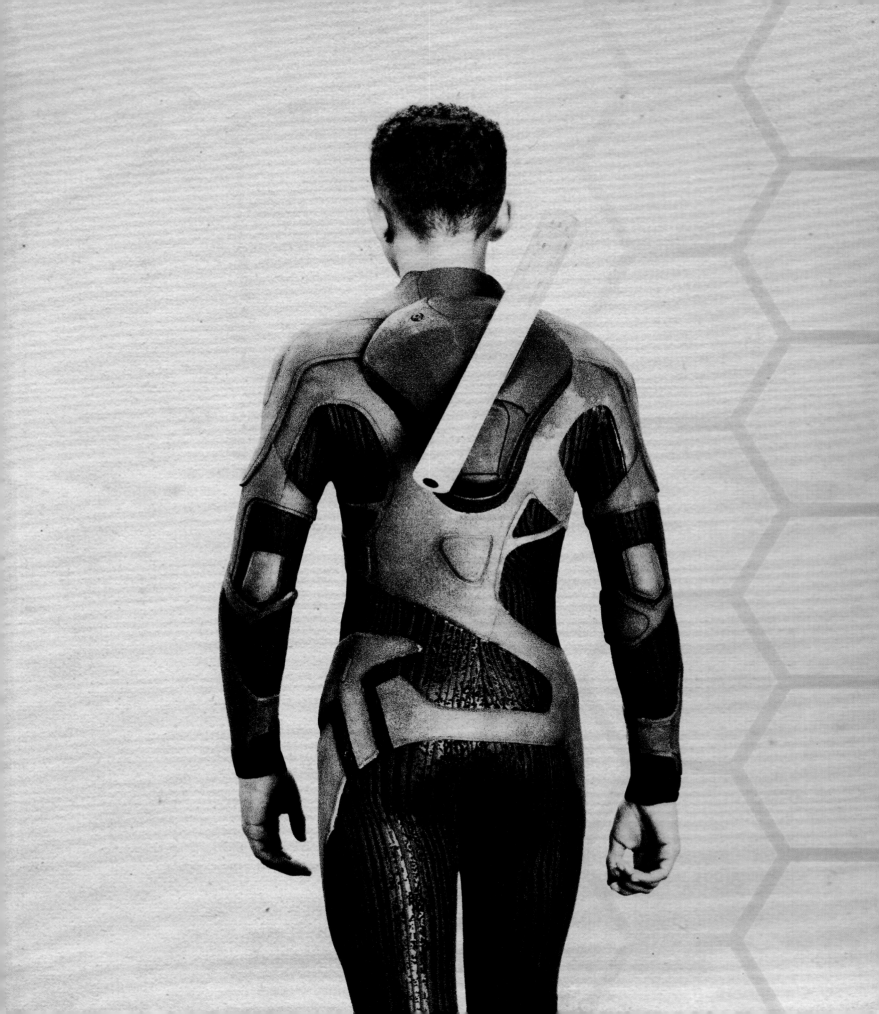

AUTHOR ACKNOWLEDGMENTS

This book exists because of the collaborative relationship fostered by Overbrook Entertainment and its writers and producers. The material found in here is a result of the ongoing efforts by Will Smith, Caleeb Pinkett, M. Night Shyamalan, Gary Whitta, Peter David, and Michael Jan Friedman, to make *After Earth* as unique and cohesive a universe as is possible. Special thanks to Gaetano Mastropasqua, Clarence Hammond, Kristy Creighton, Michael Burstein, and Inge Heyer.

—Robert Greenberger

PHOTO CREDITS

Motion Picture Artwork and Photography
© 2013 After Earth Enterprises LLC. All Rights Reserved.

Photography by Alan Silfen
Unit Stills by Frank Masi

Earth photo page 9: NASA's Earth Observatory
Underlying photo page 11: NASA's Earth Observatory

Illustrations on pages 12, 15, 18–19, 23, 41, 43, 49, 70, 89–91, 99, and 112–113 by Freddie E. Williams II

COLOPHON

Publisher: Raoul Goff
Editor: Chris Prince
Designer: Kristoffer Branco
Art Director: Chrissy Kwasnik
Production Manager: Anna Wan

Insight Editions would like to thank Gaetano Mastropasqua, Cindy Irwin, Kristy Creighton, Clarence Hammond, Caleeb Pinkett, Robert Greenberger, Alan Silfen, Tom Sanders, Dean Sherriff, Jenne Lee, The Creative Cartel, Mick Mayhew, Drew Facet, Freddie E. Williams II, Mikayla Butchart, and Elaine Ou.

INSIGHT EDITIONS

PO Box 3088
San Rafael, CA 94912
www.insighteditions.com

www.INSIGHTEDITIONS.com
FOR WEB EXCLUSIVE CONTENT!

Find us on Facebook: www.facebook.com/InsightEditions
Follow us on Twitter: @insighteditions

Library of Congress Cataloging-in-Publication Data available.

ISBN: 978-1-60887-235-0

ROOTS of PEACE REPLANTED PAPER

Insight Editions, in association with Roots of Peace, will plant two trees for each tree used in the manufacturing of this book. Roots of Peace is an internationally renowned humanitarian organization dedicated to eradicating land mines worldwide and converting war-torn lands into productive farms and wildlife habitats. Roots of Peace will plant two million fruit and nut trees in Afghanistan and provide farmers there with the skills and support necessary for sustainable land use.

Manufactured in China by Insight Editions

10 9 8 7 6 5 4 3 2 1